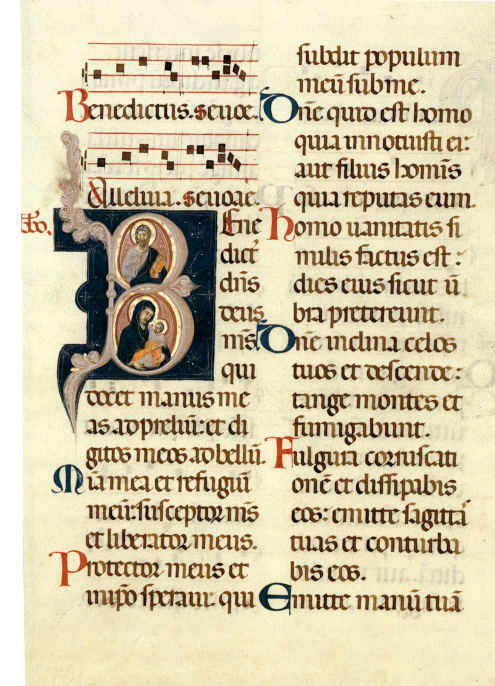

Benedictus. seuoe.

Alleluia. seuoe.

Bne
dict'
dns
deus
m's
qui

docet manus me
as ad prelui: et di
gitos meos ad bellu.

Mia mea et refugiu
meu: susceptor m's
et liberator meus.

Protector meus et
inipo speraui: qui

subdit populum
meu sub me.

Dne quid est homo
quia innotuisti ei:
aut filius homis
quia reputas eum.

Homo uanitatis si
milis factus est:
dies eius sicut ū
bra pretereunt.

Dne inclina celos
tuos et descende:
tange montes et
fumigabunt.

Fulgura coruscati
one et dissipabis
eos: emitte sagittā
tuas et conturba
bis eos.

Emitte manū tuā

Treasures of a Lost Art

Italian Manuscript Painting of the Middle Ages and Renaissance

PIA PALLADINO

THE METROPOLITAN MUSEUM OF ART

YALE UNIVERSITY PRESS, NEW HAVEN AND LONDON

This catalogue has been published in conjunction with the exhibition "Treasures of a Lost Art: Italian Manuscript Painting of the Middle Ages and Renaissance," held at the Cleveland Museum of Art (February 23–May 4, 2003), the Fine Arts Museums of San Francisco (June 7–August 31, 2003), and The Metropolitan Museum of Art, New York (September 30, 2003–February 1, 2004). Exhibition organized by The Metropolitan Museum of Art.

The following works will be exhibited in New York only: cat. nos. 2, 3b–c, e–f, 7–8, 12–14, 16–17, 21a, 24, 26, 30, 34, 35a, 37b, 40–41, 49–50, 55b, 58a, 60–61, 62a, c, 64, 66, 71, 73, 74, 77, 79, and App.1–2, 16. Not included in the exhibition are works in the Allen Memorial Art Museum, Oberlin; the Houghton Library, Cambridge; the Minneapolis Institute of Arts; as well as cat. nos. 35c, 48a–i, 57, 68–69, App. 17–19.

This publication is made possible in part by The Andrew W. Mellon Foundation.

Published by The Metropolitan Museum of Art, New York
John P. O'Neill, Editor in Chief
Joan Holt, Editor
Antony Drobinski, Designer
Peter Antony and Jill Pratzon, Production
Minjee Cho, Desktop Publishing

Typeset in Adobe Garamond
Separations by Professional Graphics, Rockford, Illinois
Printed by Brizzolis Arte en Gráficas, Madrid
Bound by Encuadernación Ramos S.A., Madrid
Printing and binding coordinated by Ediciones El Viso, S.A. Madrid

The source for the identification of all liturgical texts pertaining to antiphonaries is Renato–Johanne Hesbert's *Corpus Antiphonalium Offici,* published in six volumes in Rome between 1963 and 1979.

To reproduce as many examples as possible, many of the manuscript leaves are shown in detail only.

LIBRARY OF CONGRESS CATALOGING-IN-PUBLICATION DATA

Palladino, Pia.
 Treasures of a lost art : Italian manuscript painting of the Middle Ages and Renaissance / Pia Palladino.
 p. cm.
 Catalogue of an exhibition held at the Cleveland Museum of Art, Feb. 23–May 4, 2003, Fine Arts Museums of San Francisco, June 7–Aug. 31, 2003, and The Metropolitan Museum of Art, Sept. 30, 2003–Feb. 1, 2004.
 Includes bibliographical references and index.
 ISBN 1–58839–030–6 (hc.)—ISBN 1–58839–032–2 (pbk.)—
 ISBN 0–300–09879–0 (Yale)
 1. Illumination of books and manuscripts, Italian—Exhibitions. 2. Painting—New York (State)—New York—Exhibitions. 3. Lehman, Robert, 1892–1969—Art collections—Exhibitions. 4. Metropolitan Museum of Art (New York, N.Y.)—Exhibitions. I. Cleveland Museum of Art. II. Fine Arts Museums of San Francisco. III. Metropolitan Museum of Art (New York, N.Y.) IV. Title.

ND3159 .P35 2003
745.6'7'094507473—dc21

2002035987

COVER ILLUSTRATION: Detail of *Annunciation in an Initial M,* by Neri da Rimini (cat. no. 5b). FRONTISPIECE: *Virgin and Child and God the Father Blessing in a Initial B,* by Duccio do Buoninsegna (cat. no.27)

Contents

Acknowledgments

This exhibition and the research and writing of the present catalogue would not have been possible without the generous assistance of numerous individuals and institutions, in Europe and the United States, who made available their time, knowledge, and resources: the Accademia Etrusca in Cortona, Jonathan Alexander, the Allen Memorial Art Museum, Federica Armiraglio, Alessandro Bagnoli, the staff of the Archivio della Badia di Cava dei Tirreni, the staff of the Archivio di Stato in Gubbio, Maria Cristina Bandera, the staff of the British Library, Cristina De Benedictis, Angela Dillon Bussi, Don Roberto Donghi, Paola Errani, William Faucon and the staff of the Boston Public Library, Dott. Don Andrea Foglia, the staff of the Fondazione Giorgio Cini, the staff of the Frick Art Reference Library, Sandra Hindman, the staff of the Houghton Library, Lyle Humphrey, Martin Kauffman and the staff of the Bodleian Library, Bill Lang and the staff of the Free Library of Philadelphia, Elvio Lunghi, Giordana Mariani Canova, Massimo Medica, the Monastery of San Giorgio Maggiore in Venice, the staff of the Museo dell'Opera del Duomo in Siena, the staff of the Pierpont Morgan Library, Frances Rankine, Jennifer Saville, William Voelkle, the staff of the Thomas J. Watson Library, Valerie Zell.

A special note of appreciation goes to Suzanne Boorsch and the Yale University Art Gallery; Stephen Fliegel and the Cleveland Museum of Art; and Robert Burke, Lynn Federle Orr, and the Fine Arts Museums of San Francisco, for their enthusiastic response to this project.

Among the many individuals involved in this endeavor here at The Metropolitan Museum of Art, I wish to thank the following, in particular: Laurence Kanter, curator of the Robert Lehman Collection, for first conceiving the idea of this exhibition and for his invaluable advice throughout the writing and production of the catalogue; Manus Gallagher and Jeanne Salchli, for sorting out every practical detail of my work with efficiency and good humor; and Marjorie Shelley, Margaret Lawson, Akiko Yamazaki-Kleps, and Alison Gilchrest, in the Sherman Fairchild Center for Works on Paper, for devoting their time and skills to the meticulous examination of each object. The final appearance and readability of this catalogue is due to Joan Holt's expert editing, carried out with unflagging patience and great sensitivity; Eileen Travell's beautiful photography; and Antony Drobinski's design. Peter Antony and Jill Pratzon dealt with the logistics of the volume's production, and John O'Neill provided encouragement from its inception to completion.

I am, of course, deeply grateful for the support of our director, Philippe de Montebello.

Pia Palladino
Assistant Curator
Robert Lehman Collection

Director's Foreword

Treasures of a Lost Art presents to the public for the first time one of the largest, most impressive private collections of Italian manuscripts assembled after the First World War and comparable only to the Cini Collection in Venice. Formed by Robert Lehman over the course of three decades, it reflects the full range and achievement of manuscript production in Italy from the thirteenth through the sixteenth century. Included are representative examples of the major schools of illumination in southern Italy, Umbria, Tuscany, Emilia, Lombardy, and the Veneto. Unknown even to specialists and scholars are works by some of the principal figures in the history of Italian painting, such as the illuminated leaf by Duccio di Buoninsegna (cat. no. 27) or the cuttings by Stefano da Verona (cat. nos. 52a–b) and Cosimo Tura (cat. no. 47). Next to these are works by less widely known personalities—Neri da Rimini, Belbello da Pavia, Girolamo da Cremona, the Master B. F., Attavante—who once dominated the field of manuscript production and were sought after by popes and princes alike, but are now familiar only to art historians. Together they provide a rich tapestry of images that broadens our knowledge and appreciation of the creative genius of Italian Renaissance culture.

The Metropolitan Museum of Art takes great pride in organizing this exhibition and in sharing it with our colleagues at the Cleveland Museum of Art and the Fine Arts Museums of San Francisco. We would like to thank the private collectors and institutions—Yale University, Harvard University, Oberlin College, and the Minneapolis Institute of Arts—who have shared information with us or permitted us to borrow illuminations once owned by Robert Lehman, a collector of remarkably informed taste and a benefactor of exceptional generosity.

The exhibition and this publication were conceived by Pia Palladino, assistant curator of the Robert Lehman Collection at The Metropolitan Museum of Art. The cataloguing of this lesser-known aspect of Robert Lehman's holdings has been made possible by support from the Andrew W. Mellon Foundation. We are deeply grateful to the foundation for its long-standing commitment to scholarship at the Metropolitan Museum.

Philippe de Montebello
Director, The Metropolitan Museum of Art

Treasures of a Lost Art

Introduction

On May 26, 1825, the first sale of illuminated manuscript leaves and cuttings took place at Christie's, in London. In it were fragments of the Sistine Chapel choir books, dispersed during the Napoleonic invasion of Italy and brought to England by Abate Luigi Celotti. In the auction catalogue's introduction, William Young Ottley, the English antiquarian and collector who would later become keeper of the Print Room in the British Museum, highlighted not only the beauty and near perfect state of preservation of these works but also noted their importance as "the monuments of a lost Art," the only surviving evidence of the long forgotten technique of the "ancient Illuminists."[1] Indeed, this sale marked the beginning of a new interest, on the part of nineteenth-century collectors, in manuscript illumination as something of a curiosity but on a level equal with painting. In the Celotti sale, in particular, most of the miniatures were presented as paintings, void of any text, often framed within illusionistic borders or pasted together as collages (see cat. no. 84). It has rightly been noted that, ironically, the Celotti sale and the ensuing appreciation of Italian manuscript illumination could not have happened without the French invasion of Italy and the Napoleonic suppression of monasteries, when entire monastic libraries were dispersed and sold to collectors, very often by the monks themselves. Single leaves and fragments from books that had been cut up flooded the art market and in many cases were acquired to complement an already existing collection of paintings.

Robert Lehman (1891–1969), who may be counted among the greatest twentieth-century collectors of manuscripts, began acquiring single leaves and cuttings as an extension of the collection of early panel paintings formed by his father, Philip Lehman. Notable for its breadth, as well as quality, the collection ranged in date from the thirteenth to the sixteenth century and covered the main centers of manuscript production in Italy. Most of the miniatures were excised from liturgical texts, in particular antiphonaries and graduals, the two principal choir books of Catholic devotion, containing, respectively, the sung portions of the Divine Office and the mass. Among the most important pieces in the collection are fragments from two prestigious series of fifteenth-century choir books: one commissioned by the Greek cardinal Bessarion for the Franciscan convent of Saint Anthony of Padua in Constantinople (cat. nos. 42–45); the other produced for the Benedictine monastery of San Giorgio Maggiore in Venice (cat. nos. 58–59). Involved in the decoration of these volumes were some of the outstanding personalities in the history of Ferrarese and Lombard illumination.

The art of manuscript illumination, as evidenced by most of the examples collected by Robert Lehman, was born of a desire to highlight the most important feast days in the liturgical cycle of the Catholic Church, from Marian feasts to Christ's Passion and death. Individual monastic communities emphasized the relevance of their patron saint or others associated with their order. In the most elaborate commissions, not only was the initial introducing the text decorated with a narrative but also the pages' borders. Two fourteenth-century Bolognese leaves owned by Robert Lehman, once part of a large series of choir books for the Church of San Domenico in Bologna (cat. nos. 9a–b), include, in addition to historiated initials illustrating the feasts of Saints Andrew and John the Evangelist, further scenes from the lives of these saints in the lower border medallions, providing an elaborate, visual commentary on the day's lesson beyond the sung text.

The technique of manuscript illumination is essentially the same as that for painting on panel, beginning with a primer applied to the parchment, followed by gilding and the laying down of pigment. Thus during the fourteenth and fifteenth centuries commissions for illuminations were often entrusted to painters, not just in monastic scriptoria but in some of the major workshops of the period. Included in the collection are two cuttings by the Lombard painter Stefano da Verona (cat. nos. 52a–b), which reflect, in their exquisite technical refinement and fantastic decorative idiom, one of the highest achievements of the International Gothic style in Italy. Also published here for the first time is an antiphonary leaf illuminated by the famous Sienese painter Duccio di Buoninsegna (cat. no. 27). While he was one of the leading figures, along with Giotto and Cimabue, in the history of early Italian art, his activity as an illuminator—though presumed by scholars—has until now remained unknown. The Sienese school of painting, a particular favorite of both Philip and Robert Lehman, is also represented by a remarkably vivid miniature of Saint Bernardino of Siena (cat. no. 77). Essentially a portrait on parchment, probably excised from a book of hymns in honor of the saint, it is the work of Francesco di Giorgio, a painter, sculptor, and architect, as well as an illuminator.

The achievements of the Florentine school of illumination in the fourteenth century are represented in the collection by the two beautiful pages from a *laudario,* or book of hymns, for the lay confraternity of Sant'Agnese (cat. nos. 21a–b), decorated by the painter and illuminator Pacino di Bonaguida; and by a cutting (cat. no. 78) from the celebrated series of choir books for the Camaldolese monastery of Santa Maria degli Angeli, which were admired by all who saw them from

the sixteenth century onward. The cutting was excised from an antiphonary illuminated by Lorenzo Monaco, a monk at Santa Maria degli Angeli, who was also the foremost painter in Florence during the first quarter of the fifteenth century. Subsequent to the purchase of this miniature, Robert Lehman also acquired two panel paintings by the same artist (Metropolitan Museum of Art, Robert Lehman Collection, 1975.1.66, .67).

The progressive changes in the craft of manuscript illumination during the late fifteenth century and early sixteenth century are reflected in the creation of small works such as the beautiful *Adoration of the Shepherds* (presumed to have been owned by two popes and a Medici grand duke) by the Emilian painter Marmitta (cat. no. 85). Although executed on parchment, it is conceived essentially as an independent painting on a small scale. Completing the exceptional panorama of the history of Italian manuscript illumination offered by the present collection, Marmitta's work reflects the last glorious moment of the art of the painted page, before its extinction with the rise of modern book illustration.

1. *A Catalogue of a Highly valuable and Extremely Curious Collection of Illuminated Miniature Painting, of the Greatest Beauty, and Exquisite Finishing, Taken from the Choral Books of the Papal Chapel in the Vatican, during the French revolution; and subsequently collected and brought to this Country by the Abate Celotti,* sale, May 26, 1925, Christie's, London, May 26, 1825, as cited in Hindman et al. 2001, p. 54.

Central Italian Artist (First Master of the Cortona Antiphonaries?)

Active third quarter of the thirteenth century

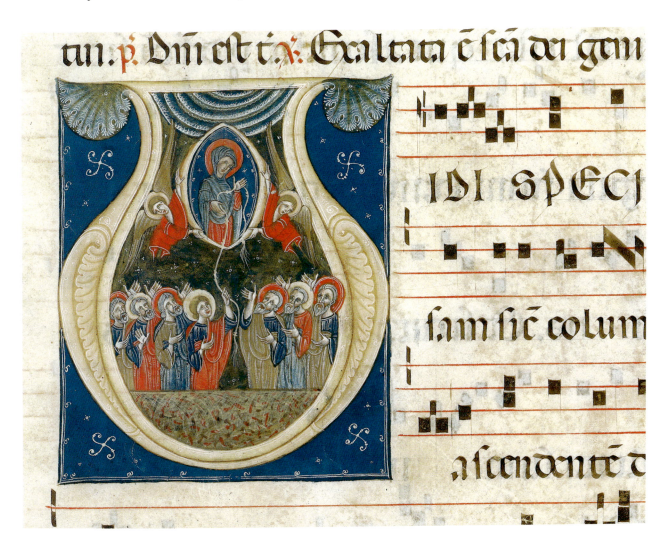

I

Assumption in an Initial V

Circa 1260–79
Leaf from an antiphonary

Tempera on parchment. Leaf: 19 ½ × 13 ¾ in. (48.8 × 35 cm).
Initial: 5 ¹¹⁄₁₆ × 4 ¹³⁄₁₆ in. (14.3 × 12.3 cm). Stave: 2.5 cm

Recto: cu[m] ang[e]lis triu[m]pha[n]s.[rubr.] *Ps.* Celi en[arrant]
[rubr.]*a.* Benedic/ta tu in mulierib[us et] benedictus fruct[us] vent[ri]s/
tui [rubr.]*ps.*D[omi]ni est t[erra]V. [rubr.]*a.* Exaltata e[st] s[an]c[t]a
dei genet[ri]x/[rubr.]*R./ Vidi* specio/sam sic[ut] columba[m]/
ascendente[m] de su/p[er] rivos aquaru[m] cuius inextimabi/lis

odor erat nimis in vestimentis e. Verso: ius. Et sicut dies verni
circu[m]daba[n]t/ eam flores rosaru[m et] lilia [con]valliu[m] [rubr.]
a./Que est ista qu[a]e ascendit p[er] des[er]tu[m] sicut / virgula
fumi ex aromatib[us] mire et/ thuris. Et sicut. [rubr.] *R.* Sicut
cedrus/ exaltata sum in libano [et] sicut/ cipressus in monte Syon
quasi mirra/ electa. Dedi suavitate[m] odo [rem].

Folio 48 written in ink, in upper right, by later hand

PROVENANCE: John F. Murray, Florence, 1924
LITERATURE: De Ricci 1937, p. 1704, D.19 (as probably written at
Bologna)

The illuminated initial V decorating this antiphonary leaf illustrates the second response ("Vidi speciosam sicut columbam" [I saw her, fair as a dove] for the first nocturn of the Feast of the Assumption of the Virgin (August 15). Inside the exuberantly foliated letter, the Virgin, enclosed in a mandorla supported by two angels, is shown dropping her girdle down to Saint Thomas, who is flanked by six other apostles with uplifted arms.

This page may be associated with four leaves, identical in style, decoration, measurement, and stave height, that were probably excised from the same antiphonary book or set: an initial A with the *Three Marys at the Tomb* in the National Gallery of Art, Washington (B–18,760); an initial H with the *Nativity* in the Cini Collection, Venice (12); an initial I with a monk holding an aspergillum, in the Free Library, Philadelphia (M68.1); and an initial P with the *Ascension of Christ,* recently on the art market in London (Maggs Brothers Ltd., *European Bulletin No. 19*, London, 1994, no. 1). The Washington, Venice, and Philadelphia cuttings were first grouped together by Carl Nordenfalk (1975, pp. 18–21) and tentatively ascribed to central Italy during the late thirteenth century.[1] Subsequently, Roberta Passalacqua (1980, pp. 16–17) convincingly identified the three leaves as products of the same, possibly Aretine, workshop responsible for the illuminations in a series of choir books in the Archivio Capitolare of the Cathedral of Arezzo and in the Accademia Etrusca of Cortona, a city that until 1253 was in the diocese of Arezzo.

The Lehman cutting and its four sister leaves bear close comparison to some of the illuminations by the so-called First Master of the Cortona Antiphonaries, one of several hands responsible for the decoration of three of the five antiphonary volumes that constitute that series (cod. 4C, 5D, and 6E), as well as of two of the choir books in Arezzo (cod. A, E). The Cortona illuminations were dated by Marcella Degl'Innocenti Gambuti (1977, pp. 33–57), on the basis of iconographic and stylistic evidence, to between 1260 and 1279. Because of the existence of miniatures closely related to them in choir books in Borgo Sansepolcro (Biblioteca Comunale, cod. I. 187) and Florence (Santa Maria Novella, cod. E), as well as in Arezzo, Degl'Innocenti Gambuti viewed the Cortona illuminations as products of a large

workshop of manuscript illuminators active during the third quarter of the thirteenth century in the territories of Arezzo and Florence.

In seeking to define the parameters of the style of the Arezzo and Cortona illuminations, both Degl'Innocenti Gambuti and Passalacqua highlighted the influence of the so-called First Style of Bolognese manuscript illumination, generally dated to between 1260 and 1270. Most recently, however, the existence of a Bolognese component in these works has been categorically denied by Maria Grazia Ciardi Dupré Dal Poggetto (1998, pp. 22–23), who instead identifies them as the product of an indigenous central Italian school of illumination and dates them significantly earlier, to the second quarter of the thirteenth century. While Ciardi Dupré Dal Poggetto is correct in her assessment of the main cultural component of these miniatures, her dating of them seems too early. Both stylistic and decorative elements, in fact, appear to support a later date and point to the generation of artists active in Tuscany and Umbria in the third quarter of the thirteenth century, shortly before the advent of Cimabue (ca. 1270).

1. A cutting in the Cleveland Museum of Art (51.549), tentatively associated with this group by Nordenfalk, is by a different hand, though clearly related to the same workshop.

Umbro-Roman (?)

Circa 1260–70

2
Saint Francis in an Initial I

Cutting from a gradual

Tempera on parchment. 6⅝ × 3¹³⁄₁₆ in. (16.6 × 9.7 cm). Stave: 3.2 cm

Recto: Sci. XCI/[rubr.] *Co.* Posueru[n]t/ In m[edio Ecclesiae aperuit os] / ei[us]. Verso: M ue/ to

PROVENANCE: Leo S. Olschki, Florence, 1924
LITERATURE: De Ricci 1937, p. 1705, B.28 (as Umbria, ca. 1350)

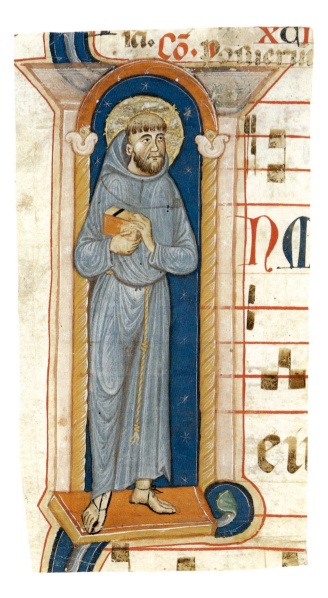

The initial I illustrates the introit ("In medio Ecclesiae" [In the gathering of the Church]) to the mass for the Common of a Doctor of the Church. Standing inside the letter, which is articulated as an architectural niche, is the full-length figure of Saint Francis of Assisi, who is identified by the Franciscan robe with a knotted cord and the wounds of the stigmata visible on his feet.

The palette and style of the present initial, as well as the blue background accented by white stars, are typical of Umbrian manuscript illumination of the second half of the thirteenth century. However, no other miniatures by the same hand have hitherto been identified. The solidly built figure of the saint, his body enveloped in ample swirls of folds, finds parallels in monumental painting in Umbria and Rome during the third quarter of the thirteenth century. More specifically, it may reflect the particular Umbro-Roman style of painting that developed during this period in Assisi, under the influence of Roman artists working in the Upper Church of the Basilica of Saint Francis.

Umbrian or Southern Italian

Circa 1270–80

3a
Last Judgment in an Initial A

Leaf from a gradual

Tempera on parchment. Leaf: 18 × 13⅛ in. (45.6 × 33.3 cm). Initial: 8⅞ × 6¾ in. (22.3 × 17.2 cm). Stave: 2.9 cm

Recto: Ad te levavi/ anima[m] mea/ in deus me/us in te co[n]fi/do non erubescam neq[ue] irri/deant me inimici mei et enim/ universi qui te expectant non. Verso: co[n]fundentur. [rubr.] *ps.* Vias tuas d[omi]ne de/mo[n]stra michi [et] semitas tuas edo/ce me [rubr.] *Gloria pat[ri].* [rubr.] *Quo finito repetit ur introitus./*Ad te levavi. [rubr.] *Et iste modus re/petendi introitus servatur per/ totum annum cum dicitur/*Gloria patri. [rubr.] *Post introitum. Et/ in festis dupplicibus. Gr./*Universi qui te ex/pectant non confundentur/ domine. [rubr.] *V.* Vias tuas/ domine

On recto, in top right corner, in black ink: 2. On verso, in center of upper margin, in red ink: II

PROVENANCE: Kalebdjian, Paris, 1924
LITERATURE: De Ricci 1937, p. 1706, A.21 (as written in Umbria)

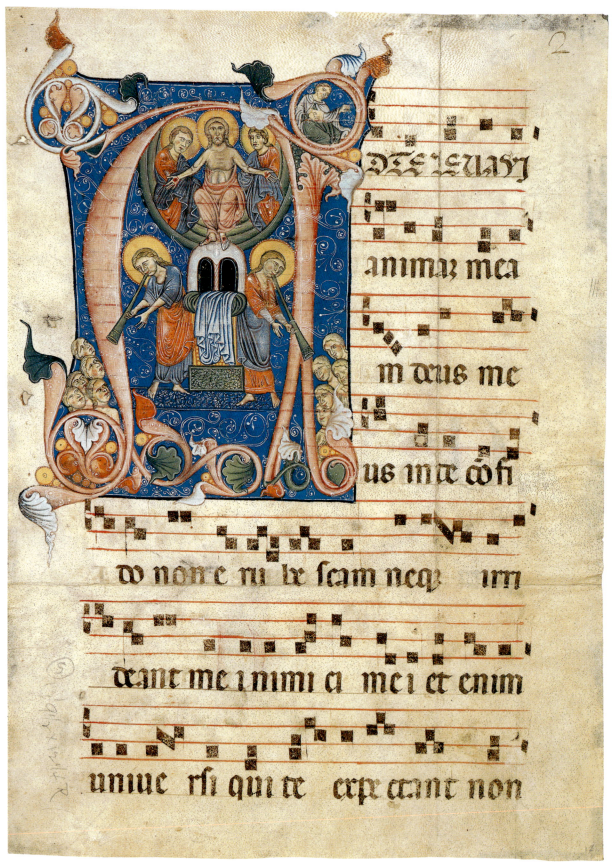

3b

Saint John the Evangelist in an Initial I

Leaf from a gradual

Tempera on parchment. Leaf: 19 × 13 ¼ in. (48 × 33.7 cm).
Initial: 4 × 2 in. (10.2 × 5.5 cm). Stave: 2.9 cm

Recto: ne ih[es]u accipe spiritu[m] meu[m] et/ ne statuas illis
hoc peccatu[m] q[ui]a/ nesciunt quid faciu[n]t [rubr.]*sancti
ioh[ann]is/ evangeliste/ officium/* In medio ecclesie aperu/it os eius et
inplevit e/um dominus spiritu sapientie/ et intellectus stola glorie.
Verso: induit eu[m]. [rubr.] *v.* Iocunditate[m]/ et exultatione[m]
thesauri[s]cavit/ super eu[m]. Gloria euouae. [rubr.] *R./* Exiit sermo
inter fratres/ q[uod] discipulus ille no[n]/ moritur. [rubr.] *v.* Set/ sic
eu[m] volo manere

On recto, in top right corner, in black ink: 12, followed by a smaller
5. On verso, in center of upper margin, in red ink: IX. In top left
corner, in black ink: 13. In center of left margin, in black ink: 5

PROVENANCE: John F. Murray, Florence, 1925
LITERATURE: De Ricci 1937, p. 1708, B.7 (as written by Berardus
de Teramo)

3c

Presentation in the Temple in an Initial S

Leaf from a gradual

Tempera on parchment. Leaf: 19 × 13 ⅛ in. (48.2 × 33.2 cm).
Initial: 4 ¼ × 3 ½ in. (10.7 × 8.8 cm). Stave: 2.9 cm

Recto: Suscepim[us] deus/ misericordia[m] tua[m]/ i[n] medio
te[m]pli tui se/cundu[m] nomen tuu[m] deus/ ita et laus tua in
fines/ terre iustitia plena est/ dextera tua. [rubr.] *v.* Magn[us].
Verso: d[omi]n[u]s et laudabilis nimis in ci/vitate d[e]i n[ost]ri i[n]
mo[n]te s[an]c[t]o eius./ Gloria.euouae. [rubr.] *R.* Susce/pim[us]
deus misericor/dia[m] tua[m] in medio/ templi tui secu[n]du[m]
nom[en]/ tuu[m] domine ita et laus

On recto, in top right corner, in black ink: 32, followed by a smaller
15. On verso, in center of upper margin, in red ink: XIX. In top left
corner, in black ink: 33. In center of left margin, in black ink: 15

PROVENANCE: John F. Murray, Florence, 1925
LITERATURE: De Ricci 1937, p. 1708, B.6 (as written by Berardus
de Teramo)

3d
Martyrdom of Saint Peter Martyr in an Initial P

Leaf from a gradual

Tempera on parchment. Leaf: 18¾ × 13¼ in. (47.5 × 33.5 cm).
Initial (with extension): 12⅜ × 4½ in. (31.5 × 11.4 cm). Stave: 2.9 cm

Recto: m[us] et delectati su/mus alle/luya. [rubr.] *com*. Ego su[m]

vitis/ vera et vos palmites q[ui] man[et]/ in me et ego in eo hic fert/ fructu[m] multu[m] alleluya./ [rubr.] *S[an]c[t]i vital[is] m[arti]ris. Offi[cium]*. P[ro]texisti me d[eu]s. All[elui]a. [rubr.] *v.*/ Iustus non [con]tu[r]bab[itu]r. [rubr.] *Offr*. Repleti sum[us]. [rubr.] *Com*./ Ego su[m] vitis. [rubr.] *In festo b[ea]ti petri m[arti]ris. Offi[cium]*. Verso: Protexisti me/ deus a conve[n]/tu malignanti/u[m] alleluya a mul/titudine operanti/u[m] iniquitate[m]/alleluya alleluya. [rubr.] *Ps*

On recto, in upper right corner, in black ink: 64, followed by a smaller 32. On verso, in center of upper margin, in red ink: XXXVI. In top left corner, in black ink: 65. In center of left margin, in black ink: 32 and Petri Mart.

PROVENANCE: John F. Murray, Florence, 1925
LITERATURE: De Ricci 1937, p. 1708, B.8 (as written by Berardus de Teramo)

3e
Translation of the Body of Saint Dominic in an Initial I

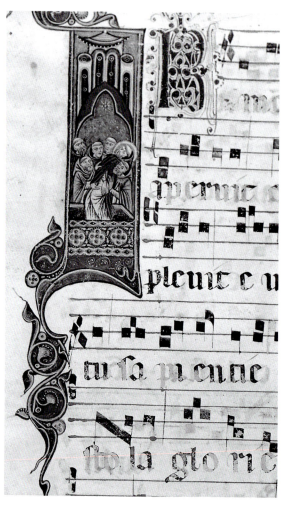

Leaf from a gradual
Oberlin, Allen Memorial Art Museum, 43.10

Tempera on parchment. Leaf: 18½ × 13½ in. (47 × 34.3 cm).
Stave: 2.9 cm

Recto: [rubr.] *offer.*Confitebuntur/ celi mirabilia tua/ domine et
veritatem/ tuam in ecclesia sancto/rum alleluya/alle/luya. [rubr.] *Com.*
Gaudete iusti in do/mino/ *In translatione beati domi/nici confessoris.*
Officium. Verso: In medio ecclesie/ aperuit os eius et im/plevit
eu[m] domin[us] spiri/tu sapientie et intellect[us]/ stola glorie
induit eu[m]/ alleluya alleluya/alleluya. [rubr.] *v.* Iocun/[ditatem]

On recto, in upper right margin, in black ink: 88, followed by 44.
On verso, in center of upper margin, in brown wash: 48. In top left
corner, in black ink: 89. In center of left margin, in black ink: 44

PROVENANCE: John F. Murray, Florence, 1925; gift of Robert
Lehman to Oberlin College, 1943
LITERATURE: De Ricci 1937, p. 1708, B.5 (as written by Berardus de
Teramo); Hamburger 1995, pp. 10–11 (as central Italy, possibly
Umbria, ca. 1290)

3f
Saint Peter in an Initial N

Leaf from a gradual

Tempera on parchment. Leaf: 18¾ × 13¼ in. (47.7 × 33.5 cm).
Initial: 4³⁄₁₆ × 3⅜ in. (10.7 × 8.7 cm)

Recto: omnia nostri tu scis/domine quia amo te./[rubr.] *In/die/*
officium. Nunc sci/o vere quia mi/sit dominus angelum su/um et
eripuit me de ma/nu herodis et de om. Verso: ni expectatione
plebis/ iudeorum. [rubr.] *Ps.* Domine /probasti me et cognovisti
me/ tu cognovisti sessionem meam et resurrectionem meam.
Gloria./euouae. [rubr.]*R.LXXXXVIII* consti/tues eos./[rubr.] *v.* Pro
pa/tribus tuis. Alle/luya

On recto, in upper right corner, in black ink: 114. On verso, in
center of upper margin, in red ink: LXI. In top left corner, in black
ink, 115. In center of left margin, in black ink: 57

PROVENANCE: John F. Murray, Florence, 1925
LITERATURE: De Ricci 1937, p. 1708, B.3 (as written by Berardus
de Teramo)

These six cuttings are part of a group of ten, maybe
eleven, leaves from a lost volume of a gradual, probably
a sanctorale, intended for Dominican use. Four other
leaves, identical in dimension and stave height, are in
the Cini Collection, Venice (26–29), while an eleventh,
known only through reproductions, is perhaps

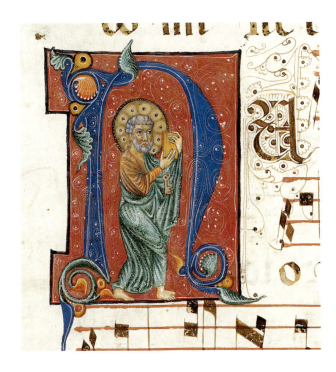

identifiable in a cutting formerly on the art market in
Amsterdam (sale, Mensing et Fils, Amsterdam, November
22, 1929, lot 64, *Saint Dominic and Confirmation of*
the Rule by Pope Honorius III in an Initial I). The liturgical sequence of the Lehman and Cini fragments may
be reconstructed as follows:

1. Cat. no.3a: *Last Judgment in an Initial A* ("Ad te
 levavi animam meam" [I lift up my soul unto thee]).
 Introit to mass for first Sunday of Advent
2. Cini 28: *Stoning of Saint Stephen in an Initial E* ("Et
 enim sederunt principes" [For princes met]). Introit
 to mass for Feast of Saint Stephen (December 26)
3. Cat. no.3b: *Saint John the Evangelist in an Initial I*
 ("In medio ecclesie" [In the gathering of the
 Church]). Introit to mass for Feast of Saint John the
 Evangelist (December 27)
4. Cat. no.3c: *Presentation in the Temple in an Initial S*
 ("Suscepimus deus misericordiam tuam" [We have
 received your kindness, O Lord]). Introit to mass for
 Feast of the Presentation in the Temple (February 2)
5. Cini 27: *Annunciation in an Initial R* ("Rorate caeli"
 [Drop down dew, you heavens]). Introit to mass for
 Feast of the Annunciation (March 25)
6. Cat. no.3d: *Martyrdom of Saint Peter Martyr in an*
 Initial P ("Protexisti me deus" [Thou hast protected

me, Lord]). Introit to mass for Feast of Saint Peter Martyr (April 29)

7. Oberlin 43.10: *Translation of the Body of Saint Dominic in an Initial I.* ("In medio ecclesie" [In the gathering of the Church]). Introit to mass for Feast of the Translation of the Body of Saint Dominic (May 24)

8. Cini 26: *Saint John the Baptist in an Initial D* ("De ventre matris meae" [From my mother's womb]). Introit to mass for Feast of the Birth of Saint John the Baptist (June 24)

9. Cat. no.3f: *Saint Peter in an Initial N* ("Nunc scio vere" [Now I know for certain]). Introit to mass for Feast of Saint Peter (June 29)

10. Cini 29: *Saint Paul in an Initial S* ("Scio cui credidi" [I know whom I have believed]). Introit to mass for the Commemoration of Saint Paul (June 30)

While these leaves are clearly products of a single workshop, their stylistic milieu remains hard to define. The four Cini fragments, formerly in the Hoepli Collection, Milan, were first attributed by Pietro Toesca (1930, pp. 30–31) to central Italy between the end of the thirteenth and beginning of the fourteenth century and compared to late-thirteenth-century Umbrian manuscript illumination influenced by the work of Cimabue. One of the Lehman illuminations (cat. no. 3a), possibly the frontispiece of the missing gradual, was also listed as Umbrian by Seymour De Ricci, who, however, confused the remaining five Lehman leaves with another group of works assembled around catalogue number 19 (by the Abruzzese illuminator Berardo da Teramo).

Toesca's reference to Umbrian manuscript illumination was based on his comparison of the Cini fragments to the miniatures in a series of choir books from the Church of San Domenico, Spoleto, which are now in Perugia (Biblioteca Comunale Augusta, m2790, 2792, 2795). While some of the decorative elements of the Cini and Lehman illuminations, such as the white filigree ornament, the dotted outline of the halos, and the linear treatment of the draperies, do find their equivalents in the San Domenico miniatures, the differing figural styles set the two groups apart. Whereas the San Domenico illuminations reflect a distinctly Cimabuesque formal and expressive vocabulary, clearly indebted to that artist's work in Assisi in the 1280s

(Todini 1982, pp. 193–95), the Cini and Lehman illuminations share a more archaic figural style and linear emphasis, still closely allied to Byzantine models. Within the context of Umbrian illumination a closer comparison is perhaps to be found in the works associated with an early phase, before 1280, of the so-called Master of the Deruta Missal (Labriola 1997, pp. 108–9), of which the Lehman and Cini fragments may reflect a coarser, provincial derivative.

At the same time, however, the figures in two of the Lehman miniatures that are attributable to a different hand in the same workshop (catalogue numbers 3b and 3c) betray a stylistic relationship to Gothic models north of the Alps and may thus point to a different area of production for this entire group of illuminations, in Swabian southern Italy. Specific decorative elements, such as the elaborately intertwined initials and the small concentric circles of different hues in the halos of some of the figures or in the borders, in particular, may be compared to southern Italian manuscripts of the second half of the thirteenth century associated with the Manfredi Bible in the Vatican (Biblioteca Apostolica Vaticana, Vat. Lat. 36).

Possibly by the same hand, or school, as the Cini and Lehman fragments is a closely related, hitherto unpublished leaf from a pontifical (fig. 1) in the Free Library, Philadelphia (M8:12).

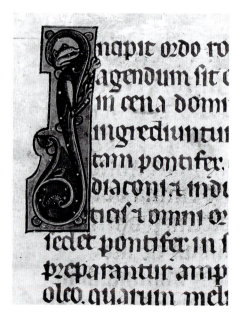

Fig. 1 Umbria or Southern Italy, *Initial I* (leaf from a pontifical). Free Library, Philadelphia, M8:12

Bolognese

Circa 1290–1300

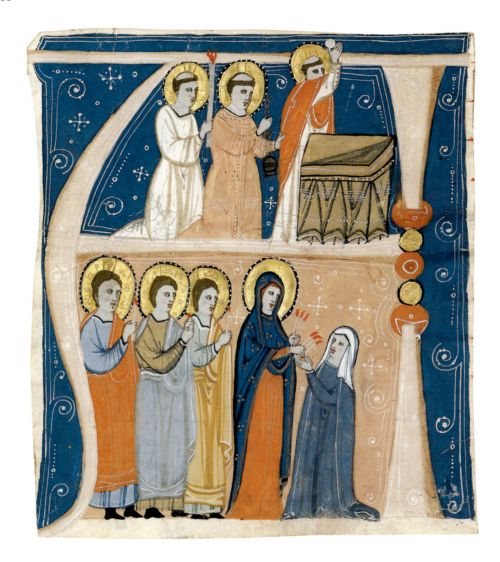

4
Elevation of the Host in an Initial A

Cutting from an antiphonary

Tempera and gold leaf on parchment. 6 × 5½ in. (15 × 14 cm).
Stave: 3.6 cm

Verso: nitrix. [rubr.]*p.* Celi/[rubr.]*a. Post par*

PROVENANCE: Rappaport, Rome, 1924
LITERATURE: De Ricci 1937, p. 1706, D.9 (as probably Umbrian,
14th century)

The initial A illustrates the first response ("Adorna
thalamum tuum" [Adorn your bridal chamber]) of the
first nocturn for the Feast of the Purification of the
Virgin (February 2). This feast, which also commemo-
rates that of the Presentation of the Christ Child in the
Temple (Luke 2:22), recalls the Jewish rite of the
purification of the mother after birth. Also known as
Candlemas, it incorporated from earliest times a pro-
cession of lighted candles in honor of the Virgin and of
Christ and the distribution of them to the faithful
(Jacobus de Voragine 1993, pp. 143–51). These various
aspects of the feast's history and its celebration are illus-
trated by the otherwise unusual scene in the lower half

of the Lehman initial, where the Virgin, followed by three unidentified haloed figures bearing lighted candles, is shown placing several in the hands of a female worshiper kneeling at her feet.

The Lehman cutting was excised from the present folio 62 of an antiphonary located in the Archivio di Stato, Gubbio (San Domenico cor.f). This volume is part of an eleven-volume series (comprising seven antiphonaries, three graduals, and a kyriale) from the former convent of San Domenico, Gubbio. Many of these books are in fragmentary condition and have been deprived of both leaves and historiated letters (Castelfranco 1929, pp. 529–55). Corale F, one of the most severely mutilated, is a sanctorale, the surviving portions of which cover the period from the Feast of Saint Agnes (January 21) to the Feast of the Chair of Saint Peter (February 22). On the recto of folio 62 appears the second antiphon of the first nocturn for the Feast of the Purification. The missing fragments of this text appear on the back of the Lehman miniature: "Sicut mirra electa o/dorem dedisti suavitatis/sancta dei ge[nitrix.] *p. Celi/ a. P*ost par]/tum virgo inviolata perman/sisti dei genitirix intercede" (Like precious myrrh you gave forth an odor of

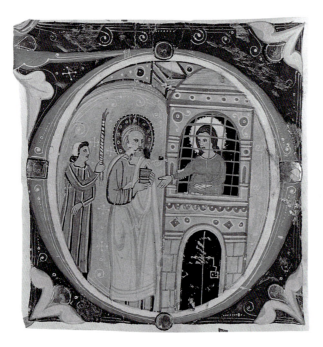

Fig. 2 Bolognese, ca. 1290–1300. *Saint Agatha in Prison in an Initial Q.* Free Library, Philadelphia, M32:8

sweetness, holy Mother of God. Even after giving birth, you remained a virgin; Mother of God intercede for us).

In addition to the Lehman miniature, three more missing illuminations from the Gubbio series may be identified with the following cuttings: a previously unpublished initial Q with *Saint Agatha in Prison,* in the Free Library, Philadelphia (M32:8), excised from Corale F, folio 82 (fig. 2); an initial I with the seven scenes of Creation in the Germanisches National hyphc museum, Nuremberg (Bredt 1903, no. 53, pl. ix), first tentatively associated with the San Domenico choir books by Luisa Morozzi (1980, p. 63, n. 6) and probably excised from folio 59 of Corale B; and an initial S with the *Trials of Job,* recently on the art market in London (Sotheby's, July 6, 2000, lot 37), probably excised from folio 2 of Corale E.

In the most extensive study to date of the San Domenico series, Giorgio Castelfranco (1929) associated their decoration, which he assigned to a single master and his workshop, with the Bolognese school of illumination. Castelfranco dated their execution, on the basis of stylistic and textual evidence, to about 1290, shortly after the consecration of the Church of San Domenico in 1287. The same author drew convincing comparisons between the San Domenico miniatures and the illuminations in two antiphonaries in the Museo Civico Medievale, Bologna (cod. 519, 520), which he viewed as products of a distinct hand but from a common artistic milieu. In addition to their similar borders, typical of Bolognese illumination at the turn of the thirteenth century, the Bologna antiphonaries share with the Gubbio miniatures the same calligraphic approach, defined by large, simplified forms and gestures and summarily outlined facial features; the same palette of brilliant oranges and blues juxtaposed with delicate pinks, grays, and pale flesh tones; and the same Byzantine-inspired decorative and architectural elements.

Most recently, the Bologna antiphonaries have been associated by Fabrizio Lollini (2000, pp. 377–79) with a gradual also in the Museo Civico (cod. 521), as part of a single commission executed about 1300 for the Dominican convent of Sant'Agnese, Bologna. The style of the anonymous illuminator, appositely christened "Maestro di Sant'Agnese," has been characterized by Lollini as a "vulgarization" (2000, p. 279), or vernacu-

inspired decorative and formal vocabulary that dominated Bolognese illumination at this date, under the influence of the so-called Master of the Gerona Bible and of Jacopino da Reggio (active end of the 13th century). The reflection of this particular idiom in the Gubbio choir books, also executed for a Dominican institution, along with the evidence of the Master of Sant'Agnese's activity for other Dominican establishments in Bologna, may indicate the existence, unverifiable at this stage of research, of a Dominican scriptorium in Bologna responsible for the production of all of these volumes.

Neri da Rimini

Documented 1300–1338

5a
Saint Agatha in Prison in an Initial D

Circa 1310–15
Leaf from an antiphonary

Tempera and gold leaf on parchment. Leaf: 21 ⅞ × 15 ¼ in. (55.5 × 38.8 cm). Initial: 5 ¼ × 5 in. (13.3 × 12.6 cm). Stave: 3.6 cm

Recto: testatur. [rubr.]*ps.* D[omi]ne do[minus] n[ost]r[i]./ Euouae. [rubr.] *an.* Ancilla/ chr[ist]i su[m] ideo me oste[n]/do servile[m] p[er]sona[m]. [rubr.] *.ps./* Celi ena[rrant]. Euouae. [rubr.] *.an./* Summa i[n]genuitas. Verso: ista est i[n] qua s[er]vit[us] chr[ist]i/ comp[ro]batur. [rubr.] *ps.* D[omi]ni e[st] t[erra]/ Euouae. [rubr.].*R./* Dum in/gre/deretur beata agatha

On recto, in upper right corner, in black ink: 123

PROVENANCE: Leonardin, Paris
LITERATURE: De Ricci 1937, p. 1706, D.28A (as 14th century, written in Umbria)

5b
Annunciation in an Initial M

Circa 1310–15
Leaf from an antiphonary

Tempera and gold leaf on parchment. Leaf: 19 × 15 ¼ in. (48.2 × 38.8 cm). Initial: 5 ⅞ × 5 in. (14.8 × 12.6 cm). Stave: 3.6 cm

Recto: Miss[us]/ est/ gabriel angelus ad/ maria[m] virginem/ desponsatam ioseph/ nu[n]cians ei verbum [et]. Verso: expavescit virgo de lu/mine ne timeas/ maria invenisti gratia[m]/ apud dominu[m] ecce [con]ci/pies et paries. Et/ vocabitur altissi[mi]

PROVENANCE: Leonardin, Paris
LITERATURE: De Ricci 1937, p. 1704, D.5 (as early 14th century, written at Bologna)

5c
God the Father and Prophet in an Initial I

Circa 1310–15
Leaf from an antiphonary
Cambridge, The Houghton Library, Harvard University, 1943.1867

Tempera and gold leaf on parchment. Leaf: 21 ¾ × 15 ¼ in. (55.5 × 39 cm). Stave: 3.6 cm

Recto: i. [rubr.] *.ps.* Venite. [rubr.].*R./*In prin/cipio/ fecit deus celu[m et] ter/ra[m et] creavit in ea ho/mine[m]. Ad/ yma. Verso: gine[m et] similitudi/nem sua[m]. [rub.] *V.* For/mavit igitur deus/ homine[m] de limo terre/ et inspiravit in facie[m]/eius spiraculu[m] vi

On recto, in upper right corner, in black ink: 67

PROVENANCE: Leonardin, Paris; gift of Robert Lehman to the Fogg Art Museum, Harvard University, 1943
LITERATURE: De Ricci 1937, p. 1706, D.28A (as 14th century, written in Umbria); Mariani Canova 1978a, p. 18, n. 19 (as Neri da Rimini); Dauner 1998, p. 226 (as Neri da Rimini, 1300–1313)

These three leaves are part of a group of twelve cuttings, uniform in style, palette, border decoration, and stave height, which were probably excised from two antiphonary volumes of a single commission. Catalogue numbers 5a and 5b, together with three related fragments—two in the Chester Beatty Library, Dublin, and one in the Cini Collection, Venice—were probably originally included in a volume of a sanctorale in the following liturgical sequence:

1. Chester Beatty W195–98: *Saint Agnes in an Initial D* ("Diem festum sacratissime virginis celebremus" [Let us celebrate the feast of a most saintly Virgin]). First response of first nocturn for Feast of Saint Agnes (January 21).
2. Cini 2182: *Saint Vincent in an Initial S* ("Sacram presentis diei solemnitatem humili celebremus devotione" [Let us celebrate this holy day with humble

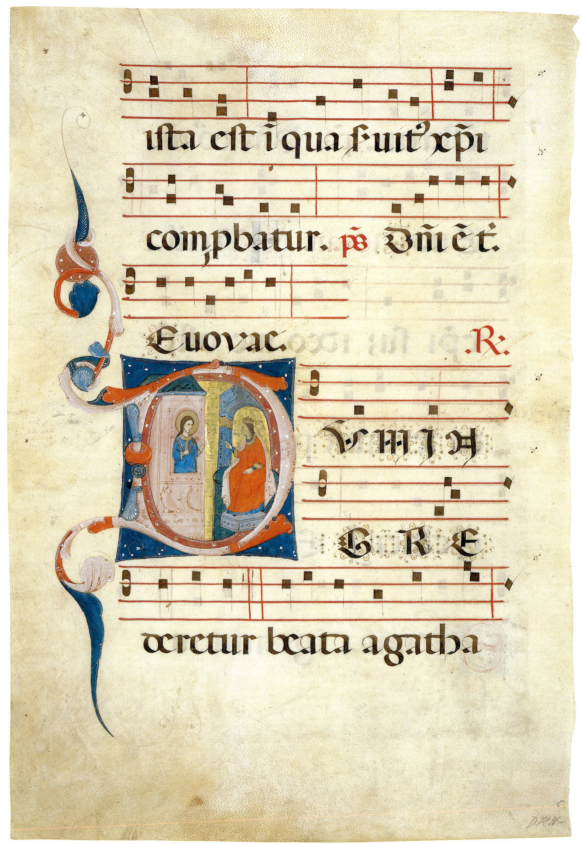

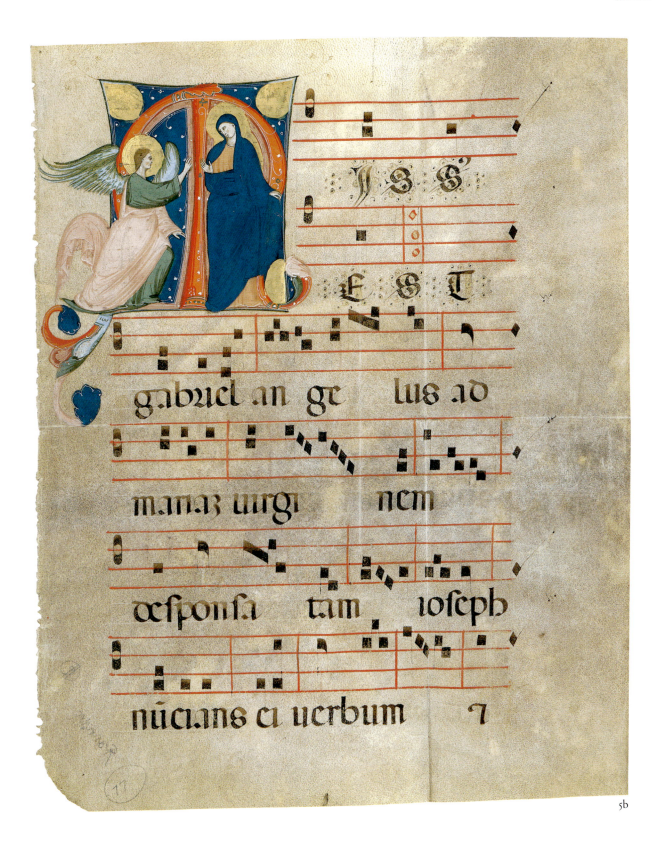

gabriel an ge lus ad

mariaz uirgi nem

ðesponsa tam ioseph

nucians ei uerbum

devotion]). First response at vespers for Feast of Saint Vincent (January 22)

3. Chester Beatty W195–98: *Saint Paul in an Initial S* ("Saulus adhuc spirans minarum" [Saul, still breathing threats]). First response of first nocturn for Feast of the Conversion of Saint Paul (January 25)

4. Cat. no 5a: *Saint Agatha in Prison in an Initial D* ("Dum ingrederetur beata Agatha in carcerem" [While Blessed Agatha entered prison]). First response of first nocturn for Feast of Saint Agatha (February 5)

5. Cat. no 5b: *Annunciation in an Initial M* ("Missus est Gabriel Angelus" [The Angel Gabriel was sent]). First response of first nocturn for Feast of the Annunciation (March 25)

The Houghton Library leaf is one of seven related cuttings divided among various collections that were probably included in a second antiphonary volume from the same series, the contents of which would have cov-

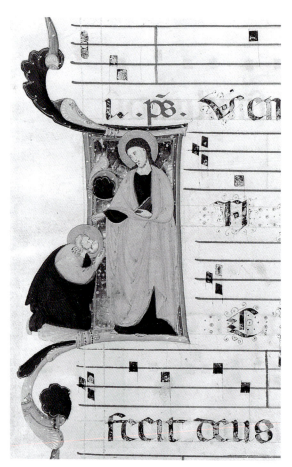

5c

ered the temporal cycle from Advent to Passion Week. This volume may be partially reconstructed as follows:

6. Milan, Longari Collection: *Christ Blessing between the Virgin and Saint John the Evangelist and Apostles in an Initial A* ("Aspiciens a longe" [Long had I been watching]). First response at matins for first Sunday of Advent

7. Aalen, private collection: *Angel Playing the Horn in an Initial C* ("Canite tuba in Syon" [Blow the trumpet in Sion]). First response at matins for fourth Sunday of Advent

8. Houghton Library 1943.1867: *God the Father and Prophet in an Initial I* ("In principio creavit Deus caelum et terram" [In the beginning God created the heavens and the earth]). First response at matins for Septuagesima Sunday

9. Chicago, Art Institute, 42.553: *Joseph and His Sons at the Well in an Initial V* ("Videntes Joseph a longe" [Seeing Joseph in the distance]). First response at matins for third Sunday in Lent

10. Cini 2031: *God Speaking to Moses in an Initial L* ("Locutus est Dominus ad Moysen" [The Lord spoke to Moses]). First response at matins for the fourth Sunday in Lent

11. Philadelphia, Free Library, M73:8 : *Prophet Kneeling Before God in an Initial I* ("In die qua invocavi te" [When I called to you]). First response at matins for Palm Sunday

12. Stockholm, Statens Konstmuseer, B1689: *Christ in the Garden of Olives in an Initial I* ("In Monte Oliveti oravit" [On the Mount of Olives He prayed]). First response of first nocturn for Holy Thursday

Except for catalogue numbers 5a and 5b, unpublished since De Ricci's cursory listing of them, respectively, as "Umbrian" and "Bolognese," the remaining ten cuttings in this series have generally been considered, either individually or in smaller groups, among the production of Neri da Rimini, one of the leading figures in the history of fourteenth-century Italian manuscript illumination (Rimini 1995; Dauner 1998). Neri's earliest recorded work, a leaf with *Christ in Majesty* in the Cini Collection, Venice (2030), signed and dated 1300, reveals a precocious assimilation of Giotto's expressive and formal vocabulary mixed with linear and decorative elements

derived from Bolognese illumination. With respect to this early work, however, the various fragments grouped with the Lehman illuminations reflect a progressive expansion of the forms and generalization of facial features, as well as a simplification of the compositions. These changes are typical of Neri's late production, beginning with the leaf with *Christ in Majesty* in the Cleveland Museum of Art (53.3651), signed and dated 1308, and continuing into the choir books for the Church of San Francesco, Rimini, dated 1314. Thus the

date of between 1310 and 1315, proposed by Robert Gibbs (in Rimini 1995, pp. 124–31) for the Dublin and Chicago initials, seems valid for the entire group.[1]

1. Volpe 1995 proposed a similar dating, in the "very first years of the second decade of the century," for Cini 2031, around which he grouped one of the Dublin cuttings (W195–97) and the Stockholm and Philadelphia fragments. The only exception is the earlier date, between 1305 and 1308, assigned by Fabrizio Lollini (in Rimini 1995 pp. 84–85) and Gudrun Dauner (1998, pp. 87–90) to the initial A in the Longari Collection.

Collaborator of Neri da Rimini (Master of the Fulget?)

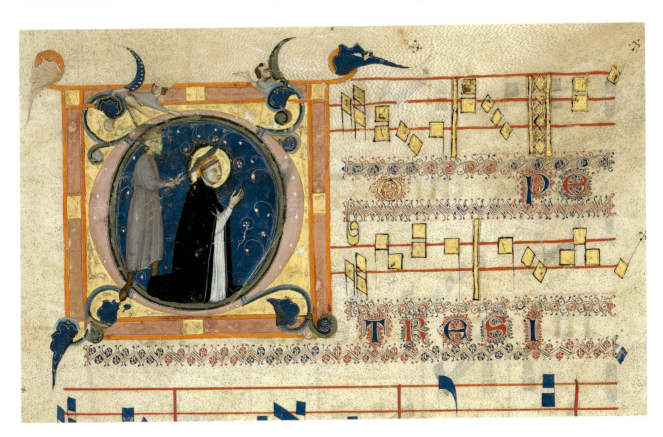

6
Martyrdom of Saint Peter Martyr in an Initial D

Circa 1300–1308
Leaf from an antiphonary

Tempera and gold leaf on parchment. Leaf: 17 ¾ × 14 ¼ in. (45.5 × 36.4 cm). Initial: 5 × 5 ⅛ in. (12.5 × 13 cm). Stave: 3.8 cm

Recto: Do pe/tre si/dus aureum summi/ vas honoris candore[m]/ servans niveu[m] do/no creatoris. Decus. Verso: habes virgineu[m] in/ supernis choris/ alleluya. [rubr.] v./ *Tu* speculu[m] munditie tu/ custos innocentie tu sanc/ti flos pudoris. Decus.[rubr.]*K*

PROVENANCE: Bruscoli, Florence, ca. 1923
LITERATURE: De Ricci 1937, p. 1707, C.3 (as probably written at Bologna, ca. 1400)

The discrepancies in execution between the various illuminations associated with Neri da Rimini's name have led to the identification of various anonymous collaborators who painted over the master's design in what must have been a large workshop. The present cutting may be included in a group of works that, while clearly indebted to Neri's style in form and composition, are distinguished from his autograph production by less volumetric effects, a general stiffness of execution, and a more brilliant palette.

Although the precise text illustrated by the scene of Saint Peter Martyr's execution remains difficult to identify and may reflect a particular Dominican usage, the leaf is perhaps one of three, possibly four, surviving cuttings, identical in style, decoration, and stave height, that may have been excised from a single volume of a Dominican sanctorale. Two related miniatures, previously linked together by Giordana Mariani Canova (1978a, p. 21), are in the Cini Collection, Venice: an initial D with *Saint Helena Adoring the Cross* (2181) and an initial D with *Clerics Adoring the Cross* (2233), illustrating, respectively, the Feasts of the Invention (May 3) and Exaltation of the Holy Cross (September 14). To these may possibly be added a fourth leaf in the Chester Beatty Library, Dublin (w195.96), associated by Alessandro Volpe (in Rimini 1995, pp. 74–77) with the Cini fragments, which shows two Dominican monks and various other figures before a sepulchre in an initial F to illustrate the Common of a Confessor ("Fulget decus ecclesie" [The glory of the Church shines forth]), sometimes also included in a sanctorale.[1]

The Chester Beatty fragment has been attributed by Robert Gibbs (in Rimini 1995, pp. 80–81) to a close collaborator of Neri, christened "Master of the Fulget," and dated to between 1300 and 1305. The same artist may also have been responsible for the Lehman illumination, the style of which most closely approaches Neri's in the first decade of the fourteenth century, between the early Cini leaf of 1300 and the Cleveland cutting of 1308.

1. Contrary to Volpe's assertion (in Rimini 1995, p. 74), the cutting by a collaborator of Neri in the Art Institute of Chicago (inv. 42.552) is unlikely to have come from the same book as the Cini and Chester Beatty fragments, since it was originally part of a temporale. This does not preclude the possibility, however, that it may have been included in the same choir book series.

Emilian

Circa 1300–1320

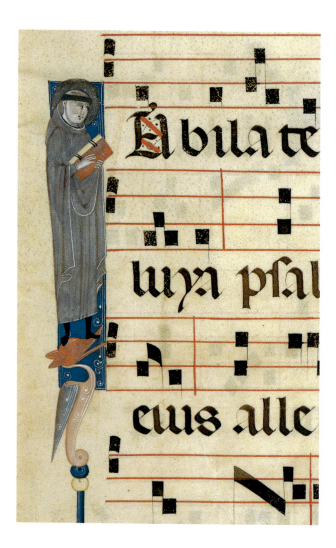

7

Monastic Saint Holding a Book in an Initial I

Leaf from a gradual

Tempera and silver (?) on parchment. Leaf: 21 5/8 × 15 1/4 in. (54.8 × 38.8 cm). Initial: 4 3/4 × 7/8 in. (11.9 × 2.4 cm). Stave: 2.9 cm

Recto: e alleluya alleluya. [rubr.] *D[omi]nica/II(sic): officium./* Iubilate deo om[n]is terra alle/luya psalmu[m] dicite nomini/ eius alleluya/ date gloria[m]/ laudi ei[us] alleluya/ allelu/ya alleluya. [rubr.] *v.* Dicite deo/ qua[m] terribilia su[n]t op[er]a tua. Verso: d[omi]ne in multitudine v[ir]tutis/ tue. Gl[or]ia. Euouae. Allelu/ ya./[rubr.] *v.* Modicum et/ no[n] videbitis me di/cit dominus iteru[m]/ modicu[m] et videbitis me.

On verso, in center of bottom margin: quia. In center of left margin, in red ink: xx

PROVENANCE: Leonardin, Paris
LITERATURE: De Ricci 1937, p. 1706, D.28A (as written in Umbria)

This leaf, excised from an unidentified gradual, illustrates the introit to the mass for the third Sunday after Easter ("Iubilate deo" [Shout joyfully to God]). The identity of the young, haloed monk in a gray robe, who occupies the whole length of the initial I, cannot be determined on the basis of the text or the provenance of the cutting, which at present is unknown.

The style of the illumination reflects knowledge of Neri da Rimini's mature production, in the drawing of the monk's head as a perfect oval and in the definition of the features with white highlights, as well as in the pale coloring of the face with its rose-colored cheeks. Absent, however, is the monumental quality that distinguishes Neri's work and, to a lesser degree, that of his collaborators. The leaf's closest comparison is a miniature with the *Standing Redeemer in an Initial I* in the Cini Collection, Venice (2162), that was first attributed by Pietro Toesca (1958, p. 22, no. 64) to "manner of Neri da Rimini" but subsequently placed by Giordana Mariani Canova (1978a, p. 22, no. 39) within the more general context of Emilian or Romagnole illumination of the first decades of the fourteenth century.

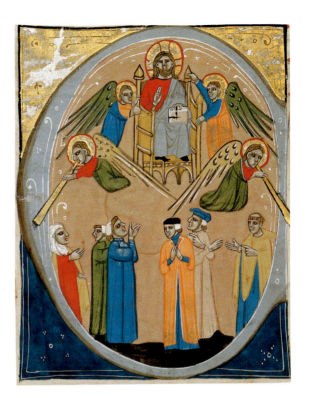

Bolognese (?)
First quarter of the fourteenth century

8a
Last Judgment in an Initial C
Cutting from an antiphonary

Tempera and gold leaf on parchment. 5¼ × 4¼ in. (13.5 × 10.8 cm). Stave: 4 cm

Verso: Not visible (cutting glued on cardboard)

PROVENANCE: Madame Fould (sale, Galerie Georges Petit, Paris, December 26, 1926, lot 33)
LITERATURE: De Ricci 1937, p. 1704, C.9a (as early-14th-century Italian)

8b
King David Playing a Viol in an Initial S
Cutting from an antiphonary

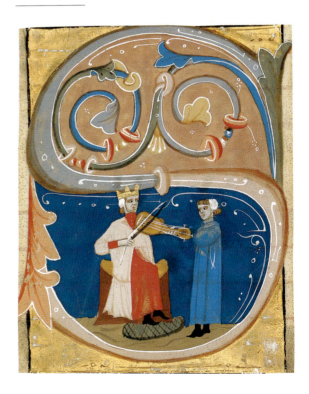

Tempera and gold leaf on parchment. 5 × 4⅛ in. (12.6 × 10.4 cm). Stave: 4 cm

Verso: Not visible (cutting glued on cardboard)

PROVENANCE: Madame Fould (sale, Galerie Georges Petit, Paris, December 26, 1926, lot 33)
LITERATURE: De Ricci 1937, p. 1704, c.9b (as early-14th-century Italian)

The two cuttings, identical in style, decoration, and stave height, were excised from the same volume or series of an unidentified antiphonary. The initial C, showing *Christ Enthroned as Last Judge*, illustrates the second response of the first nocturn for the Office of the Dead ("Credo quod Redemptor meus vivit" [I believe that my Redeemer lives]). The initial S with the psalmist King David illustrates the first response at matins for the fourth Sunday after Easter ("Si oblitus fuero tui" [If I ever forget you]), the text of which is derived from Psalm 136 (verse 5).

Although De Ricci listed these fragments generically as "early fourteenth-century Italian," in the 1926 Paris sale catalogue they were more specifically identified as Bolognese and dated to the first half of the fourteenth century. Early-fourteenth-century Bolognese manuscript production, as exemplified by the famous series of choir books executed for the churches of San Domenico (see below, cat. nos. 9a–b) and Santa Maria dei Servi, Bologna (Conti 1981, pp. 77–79), does, in fact, provide a point of reference for the overall style and border decoration of these fragments. However, while the miniatures in those volumes, with their anecdotal narrative style and concern with spatial definition, reflect the progressive assimilation of Giottesque models by Bolognese illuminators, the Lehman cuttings are distinguished by a schematic approach to storytelling and coarser execution. These characteristics denote a more archaic idiom that suggests an earlier date for the Lehman fragments, although it has not yet been possible to associate them with a specific workshop.

Second Master of San Domenico

Bolognese, active first half of fourteenth century

9a

Calling of Saint Peter and Saint Andrew in an Initial D

1307–24/26
Bifolium from an antiphonary

Tempera and gold leaf on parchment. Leaf: 24¼ × 16 in. (61.5 × 41 cm). Initial: 6¾ × 5¼ in. (17.1 × 13.2 cm). Stave: 4.9 cm

On recto of first leaf early numeration, in black ink: 3. On second leaf: 4
Folio 3r: Qui victorem per/ crucis tropheum/ coronavit beatum/ andream aposto/lum. [rubr.]*ps.* Venite. [rubr.] *In. I./noc./.A.* Folio 3v: Vidit dominus pe/trum et andream et/ vocavit eos. [rubr.] *ps.* Celi en[arrant]./ Euouae.[rubr.]*A.* Venite/ post me dicit domi[nus]. Folio 4r: [Domi]nus faciam vos fieri/ piscatores ho/minum. [rubr.]*ps.*B[e]n[e]dicam./ Euouae.[rubr.]*A. R*elictis/ retibus suis secuti s[un]t. Folio 4v: dominum redempto/rem. [rubr.] *ps.* Eructav[it]. Euouae./[rubr.] *v.* In o[mn]e[m]/ terra[m]. [rubr.]/*R.* Dum /perambu/laret dominus iux[ta]

PROVENANCE: Bruscoli, Florence, 1922
LITERATURE: De Ricci 1937, p. 1704, c.9 (as ca. 1340, probably written at Bologna); Mariani Canova 1979, p. 377 (as First Master of San Domenico)

9b

Christ and the Apostles Appearing to Saint John the Evangelist and Miracle of the Manna in Saint John's Grave in an Initial V

1307–24/26
Leaf from an antiphonary

Tempera and gold leaf on parchment. Leaf: 24¼ × 16 in. (61.5 × 41 cm). Initial: 7 × 4¾ in. (17.8 × 12.1 cm). Stave: 4.9 cm

Recto: [sa]cro dominici pectoris/ fonte potavit. [rubr.]*p.* B[e]n[e]dica[m]./ Euouae. [rubr.] *A.* Quasi u/nus de paradisi flumi/nibus evangelista io[hannes]. Verso: [Io]hannes verbi dei gra/tiam in toto terrarum/ orbe diffudit. [rubr.]*p.* Eruct[avit]./ Euouae. [rubr.]*R./* Valde hono[randus]

On recto, in right margin, later numeration, in black ink: 78. On verso, in lower margin, catchword: randus

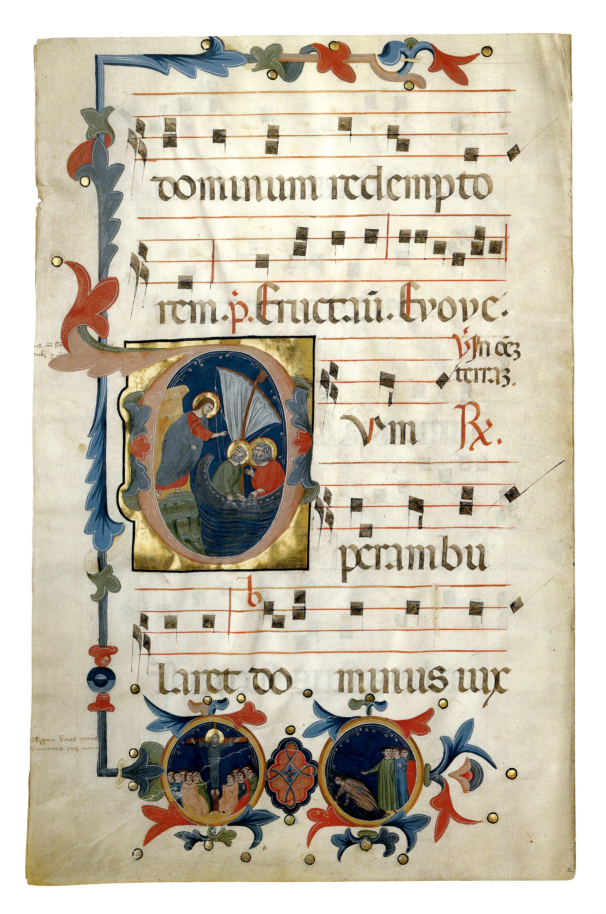

dominum redempto

rem. p. fructaũ. Euoue.

Vn cõz
terra3.

Vm ℞.

perambu

laret dominus uir

PROVENANCE: Bruscoli, Florence, 1922
LITERATURE: De Ricci 1937, p. 1704, c.9 (as ca. 1340, probably written at Bologna); Mariani Canova 1979, p. 377 (as First Master of San Domenico)

These two fragments, generically identified by De Ricci as Bolognese, were first correctly associated by Giordana Mariani Canova (1979) with a large series of choir books executed between 1307 and 1324/26 for the Dominican church of San Domenico, Bologna. The single most important cycle of liturgical books executed in that city during the first quarter of the fourteenth century, the San Domenico series originally comprised a fourteen-volume antiphonary set, three books and numerous fragments of which are missing at present (Alce 1961).

According to Mariani Canova, the Lehman pages, which are identical to the San Domenico antiphonaries in measurement, stave height, and decoration, would have been included in the missing volume of a sanctorale that, according to old inventories, covered the liturgical cycle from the Feast of Saint Andrew (November 30) to the Feast of Holy Innocents (December 28). Located near the beginning of this book would have been catalogue number 9a, a bifolium containing on folios 3r–4r the first three antiphons at matins for the Feast of Saint Andrew and on folio 4v the first response at matins for the same feast ("Dum perambularet Dominus iuxta mare Galilae" [As the Lord was walking by the Sea of Galilee]). Inside the initial D is a miniature of the *Calling of Saints Peter and Andrew,* below which are two *bas-de-page* roundels with episodes from the life of Saint Andrew: *Saint Andrew Preaching from the Cross,* and the *Miracle of the Resuscitated Drowned Men.*

Catalogue number 9b, containing the first response in the first nocturn ("Valde honorandus est beatus Ioannes" [Very highly we must venerate Blessed John]) for the Feast of Saint John the Evangelist (December 27), would have been inserted toward the end of the lost sanctorale. This text is illustrated by a miniature of *Christ and the Apostles Appearing to Saint John the Evangelist,* in the upper half of the initial V, and the *Miracle of the Manna in Saint John's Grave,* in the lower half of the initial. Below are four *bas-de-page*

medallions with the *Last Supper,* the *Attempted Martyrdom of Saint John before the Latin Gate, Saint John on Patmos,* and the *Miracle of Drusiana.*

The author of the Lehman fragments was identified by Mariani Canova as the so-called First Master of San Domenico (also known as the Seneca Master), the leading figure in a team of no less than seven illuminators who appear to have been engaged in the decoration of the entire San Domenico series (Alce 1961, pp. 162–65; Conti 1981, pp. 72–73). In contrast to the miniatures generally attributed to the First Master, however, which are defined by elongated, expressive figural types with small heads and minute proportions, the Lehman illuminations are characterized by stocky types with broad jaws and large features, flatly modeled with broad strokes of color, that are more characteristic of the illuminator known as the Second Master of San Domenico. This artist was responsible for the decoration of at least one volume in San Domenico (cor. 9), to which may be related four out of six (possibly seven) fragments by the same hand, in the Cini Collection, Venice (Mariani Canova 1978a, pp. 3–9), that are identical in style and execution to the Lehman pages.

The Second Master of San Domenico has been viewed as deriving decorative and compositional elements from the First Master, who was possibly his teacher, although he transformed the latter's elegant vocabulary, still reminiscent of thirteenth-century models, into a more rustic and, at the same time, more Giottesque idiom typical of Bolognese illumination of the first half of the fourteenth century. The San Domenico miniatures appear to represent the earliest phase of the artist's activity, which, as recent studies have demonstrated, seems to have extended into the 1340s (Brunori 1998, pp. 87–104) and to have included the decoration of secular as well as liturgical texts.[1]

1. Among the secular commissions convincingly attributed the same hand are the miniatures in two juridic manuscripts located, respectively, in the Biblioteca Capitolare, Padua (MS B.18., Conti 1981, p. 86) and in the Biblioteca Braidense, Milan (AE.XIV.15., Vanoli 1997, pp. 152–57); and a leaf of the register of the confraternity of Sant'Eustachio, in the Biblioteca Comunale dell'Archiginnasio, Bologna (Gozz. 210, op. 8, Battistini 1999, pp. 188–89).

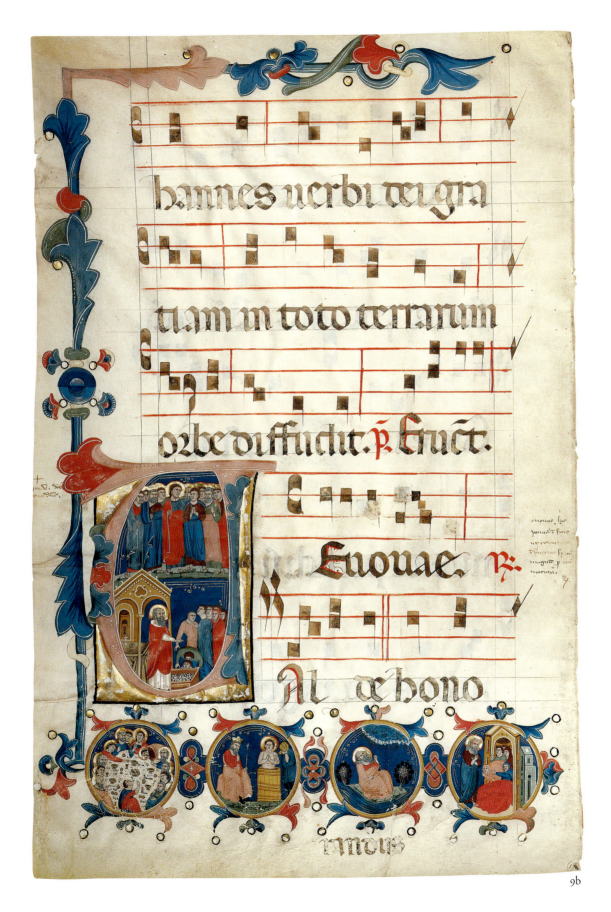

hannes uerbi dei gra

tiam in toto terrarum

orbe diffudit. ꝑ Enct.

Euouae. ꝶ

Al de bono

Niccolò di Giacomo da Bologna

Bolognese, documented 1353–1401

10

Jacob's Blessing in an Initial T

Circa 1370–80
Cutting from an antiphonary

Tempera and gold leaf on parchment. Cutting: 10¼ × 8 in. (26.2 × 20.8 cm). Initial: 4⅛ × 4³⁄₁₆ in. (10.5 × 10.7 cm). Stave: 2.8 cm

Recto: [as]cendit in mon/[tem et transfig]uratus est ante/ [eos] Ad/m./a.Visionem / [quam vidistis] nemini dixeri/[tis donec a m]ortuis resurgat. Verso: suam Quia i... / omnes fin... / To[lle arma tua, pharetram] /et arcum

PROVENANCE: Kalebdjian, Paris, 1924
LITERATURE: De Ricci 1937, p. 1705, A.18 (as Niccolò da Bologna)

This miniature, excised from an unidentified antiphonary leaf, illustrates the first response at matins ("Tolle arma tua pharetram et arcum" [Take your weapons, quiver and bow]) for the second Sunday of Lent. On the back of the illumination, which appeared on the original leaf's verso, are fragments of the preceding antiphon of the Magnificat at first vespers ("Visionem quam vidistis nemini dixeritis" [Tell no one about the vision you have seen]) for the same feast. Inside the initial T are represented all the salient points of the Old Testament episode of Jacob's stolen blessing (Genesis 25:19–34; 27; 28:1–5). On the left is Jacob in disguise receiving from his aged father, Isaac, the blessing intended for his brother Esau. In the background, looking on, is Isaac's wife, Rebekah, who had conspired with Jacob to trick her husband. And to the right is Esau, arriving too late with the venison that his father had requested to eat before bestowing his final blessing upon him.

This illumination is one of five cuttings formerly in the Lehman collection that were correctly attributed by De Ricci to Niccolò di Giacomo da Bologna, the most famous and prolific Bolognese illuminator working in the second half of the fourteenth century. During the long period of his activity, continuously documented between 1353 and 1401 (Filippini and Zucchini 1947, pp. 175–81), this artist appears to have held a virtual monopoly over the production of both secular and liturgical manuscripts in his native city. The vast number of surviving works by his hand, many of them signed, attest to his role as the head of a large workshop, equally involved in the decoration of choir books for churches and convents in and outside Bologna, humanistic texts for cultured patrons affiliated with the famous university, and corporate and communal statutes. Evidence of Niccolò's financial success and reputation includes the numerous properties he owned in Bologna, along with his various appointments to public office.

Niccolò's pictorial vocabulary, firmly rooted in a local miniaturist tradition, takes its main inspiration from the intensely expressive and decorative idiom evolved by the so-called Master of 1346, the anonymous artist who dominated Bolognese manuscript illumination in the 1340s and who may have been Niccolò's teacher (Conti 1981, pp. 94–95; Medica 1999, pp. 126–27). While Niccolò's earliest production is closely related to that of this illuminator, during the course of his career the meticulousness that characterizes his predecessor's

production was increasingly sacrificed for a quickness of execution, general simplification of the forms, and brilliant coloristic effects to achieve greater narrative impact. The result is an immediately pleasing but essentially uniform style that makes it difficult to assign a precise date to the many undocumented fragments associated with Niccolò's maturity, such as the present Lehman cutting and the four others that follow (cat. nos. 11–14).

A dating between 1370 and 1380 for catalogue number 10 is suggested by its affinity with various dated miniatures by Niccolò from this period, beginning with those in the 1373 *Pharsalia* in the Biblioteca Trivulziana, Milan (cod. 691). These illuminations share the same compressed narrative style as the Lehman fragment and display a similar, tighter execution than his works of the following decade.[1]

1. For a detailed discussion of the works produced by Niccolò during the 1370s see Pasut 1998.

Niccolò di Giacomo da Bologna

11

Two Kings in an Initial A

Circa 1370–80
Cutting from an antiphonary (?)
Cambridge, The Houghton Library, Harvard University, 1943.1871

Tempera and gold leaf on parchment. Cutting: 3⅛ × 3⅜ in. (8 × 8.5 cm). Stave: ca. 5 cm

No text visible

PROVENANCE: French & Co., New York; gift of Robert Lehman to the Fogg Art Museum, Harvard University, 1943
LITERATURE: De Ricci 1937, p. 1705, A.18 (as Niccolò da Bologna)

The subject of this miniature suggests that it may have been excised from an unidentified antiphonary, where it would have illustrated the first antiphon in the first nocturn of Passion Friday ("Astiterunt reges terrae" [The kings of the Earth rise up]). The foliate border and handling indicate a date in proximity to the previous cutting (cat. no. 10) by Niccolò di Giacomo, in the decade between 1370 and 1380.

Niccolò di Giacomo da Bologna

12

Saint Denis and His Companions in an Initial I

Circa 1380–90
Leaf from a gradual

Tempera and gold leaf on parchment. Leaf: 23 × 16 in. (58.5 × 40.5 cm). Initial: 6 × 3⅛ in. (15.1 × 7.9 cm). Stave: 4.2 cm

Recto: [rubr.] *S[an]c[t]i Dionisii socior[um]/ q[uem] ei[us] officium./* Intret in/ conspectu tuo do/mine gemitus/ compeditorum. Verso: redde vicinis n[ost]ris/ septuplum in/sinu eoru[m]/ vindica sanguinem/ sanctorum tuo[rum]

On recto, in center of upper margin, in red ink: lxxxxix. In upper right corner, in black ink: 99, lxxxxix

PROVENANCE: Kalebdjian, Paris, 1924
LITERATURE: De Ricci 1937, p. 1704, A.18 (as Niccolò da Bologna, ca. 1350)

Excised from an unidentified gradual, this leaf contains the introit to the Mass for Two or More Martyrs outside of Paschaltide ("Intret in conspectu tuo Domine gemitus compeditorum" [Let the sighs of the imprisoned come before you, O Lord]). As stated by

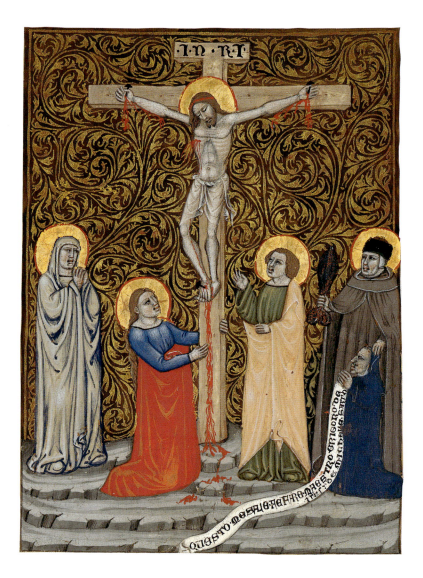

Fig. 3 Stefano degli Azzi, *David Lifting up His Soul to God in an Initial A* (leaf from a missal). Staatlichen Graphischen Sammlung, Munich, inv. nr. 40097

Niccolò da Bologna, was the most active and sought-after illuminator in Bologna in the second half of the fourteenth century. In contrast to Niccolò's expressively exuberant narrative style, representative of the newest currents in Bolognese illumination, Stefano's idiom is characterized by a stiffness of execution and coarseness, which, together with the simple foliate border decorations, reflect an essentially conservative approach that is still tied to examples of the first half of the century.

The rigidly posed figures with darkly outlined features and square jaws that appear in the Lehman and Munich miniatures are typical of Stefano's later production at the turn of the century. The Munich page was convincingly compared by both Hans-Joachim Eberhardt (1984, p. 79) and Medica (1987, pp. 198–200;

1999, p. 68) to the artist's last documented work, the *Collectario* (Book of Orations) dated 1400, in the Museo Civico Medievale, Bologna (MS 638). Both fragments are also closely related to the miniatures in the copy of Petrarch's *Eclogues* in the Bodleian Library, Oxford (Bodley 580), first attributed to Stefano by Robert Gibbs (1984, pp. 638–41) with a dating in the latest phase of his activity.

Venetian

Circa 1360–70

16

Christ Blessing in an Initial D

Cutting from a choir book

Tempera and gold leaf on parchment. 3 ⅞ × 3 ¾ in (9.7 × 9.4 cm).
Stave: 2.9 cm

On verso, partially hidden by remnants of paper backing: Gl…a./a
do…a

PROVENANCE: Leo S. Olschki, Florence, 1924
LITERATURE: De Ricci 1937, p. 1705, B.26 (as probably Bologna,
ca. 1350)

Although listed tentatively by De Ricci as Bolognese,
this fragment may more appropriately be compared to
Venetian illumination in the second half of the four-
teenth century, particularly as reflected in the produc-
tion of the illuminator Giustino di Gherardino da
Forlì. The corpus of this artist was first defined by
Mirella Levi D'Ancona (1967) on the basis of his

signature and the date 1365 in a gradual from the
Scuola di Santa Maria della Carità, Venice (Biblioteca
Marciana, MS Lat. II.119). His hand was subsequently
recognized in a number of both secular and liturgical
manuscripts, ranging in date from the early 1360s to
the 1390s. As noted by most scholars, these works
reflect a simplification of the refined, Byzantine-
inspired vocabulary of Paolo Veneziano (active first
half of the 14th century) into a vernacular narrative
idiom influenced by Bolognese illumination.

Among the miniatures recently attributed to
Gherardino are a series of cuttings divided among vari-
ous collections (De Benedictis 1996, pp. 140–43) that
compare to the Lehman *Christ Blessing* in style, palette,
and foliate decoration and include the same white
filigree pattern over the initial. The Lehman fragment
is distinguished from these illuminations, however, by
a slightly looser brushstroke and more hurried execu-
tion, making an attribution to Gherardino problematic
and suggesting that it might instead be the product of
an artist in his circle. By the same hand and possibly
from the same manuscript is a previously unpublished
cutting in the Free Library, Philadelphia, showing
Christ Blessing and a Man in Prayer (M25:4; fig. 4).

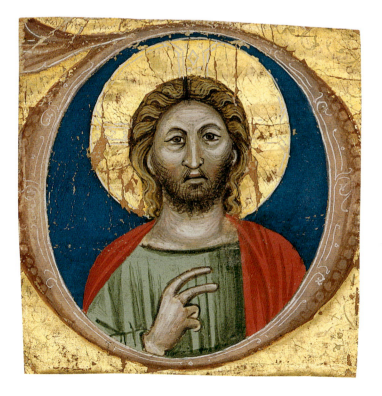

Fig. 4 Venetian,
circa 1360–70,
*Christ Blessing and
a Man in Prayer.*
Free Library,
Philadelphia,
M25:4

"Fra Jacobus"

Emilia or Veneto, last quarter of the fourteenth century

17

Last Supper

Leaf from an antiphonary

Tempera and gold leaf on parchment. Leaf: 21⅞ × 15⅜ in. (55.7 × 38.9 cm). Miniature: 5 × 5⅛ in. (12.7 × 12.8 cm). Stave: 3.5–3.6 cm

Recto: Ymola/bit hedum/ multitudo filio[rum] israhel/ ad vesperam pasce. Et e/dent carnes et azi/mos panes. *V.* Pascha. Verso: nostru[m] y[m]molatus e[st] cristus./ ita[que]m epulemur i[n] azimis/ sinceritatis et veritatis. Et. *R.*/ Comede/tis carnes et saturabi/mini panibus. Iste est

On recto, slightly above center of right margin, in black ink: 102. Below miniature, in gold letters: fr[a]. iacobus. fecit

PROVENANCE: Unknown

LITERATURE: De Ricci 1937, p. 1709, A.37 (as early 15th century, probably written in Venice)

This leaf was excised from an unidentified antiphonary. The large miniature of the *Last Supper* illustrates the second response in the first nocturn for the Feast of

Corpus Domini: "Immolabit hedum multitudo filiorum Israel ad vesperam Paschae" (With the whole assembly of Israel present, the young goat shall be slaughtered on the eve of the Passover). The scene is set in an ornate Gothic niche, framed by a square architectural border, at the base of which is the following signature: "Fra Jacobus fecit" (Brother Giacomo made this).

Aside from what may be gathered from the Lehman leaf, his only signed work, nothing else is known of "Fra Jacobus," presumably a monk in the monastery for which the antiphonary was illuminated. Although no other manuscripts by the same hand have so far been traced, general stylistic considerations point to an area of production in either Emilia or the Veneto during the last quarter of the fourteenth century. Both the figural style and composition appear derived from Bolognese prototypes but as represented by monumental painting, not manuscript illumination; while the foliate border and palette recall Paduan manuscripts painted in the 1370s (Padova 1999, pp. 135–37). This would suggest a possible origin in Emilia or one of the regions of the Veneto influenced by the Bolognese school of painting.

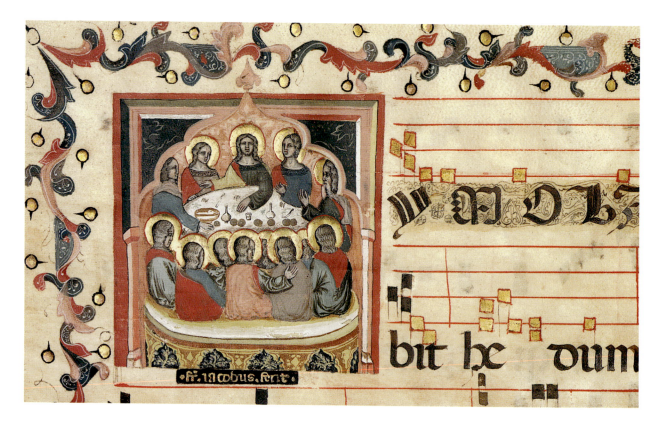

Workshop of Vanni di Baldolo (Master of the Matricole dei Notai)

Perugian, circa 1330–40

18

Pentecost in an Initial S

Leaf from a gradual

Tempera and gold leaf on parchment. Leaf: 21 × 15 in. (53.2 × 38.2 cm). Initial: 5⅝ × 5½ in. (14.4 × 13.9 cm). Stave: 3.9–4 cm

Recto: [ma]ria que om[n]iu[m] porta/sti creatore[m]/ genuisti qui te fe/cit et in eter/num permanes/. Verso: virgo. Alle/luya.[rubr.] *COM* Beata viscera [rubr.] *A. penteconst[em]. Usq[ue]/ ad adventu[s]. Ad missa[m]. Introitus.* Salve/ s[an]c[t]a parens. [rubr.]*XIII Gr.* Bened[i]c[t]a tu. [rubr.]*XIIII* All[elui]a. [rubr.]*v.* post partu[m] virgo. [rubr.]*XII offer.* Ave/ ma[r]ia. [rubr.]*VIII Com.* Beata viscera. [rubr.] *XIII/ Mis/sa d[e] sp[irit]u/ s[an]c[t]o. In/troitus./* Spiritus do/mini reple/vit orbem terraru[m] alle[luia].

On verso, in center left margin, in red ink: XIX

PROVENANCE: Kalebdjian, Paris, 1924
LITERATURE: De Ricci 1937, p. 1707, A.16 (as ca. 1400, written in Umbria)

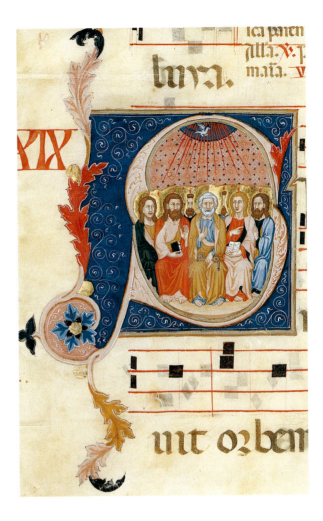

The illuminated S, which appears on the folio's verso, illustrates the introit to the mass ("Spiritus domini replevit orbem terrarum" [The spirit of the Lord has filled the whole world]) for Pentecost Sunday, the feast celebrating the appearance of the Holy Ghost to the apostles. Inside the initial are the twelve seated apostles and, above them, the Holy Spirit in the form of a dove radiating beams of light.

This leaf is one of two surviving fragments from an unidentified gradual volume or series. A second page, illuminated by the same artist and identical to the present in size and stave height, is in the Victoria and Albert Museum, London (E. 376–1911). It shows the *Annunciation in an Initial V*, illustrating the introit to the mass ("Vultum tuum deprecabuntur" [They seek your favor]) for the Feast of the Annunciation (March 25).

While the Lehman miniature was generically identified as Umbrian by De Ricci, the London *Annunciation* was specifically attributed by Filippo Todini (1989, p. 331) to the Perugian painter and illuminator Vanni di Baldolo. This artist has been recognized as one of the first exponents of a distinctly Perugian school of manuscript illumination in the early decades of the fourteenth century, strongly influenced by the models of the painter Meo da Siena, working in Perugia between 1319 and 1333.

The activity of Vanni di Baldolo was first reconstructed on the basis of the signature *"VANES BALDOLI ET SOCII"* (Vanni di Baldolo and Associates), followed by the date 1333, below a miniature of the *Annunciation* decorating a *matricola* (register) of the Perugian Guild of Notaries, at present in a private collection (Subbioni 2001, pp. 212–13). As a result of the rediscovery of this manuscript, Vanni di Baldolo was associated with the decoration of a significant number of other illuminations, both secular and liturgical, including those formerly grouped together under the name "Master of the Matricole dei Notai," after the miniature in a second *matricola* of the Perugian Guild of Notaries, dated 1343, in the Biblioteca Augusta, Perugia (MS 972). The result

is a large body of works, not always homogeneous in execution, that confirm Vanni di Baldolo's role as the head of a successful enterprise involving the participation of various assistants and collaborators—a circumstance alluded to by the signature on the 1333 *matricola*.

Most recently, Dillian Gordon (1991, p. 330) has drawn a distinction between the style of the signed 1333 *matricola* and that of the 1343 manuscript. The latter appears characterized by a greater refinement of execution and subtlety of modeling, leading Gordon to convincingly propose that the Master of the Matricole dei Notai was a distinct personality, and perhaps an associate, in Vanni di Baldolo's workshop. Since the closest comparison for the Victoria and Albert Museum *Annunciation* is the miniature of the same subject in the 1343 manuscript, it is included by Gordon among this master's production.

Additional comparisons for the Victoria and Albert Museum and Lehman leaves may be found in the illuminations in two volumes of an antiphonary series for the Cathedral of San Lorenzo, Perugia (Biblioteca Capitolare MSS 7, 13), datable to the fourth decade of the fourteenth century, which have also been attributed by Gordon (1991, p. 330) to the Master of the Matricole dei Notai.[1] The correspondence in style, palette, and foliate border between the two leaves and the San Lorenzo miniatures suggests a virtually contemporary date of execution and a possible provenance for these fragments from a hitherto missing gradual series for San Lorenzo that would have complemented the surviving antiphonary volumes.[2]

Although Vanni di Baldolo's activity as a painter is documented in two payments, dated 1332 and 1333, for works executed in the Church of San Ercolano, Perugia (Gordon 1991, p. 332), no surviving panel paintings or frescoes have thus far been associated with his workshop. On the other hand, Elvio Lunghi (1992, p. 258) has pointed out the stylistic relationship between a dossal from the Abbey Church of Montelabate in the Galleria Nazionale dell'Umbria (inv. 25, 28), attributed to the so-called Master of the Montelabate Dossals, and the miniatures in the San Lorenzo antiphonaries, tentatively proposing that they are by the same hand. The possibility that the Master of the Montelabate Dossals might in fact be the same person as the Master of the

Matricole dei Notai, one of the *socii* in Vanni di Baldolo's workshop, merits further consideration.[3]

1. These works are given to a related but separate personality, named "Second Master of the Choirbooks of San Lorenzo," by Todini (1989, vol. 1, p. 121) and Elvio Lunghi (1982, pp. 256–57; 1992, p. 259).
2. At present only six antiphonary volumes (MSS 7, 9, 13, 14, 17, 45) and a breviary (MS 38, also decorated by the Master of the Matricole dei Notai) survive from the San Lorenzo choir books (Caleca 1969, pp. 91–101).
3. Todini (1989, vol. 1, p. 331), who identified the Master of the Matricole dei Notai as Vanni di Baldolo, referred to the "tight relationship" between him and the Master of the Montelabate Dossals.

Berardo da Teramo
Abruzzese, active first half of the fourteenth century

19
Nativity in an Initial H
Leaf from an antiphonary

Tempera and gold leaf on parchment. Leaf: 23 × 15½ in. (58.5 × 39.3 cm). Initial: 4¾ × 4⅞ in. (12 × 12.3 cm). Stave: 2.7 cm

Recto: et p[os]t partu[m] que[m] lauda[n]tes o[mne]s dicim[us] b[e]n[e]dicta tu i[n] mu/lie[r]ib[us]. [rubr.] *p*. p[o]p[u]l[u]s gen[tium].[1] [rubr.]*a*.Gaudea[mus] o[mne]s fideles salvator n[oste]r/ nat[us] est i[n] t[er]ris. hodie p[ro]cessit p[ro]les mag[ni]fici germinis et/ p[er]severat pudor virginitatis. [rubr.] *p*. Aos. [rubr.]*a*. Nescie[n]s mat[er]/ virgo vir[um] peperit sin[e] dolore salvatore[m] seculoru[m] ip[sum]/ rege[m] a[n]g[e]lo[rum] sola virgo lactabat ube[re] de celo pleno.[rubr.] *p*. Aos [rubr.] *R.br.*/ Natus e[st] nob[is] hodie salvator. [rubr.]*V*. Q[ui] e[st] chr[istu]s d[omi]n[u]s in civitate d[avi]d. [rubr.] *R.br.*/ Suscepim[us] d[eu]s.[rubr.] *V*. In medio te[m]pli tui./[rubr.] *R.br.* Viderunt o[mne]s.[rubr.]*V*. Salutare do[min]i.[rubr.] *R.br.*/ Notu[m] fecit d[omi]n[u]s. [rubr.] *V*. An. [rubr.] *R.br.* v[er]bu[m] ca/ro.[rubr.] *V*. Et habitabit in nob[is].[rubr.] *R*./ Hodie nob[is] celor[um] rex de virgine/ nas[c]i di[g]nat[us] est. Ut homi/ne[m] p[er]ditu[m] ad regna celestia. Verso: revocaret. Gaudet ex[er]cit[us] a[n]gelor[um]. Ora salus ete[r]/na humano generi apparuit. [rubr.]*V*./ Gl[or]ia in excelsis deo et in t[er]ra pax hominib[us] bone/ voluntatis. Ora.[rubr.]*R*. hodie nob[is] de celo/ pax vera desce[n]dit. Hodie p[er] totu[m] mundu[m]/ melliflui facti sunt celi. [rubr.] *V*. hodie illux[it]/ dies rede[m]ptionis n[ost]re p[re]paratio[n]is [*sic*][2] antiq[uae] felicitatis/ eterne. Ho.[rubr.] *R*. hodie nat[us] e[st] domin[us] ih[esu]s/

et pt partu; que laudātes ōs dicim̄ bn̄dicta tu im̄u

licib;̄ p̄ pplm̄ gen. ā. **G**audeat ōs fideles saluator nr̄

nat̄ est itn̄s hodie peessir p̄ les magn̄a gentium et

pseuerat̄ pudoz uirginitatis p̄ flos. ā. **N**esciens mat

uirgo uir pepit sin̄ doloze saluatorē seculo rū ip̄s

regē ā glōz sola uirgo lactabat ube̅ de celo pleno. p̄ flos. **R**bi

Natus e nob̄ hodie salua toz.

Otie nob̄ de celoz rex de uirgine

na si di i nat̄ est. Vt hom̄

her poitur ad re gn̄a ce lesti a

christus in bethleem iud[a]e in dieb[us] he/rodis regis in civitate david regnans.

On verso, in upper left corner, in red ink: xxxxix

PROVENANCE: Monastery of San Benedetto a Gabiano, near Giulianova; John F. Murray, Florence, 1925
LITERATURE: De Ricci 1937, p. 1707, B.13 (as written in northern Italy, ca. 1400)

This leaf is one of eleven fragments excised from a lost antiphonary volume decorated by the fourteenth-century Abruzzese illuminator Berardo da Teramo. Nine other leaves from the same book, identical to the present one in size, decoration, and stave height, were formerly in the Hoepli Collection, Milan (Hoepli 1927, nos. 331–32; Toesca 1930, pp. 84–89, nos. LXXXIV–XC); four of these are now in the Cini Collection, Venice (2084, 2085, 2087, 2090). A tenth leaf appeared in the 1929 Mensing sale in Amsterdam (Mensing et Fils 1929, lot 66).

The original liturgical sequence of these fragments, excised from a sanctorale, may be reconstructed as follows:

1. Cini 2084: *Last Judgment in an Initial A* ("Aspiciens a longe" [Long had I been watching]). First response in first nocturn for first Sunday of Advent

2. Ex-Hoepli: *Martyrdom of Saint Lucy in an Initial L* ("Lucia virgo" [O Virgin Lucy]). First response at matins for Feast of Saint Lucy (December 13)

3. Cat no. 19: *Nativity in an Initial H* ("Hodie nobis" [Unto us this day]). Second response in first nocturn for Christmas Day (December 25)

4. Cini 2087: *Martyrdom of Saint Stephen in an Initial S* ("Stephanus autem" [Now Stephen]). First response in first nocturn for Feast of Saint Stephen (December 26)

5. Ex-Hoepli: *Adoration of the Magi in an Initial A* ("Afferte domino" [Bring your offerings to the Lord]). First antiphon in first nocturn for Feast of Epiphany (January 6)

6. Ex-Mensing: *Baptism of Christ in an Initial B* ("Baptizat miles regem" [He baptized a thousand kings]). First antiphon at vespers for the commemoration of the Baptism of Christ (Octave of Epiphany, January 13)

7. Ex-Hoepli: *Saint Maurus Rescuing Placidus from Drowning in an Initial B* ("Beatissimus Maurus" [Most blessed Maurus]). First response in first nocturn for Feast of Saint Maurus (January 15)

8. Ex-Hoepli: *Martyrdom of Saint Sebastian in an Initial S* ("Sebastianus mediolanensium" [Sebastian of Milan]). First antiphon in first nocturn for Feast of Saint Sebastian (January 20)

9. Cini 2085: *Presentation in the Temple in an Initial A* ("Adorna thalamum tuum" [Adorn your bridal chamber]). First response in first nocturn for Feast of the Presentation (February 2)

10. Cini 2090: *Saint Benedict and His Monks in an Initial F* ("Fuit vir" [There was a man]). First response in first nocturn for Feast of Saint Benedict (March 21)

11. Ex-Hoepli: *Assumption of the Virgin in an Initial E* ("Exaltata est sancta Dei genetrix" [The holy Mother of God has been exalted]). First antiphon in first nocturn for Feast of the Assumption of the Virgin (August 15)

The identity of the manuscript's donor, along with the name of the illuminator, may be ascertained from the inscriptions on the Cini frontispiece with the *Last Judgment in an Initial A* (fig. 5). At the top of the page, above the miniature, is the following signature: "Dominus Beradus de Teramo fecit hoc opus" (Berardus[6] of Teramo made this). Along the base of the illumination,

Fig. 5 Berardo da Teramo, *Last Judgment in an Initial A* (leaf from an antiphonary). Fondazione Giorgio Cini, Venice, 2084

in gold letters, is a dedication: "Archipresbiter Jacobus de sancto Flaviano fecit fieri hoc opus pro anima fratris Mathei propositi Gabiani cuius anima benedicatur" (Archpresbiter Giacomo of San Flaviano had this made for the soul of brother Matteo curate of Gabiano whose soul be blessed). As noted by Pietro Toesca (1930, p. 84), the deceased Brother Matteo is identifiable in the kneeling Benedictine monk shown to the right of the initial A and in the figure lying on a bier in the center of the foliate margin at the bottom of the page; whereas the kneeling prelate on the other side of the initial may represent the donor, Giacomo. Based on the information in the Cini leaf, the provenance of the original volume can be traced to the Benedictine monastery of San Benedetto a Gabiano, near Giulianova in the province of Teramo (Lehmann-Brockhaus 1983, p. 433).[4]

Nothing is known of the supposed illuminator of this lost choir book, Berardo da Teramo, beyond what may be gathered from this signed and only known work. The Cini fragments have been compared in both style and border decoration to the production of other fourteenth-century Abruzzese illuminators, such as Muzio di Francesco di Cambio da Teramo, whose signature appears in a Bible decorated for the Franciscan convent of San Valentino, Abruzzo Citeriore, in the Vatican Library (cod. Vat. Lat. 10220); and Nicolò di Valle Castellana, whose signature, along with the date 1365, is found in a missal in the Biblioteca Capitolare of the Duomo of Atri (MSA2) (Matthiae 1959; Lehmann-Brockhaus, *loc. cit.*). The roots of these artists' pictorial idiom have been sought within the context of the stylistic exchanges between Neapolitan and Abruzzese illuminators active at the Angevin court in Naples during the first half of the fourteenth century (Rotili 1972, pp. 19–20).

1. According to Hesbert vol. 2, p. 65, this is a *prosula* occurring only in southern Italian usage.
2. "Nostre preparationis" should read "novae reparationis." The first "p[re]" in "preparationis" has been partially erased but not corrected.
3. This is generally interpreted as "Berardus," though it could also be read as "Bernardus."
4. For this monastery, see Cottineau 1939.

Pacino di Bonaguida

Florentine, active first half of the fourteenth century

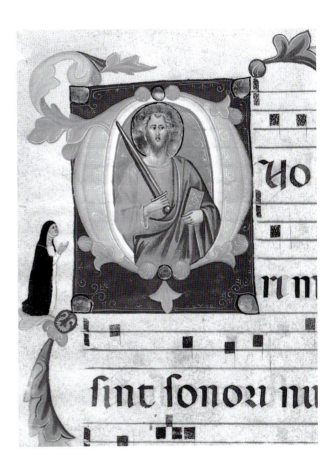

20

Saint Paul in an Initial D

Circa 1335–40
Leaf from a gradual
Cambridge, The Houghton Library, Harvard University, 1943.1868

Tempera and gold leaf on parchment. Leaf: 21⅛ × 15 in. (53.5 × 38 cm). Stave: 3.2 cm

Recto: [rubr.] *In conversione/ s[an]c[t]i pauli ap[osto]li./* Dyo cho/ri modulantes/sint sonori nuntiantes ver/ba sapientie. Omnes/ quidem sollempnicent/ cantent idem coreicent si. Verso: cut decet hodie. Psuedo/ saulus est conversus. doc/tor paulus est reversus/ ut ovis ad victimam./ Vulpes ta[m] quam sanson/ capit. Sanetos qua[m]quam

This leaf is one of three related fragments from an unidentified Dominican gradual. The initial D illustrates the sequence sung at the mass for the Feast of the Conversion of Saint Paul (January 25). Two other leaves, identical in style and border decoration to the present one, are in the Amati Collection, London (Offner/Boskovits 1987, p. 564, Add. Pl. va–b). They show, respectively, *Saint Helena Adoring the Cross in an Initial R* and *Constantine the Great Adoring the Cross in an Initial L,* illustrating two different sequences sung at the mass for the Feast of the Holy Cross. Like the Lehman page, these leaves include the figure of a Dominican nun kneeling in prayer in the border outside the illuminated letter, suggesting a probable provenance from a Dominican convent.

The Amati fragments, first attributed by Federico Zeri and Filippo Todini (*in litteris*) to the workshop of Pacino di Bonaguida, were most recently published among the artist's autograph production by Miklòs Boskovits (Offner/Boskovits 1987). A slightly younger contemporary of Giotto whose activity is documented between 1303 and 1330, Pacino di Bonaguida was the most important and prolific illuminator active in Florence during the first half of the fourteenth century. His artistic personality was first reconstructed eighty years ago by Richard Offner (1922) on the basis of a single signed altarpiece in the Galleria dell'Accademia, Florence (inv. no. 8568). Around this work Offner grouped a significant number of panel paintings and, in subsequent studies, a large body of illuminations that attest to the artist's virtual monopoly over the production of manuscripts in Florence during the first four decades of the fourteenth century (Offner 1956; Offner/Boskovits 1987).

While Offner's attributions have generally been accepted by scholars, the various interpretations of the fragmentary date painted below Pacino's signature in the Accademia Altarpiece, ranging from 1312 to 1341, have resulted in a lack of consensus regarding the relative chronology of his production and his stylistic development. According to Boskovits, the Amati leaves should be placed close to the beginning of the artist's career, as early as 1320. Todini, on the other hand (cited in Offner/Boskovits 1987, p. 564, n. 1), proposed a later dating between 1320 and 1330, contemporary with a closely related leaf formerly in the Bruscoli Collection, Florence (Offner 1956, p. 194, pl. LIV). The ex-Bruscoli page has since been associated with the famous *Laudario di Sant'Agnese,* one of Pacino's most prestigious commissions, convincingly dated by Laurence Kanter to about 1340, toward the end of the artist's career (Kanter 1994, pp. 45, 62; Ziino and Zamei 1999, pp. 485–505; and see following entry). Closer in style and border decoration to the Amati and Lehman fragments, however, are Pacino's illuminations in a series of choir books for the Collegiata of Santa Maria all'Impruneta, datable to slightly earlier than the *laudario,* between 1335 and 1340 (Offner 1956, pp. 199–211; Kanter 1994; Labriola 1995, p. 4).

Pacino di Bonaguida

21a
The Ascension

Circa 1340
Leaf from a *laudario*

Tempera and gold leaf on parchment. Leaf: 17½ × 12½ in. (44.4 × 31.8 cm). Illumination: 10⅜ × 8³⁄₁₆ in. (26.3 × 20.9 cm). Stave: 2.7 cm

Recto: Laudate la surrec[tione]. Verso not visible (leaf glued on cardboard)

PROVENANCE: W. Y. Ottley (sale, Sotheby & Co., London, May 11, 1838, perhaps lot 179); Frank Channing Smith Jr., Worcester, Mass.; bought by Robert Lehman from Julius Weitzner, New York, 1954
LITERATURE: Offner/Boskovits 1987, pp. 206–8, pls. LXXVI– LXXVII (with previous bibliography, as shop of Pacino di Bonaguida); Boehm 1994, pp. 62, 70, 4f (as Pacino di Bonaguida); Ziino and Zamei 1999, p. 498 n. 39 (as Pacino di Bonaguida)

21b
The Martyrdom of Saint Bartholomew

Circa 1340

Leaf from a *laudario*

Tempera and gold leaf on parchment. Leaf: 18½ × 13¾ in. (47 × 35 cm). Illumination: 7 × 8⅛ in. (17.8 × 20.6 cm). Stave: 2.7 cm

Recto: previleggiato. nobile/ predicatore./ La puritade in te fue tanta./ che chr[ist]o la sua dolce infantia./ ad te dilecto gram su ama[n]za./ revelo p[er] grande amore./ Tosto il mondo abandona/sti. col suo fiore il dispregiasti./ predicando l'affermasti. ke/ra vano et pieno d'errore./ Sa[n] bernardo kiara stella ke ri/splendesti in cestella. vite fro[n]/dosa novella. fructo co[n] suave/ odore:. Verso: Appostolo beato da gesu/ cristo amato. bartholo[m]meo/ te laudiam di bon core

On recto, in the center top margin, in red and blue ink: .CIX

PROVENANCE: M. and Mme Avenant Du Plessis (?); M. Mori, Paris, 1924

LITERATURE: De Ricci 1937, p. 1705, D.22 (as ca. 1350, probably written at Bologna); Offner 1956, pp. 226–27, pl. LXV (as Pacino di Bonaguida and workshop); Nordenfalk et al. 1975, p. 24, n. 9 (as workshop of Pacino di Bonaguida); Boskovits 1984, p. 52, n. 179 (as Pacino di Bonaguida); Offner/Boskovits 1987, p. 71 (as Pacino di Bonaguida); Boehm 1994, pp. 62, 77, 4k (as Pacino di Bonaguida); Ziino and Zamei 1999, p. 499, n. 44 (as Pacino di Bonaguida)

These two leaves are part of a group of twenty-three fragments, divided among various European and American collections, that were excised from a *laudario,* a book of hymns sung in Italian by the lay members of a confraternity. The first Lehman folio, with the *Ascension,* illustrates the opening words of the hymn for the Feast of the Ascension: "Laudate la surrectione" (Praise the Resurrection). The second folio, with the *Flaying and Decapitation of Saint Bartholomew,* illustrates the hymn for the Feast of Saint Bartholomew (August 24): "Apostolo beato da gesu cristo amato. bartholomeo te

laudiam" (Blessed apostle beloved of Jesus Christ, Bartholomew, you we praise). In the left border medallions are the *Burial of Saint Bartholomew* and *Saint Bartholomew Preaching to a Crowd.*

Based on the inclusion of two Carmelite saints in a fragment in the National Gallery of Art, Washington (1950.1.8) and on the elaborate decoration of a leaf with *Saint Agnes Enthroned* in the British Library, London (Add. MS 18196), this *laudario* has been traced to the Compagnia di Sant'Agnese in Santa Maria del Carmine, Florence, a lay religious society founded in 1248 (Boehm 1994, pp. 59–60, with previous bibliography). Members of this confraternity are shown kneeling in prayer in the border medallion below the Lehman *Ascension* and are also included in the borders of other leaves from the same series.

Following upon Richard Offner's initial study of several of these fragments, all but five of the twenty-three illuminations thus far associated with the *Laudario di Sant'Agnese* have been attributed to Pacino di Bonaguida. The remainder have been assigned to the Master of the Dominican Effigies, another dominant personality in Florentine illumination during this period, who collaborated with Pacino on several other commissions (Boskovits 1984, pp. 52–53, n. 179; Boehm 1994, pp. 58–80).

Possibly Pacino's last major endeavor, the *Laudario* miniatures have been dated by Laurence Kanter (1994, pp. 44–45) to about 1340, in close proximity to the artist's signed altarpiece in the Galleria dell'Accademia, Florence. While reflecting an awareness of Giottesque motifs and figural types, these works betray, in their brilliant coloristic effects, simplicity of design, and focus on the essential elements of the action, the artist's enduring allegiance to thirteenth-century narrative models. The result is an immediately accessible, "pictographic" style eminently suited to the demands of book illustration.

Apostolo beato. da gesu

cristo amato. bartholomeo

te laudiam dibon core.

impact of Pacino's work in the Impruneta choir books. Notwithstanding a possible Pisan origin, a specifically Florentine context in which to view the master's activity is provided by the evidence of his collaboration with Pacino in at least one other Florentine commission beyond the Impruneta illuminations. The same hand was also responsible, in fact, for the miniatures in a little-studied gradual in the Museo Civico, Montepulciano (cor. H.2), possibly part of a set of choir books decorated by Pacino and the Maestro Daddesco for the Augustinian church of Santo Stefano al Ponte in Florence.[3]

While nothing is known of the original provenance of the Yale cutting and its sister leaves, the inclusion of a group of singing monks dressed in brown habits at the bottom of the Cleveland page suggests a Franciscan commission.

1. The unusual subject matter of the initial makes it difficult to ascertain what text it might have illustrated. The present suggestion is based on the fact that the response "Attendite" occurs after the reading of the Gospel of John (9:1–38), referring to the Healing of the Blind Man.

2. An initial A with the *Presentation in the Temple* in the former Mortimer Brandt Collection, also attributed to the same hand by Labriola (1995, p. 16, n. 28), is instead by a distinct, probably Pisan, illuminator. Not included in Labriola's list, on the other hand, is the private collection fragment with the *Healing of the Blind Man*, previously published as "Workshop of Pacino di Bonaguida" (*Les Enluminures* 1996, cat. no. 5, no. 1, pp. 16–17).

3. The decoration of this gradual was attributed to the Florentine school by Mario Salmi (1953, p. 208, no. 316). One of its miniatures was reproduced by Elly Cassee (1980, fig. 97) and identified as fourteenth-century Bolognese/Sienese. It is not included among the Montepulciano volumes listed in Boskovits 1984, which focuses only on the illuminations by Pacino and the Maestro Daddesco.

Duccio di Buoninsegna

Sienese, documented 1278–d. 1318

27
Virgin and Child and God the Father Blessing in an Initial B

Leaf from an antiphonary
Circa 1285–90

Tempera and gold leaf on parchment. Leaf: 14½ × 10⅝ in. (36.7 × 27 cm). Initial: 3⅜ × 2⅝ in. (8.7 × 6.7 cm). Stave: 2.3–2.4 cm

Recto:[rubr.]*ym*/Plasmator ho[m]i[ni]s/ deus. qui cu[n]cta so/lus ordina[n]s humu[m]/ iubes producere reptantis et fere gen[us]....
Verso: Benedictus. seuoe./ Alleluia. seuoae./ Bene/dict[us]/ d[omi] n[u]s/ deus/ m[eu]s/ qui/ docet manus me/as ad preliu[m]: et di/gitos meos ad bellum....

Leaf cut along right edge. On verso, in left margin (slightly above center), in red ink: [sa]bb[at]o

PROVENANCE: Maggs Brothers, London, 1924
LITERATURE: De Ricci 1937, p. 1704, D.19 (as probably written at Siena, early 14th century)

This leaf was possibly the frontispiece of an antiphonary. The initial B introduces the antiphon at vespers ("Benedictus Dominus Deus meus" [Blessed be the Lord, my God]) for the Saturday before the first Sunday of Advent, beginning the temporal cycle. The text is illustrated by an exceptionally fine miniature of the *Virgin and Child*, in the lower half of the initial, and of *God the Father Blessing*, in the upper half. Both representations are remarkable for the subtle modeling of the figures, the delicacy and expressiveness of their gestures, and their articulation in depth, despite the small scale and the constraints of the initial.

The main cultural component of the Lehman folio was correctly identified by De Ricci, who listed it as probably early-fourteenth-century Sienese. Decorative elements in the foliate border and the design of the initial do, in fact, find precedents in Sienese manuscript production, in particular as represented by the late-thirteenth-century series of choir books for Siena Cathedral (e.g., Museo dell'Opera del Duomo, Siena, MS 34 D). None of these works, however, approach the sensitive handling or the spatial and formal sophistication

of the Lehman miniature, the most convincing comparisons for which are not found in any examples of Sienese illumination but in monumental painting, as represented by the oeuvre of Duccio di Buoninsegna.

The father of the Sienese school of painting, Duccio was one of the leading figures, along with Cimabue and Giotto, in the history of early Italian art. He transformed Byzantine iconographic and decorative formulas, through spatial and volumetric effects derived from his predecessor Cimabue, into a refined, incipiently modern pictorial idiom that influenced generations of local artists. Among Duccio's production, it is his early paintings, beginning with the *Ruccellai Madonna* in the Uffizi, Florence, datable to 1285, and the slightly later *Madonna dei Francescani* in the Pinacoteca Nazionale, Siena (fig. 6), that are brought to mind by the Lehman leaf. Particularly relevant is the close relationship in conception and execution of the Lehman miniature to the preciously executed, small panel of the *Madonna dei Francescani* or to the tondos with busts of saints painted on the frame of the *Ruccellai Madonna* (fig. 7), which have frequently been cited as evidence of Duccio's presumed but unrecorded activity as a miniaturist (Previtali 1982, pp. 13–14; Santi, 1984, pp. 17–19).

The early date of the Lehman leaf may be confirmed by iconographic details in the depiction of the *Virgin and Child.* The gesture of the Christ child extending his hand to touch the hood of his mother's mantle first appears in Duccio's art in the *Crevole Madonna* (Museo dell'Opera del Duomo, Siena), a painting viewed by current scholarship as Duccio's earliest effort. In this panel, however, the child's legs are crossed, whereas in the Lehman miniature their position is comparable to that in the *Ruccellai Madonna* and the *Madonna dei Francescani.* More clearly related to the iconography of the Lehman *Virgin and Child* is that of a panel by Duccio formerly in the Stoclet Collection, Brussels (now in a private collection), where the Christ child is shown in the same pose, supported in the Virgin's arms, and reaching for her veil. This painting has generally been viewed as postdating the *Ruccellai Madonna* and the *Madonna dei Francescani* and as introducing a significant iconographic change in the substitution of the Virgin's red headdress (the archaic, Byzantine-derived *maphorion*) with a white veil (Ragionieri 1989, p. 40). The presence of the traditional red headcovering on the Lehman *Virgin,* despite its overall similarities to the *Stoclet Madonna,* would therefore appear to confirm the earlier date of this miniature, and its importance as marking the first step in Duccio's development of this particular iconographic theme.

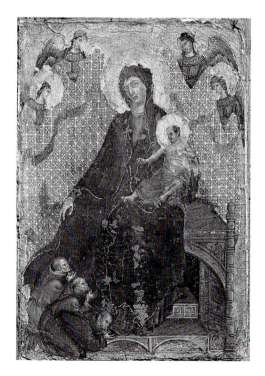

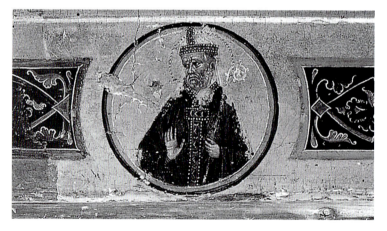

Fig. 6 Duccio di Buoninsegna, *Madonna dei Francescani.* Pinacoteca Nazionale, Siena, no. 20

Fig. 7 Duccio di Buoninsegna, *Ruccellai Madonna. Detail of Frame: Saint Zenobius.* Galleria degli Uffizi, Florence

Master of Sant'Eugenio

Sienese, active second quarter of the fourteenth century

28
Adoration of the Cross in an Initial N

Leaf from a gradual

Tempera and gold leaf on parchment. Leaf: 23¾ × 16¾ in. (60.2 × 42.5 cm). Initial: 6⅝ × 5¼ in. (16.9 × 13.3 cm). Stave: 4.7 cm

Recto: te[m]pore semp[er] la[us] eni[m]/ i[n] ore meo. [rubr.] *Gr.* Beata gens. [rubr.] *V.* Ve[r]/bo do[min]i. All[elui]a. [rubr.] *V.* Veni s[an]c[t]e S[piritus]/[rubr.] *Off.* Co[n]fir[m]a hoc deus. [rubr.] *co./* factus est repente de celo./[rubr.] *pro. o[mn]ib[us].* s. *sc[ri]ptis req[ue]* re ret./ In [com]m[emorati]o[ni]b[us] s[an]c[t]e crucis./ Int[ro]i/tus./ Nos au/tem glo/riari oportet i[n]. Verso: cruce domini no/stri yhesu xpisti/ in quo est salus vi/ta et resurrectio/ nostra per quem

On recto, in center of top margin, in red ink: .xxxIIII

PROVENANCE: John F. Murray, Florence, 1924

LITERATURE: De Ricci 1937, p. 1707, B.17 (as ca. 1400, probably written at Siena)

The initial N illustrates the introit to the mass "Nos autem gloriari oportet" (But it is fitting that we should glory) for the Feast of the Invention of the Holy Cross (May 3). This leaf is one of nine surviving fragments from a hitherto unidentified gradual volume or series. Three other leaves, identical to the Lehman folio in style, measurement, stave height, and numeration, are in the Cini Collection, Venice: an initial S with the *Birth of the Virgin* (2065); an initial I with *Saint Augustine* (2066); and an initial S with the *Pentecost* (2067). To these may be added: an initial D with *Christ Appearing to the Apostles* in the Musée des Beaux-Arts, Bayonne; an initial V with the *Annunciation* in the Musée du Louvre, Paris (Cabinet des Dessins, inv. 1313); an initial B with *Saint Michael Slaying the Dragon* formerly in the Kenneth Clark Collection; a leaf with the *Burial of Saint Augustine in an Initial R* in the Bibliothèque Publique et Universitaire, Geneva; and a leaf with the *Apostles Adoring the Virgin in an Initial R* in the Free Library, Philadelphia (M74:1).

The Cini, Paris, and Bayonne fragments, previously attributed to Lippo Vanni, were first grouped together as part of the same series by Ferdinando Bologna (1977), who associated them with the fourteenth-century Sienese miniatures pasted into a later antiphonary from the Benedictine abbey of Sant'Eugenio, Siena, now in the Badia di Cava dei Tirreni, near Naples (Biblioteca della Badia, Antifonario Sen. B).

The Cava dei Tirreni miniatures were identified by Bologna as the product of two distinct hands to which he assigned the names "First" and "Second" Master of Sant'Eugenio. Each artist purportedly represented a different phase in the evolution of Sienese manuscript illumination from about 1330 to 1340, in the wake of Pietro Lorenzetti's production and before the advent of Niccolò di Ser Sozzo (cat. no. 29) and Lippo Vanni. According to Bologna, the "Second" Master of Sant'Eugenio was the author of the Cini, Paris, and Bayonne miniatures, as well as of the illuminations in two antiphonary volumes in the Museo d'Arte Sacra, San Gimignano, near Siena, that were otherwise attributed by Cristina De Benedictis (1976, pp. 87–95) to the Sienese painter Niccolò di Segna.

Bologna's distinction between a "First" and "Second" Master of Sant'Eugenio was accepted by subsequent scholars, from Mario Rotili (1978, pp. 89–94) to Giulietta Chelazzi Dini (1982, pp. 222–28). The latter accepted the Cini–Paris–Bayonne grouping as the work of the "Second Master," while publishing the ex–Kenneth Clark *Saint Michael*, previously attributed to a follower of Niccolò di Ser Sozzo, as a work of the "First Master."

Most recently, Gaudenz Freuler (1991, pp. 39–40) added the Geneva leaf to the Cini–Paris–Bayonne fragments and further enlarged the corpus of the "Second" Master of Sant'Eugenio by attributing to the same hand a 1329 *biccherna* cover in the Kunstgewerbemuseum, Berlin (no. K9222). At the same time Freuler dismissed Bologna's proposal that these fragments, all excised from a gradual, be associated with the same series as the antiphonary cuttings in Cava dei Tirreni (with which, in fact, they do not correspond in stave height). Based on the subject of the Geneva miniature, he suggested a more convincing provenance from one of the two major Augustinian convents in Siena, Sant'Agostino or San Leonardo al Lago.[1]

While the Cava dei Tirreni miniatures, the fragments listed above, and the San Gimignano illuminations clearly constitute a homogeneous group, the distinction still drawn by scholars between a "First" and

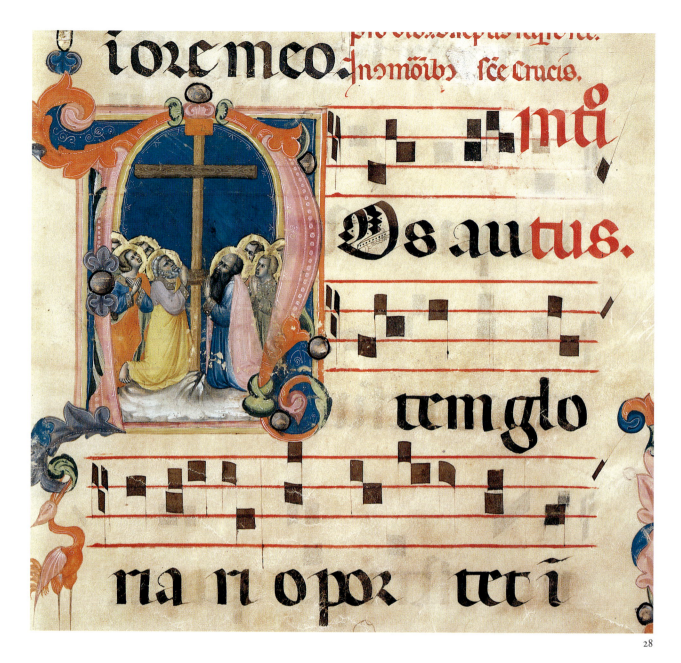

28

"Second" Master of Sant'Eugenio seems artificial. Close scrutiny of the Cava dei Tirreni illuminations reveals a general uniformity in concept, handling, and execution that suggests a single personality involved in this series and in all the works associated with it. The fluidly elongated, insubstantial limbs, oval heads, and darkly shadowed, narrow features that distinguish the execution of the *Saint Michael* on folio 54 of the Cava dei Tirreni antiphonary, attributed by Bologna and Rotili to the "First Master," were, for example, viewed as characteristic elements of the works associated with the "Second Master" by Marie-Claude Léonelli (1983, p. 214), who assigned this miniature to the latter. It is in effect impossible to draw a distinction between this *Saint Michael* and the elegantly poised, standing figure of Christ on folio 107 of the same volume, assigned by Bologna and Rotili to the "Second Master"; or between the ex-Kenneth Clark *Saint Michael,* given by Chelazzi Dini to the "First Master," and any of the figures in the Cini or Bayonne fragments, which despite their reduced scale share not only identical formal elements but also the same lively quality and refinement of execution.

The possible attribution of the 1329 *biccherna* cover to the Master of Sant'Eugenio would appear to support his identification as a slightly older contemporary of Lippo Vanni, whose activity is first documented more than a decade later, in 1344. The master's roots among an earlier generation of miniaturists may ultimately account for the more archaic quality that distinguishes his decorative borders in the San Gimignano antiphonaries from those of Lippo Vanni and Niccolò di Ser Sozzo in other volumes of the same series.[2] Freuler's suggestion *(loc. cit.)* that the often noted stylistic similarities between the artist's production and that of Lippo Vanni be explained in terms of a master-pupil relationship merits further consideration.[3]

1. The only one of the fragments related by Bologna to the Cava dei Tirreni miniatures that may have been excised from the same volume is the initial S with a haloed nun in the Cini Collection (2058), which corresponds to the Cava dei Tirreni group in both measurement and stave height (2.9 cm).

2. A tentative proposal that the master's activity in San Gimignano may actually have preceded that of Lippo Vanni and Niccolò di Ser Sozzo in different volumes of the same series is supported by indications that the books were written in at least three different moments in time. The two antiphonary volumes by the Master of Sant'Eugenio (LXVIII 2; LXVIII 3), identical in measurement and stave height, contain the sanctorale (the Commons and Propers of the saints), while the three volumes by Lippo Vanni (cod. LXVIII 5; LXVIII 7; LXVIII 6) constitute a temporale complete in three parts. Two of the three volumes of the temporale share the same measurement and stave height with the sanctorale and were presumably written at the same time. The third and final volume of the temporale employs a different stave height and was clearly written later. Since Lippo Vanni's hand appears consistent throughout these three books, it seems likely that they were all decorated at the later date.

 A third phase in the writing of these books must be represented by the two gradual volumes by Niccolò di Ser Sozzo, which are completely different from the antiphonaries in both stave height and pagination.

3. More recent efforts to discern the master's hand, next to that of a young Lippo Vanni, in an antiphonary in the Badia a Settimo, Florence (De Benedictis 1994, pp. 23–25), fail, however, to convince. The style of the *Annunciation* on folio 30r, one of three illuminations given by the author to the supposed "Second" Master of Sant'Eugenio, has little in common with that of the Louvre *Annunciation*, for example, and appears more closely related to the workshop of Niccolò di Ser Sozzo.

Niccolò di Ser Sozzo

Sienese, documented 1348–d. 1363

29
Ascension in an Initial V

Circa 1342–50
Cutting from an antiphonary
New York, The Metropolitan Museum of Art, Robert Lehman Collection, 1975 (1975.1.2472)

Tempera and gold leaf on parchment. Cutting: 6⅛ × 6¼ in. (15.4 × 16 cm). Initial: 4¼ × 3⅞ in. (10.8 × 9.8 cm). Stave: 2.9 cm

Recto: Viri/ lile. Verso: illum: ecce duo/ xta illos i[n]vesti

PROVENANCE: Sale, Maggs Brothers, London, 1921, lot 92; Leo S. Olschki, Florence, 1924[1]
LITERATURE: Levi D'Ancona and Palladino 1997, no. 15, pp. 123–27, pl. 15 (as Niccolò di Ser Sozzo, ca. 1342/43–50, with previous bibliography); Palladino 1997b, p. 17, pl. 2 (as Niccolò di Ser Sozzo, ca. 1342–50)

This miniature, excised from an unidentified antiphonary, illustrates the first antiphon at lauds for the Feast of the Ascension: "Viri [ga]lile[i quid aspicitis in caelum?]" (Men of Galilee, why do you stand looking

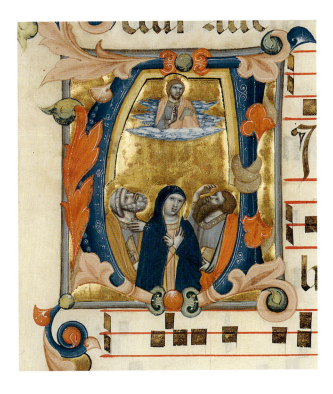

up to heaven?). On the reverse of the cutting is a fragment of the second antiphon at lauds for the same feast: "[Cumque intuerentur in caelum euntem]illum, ecce duo [viri astiterunt iu]xta illos investi[bus albis]" (And while they were gazing up to heaven as he went, behold two men stood by them in white garments). Inside the initial V is the Virgin flanked by Saint Peter on the left and an unidentified apostle on the right. Hovering above them is the figure of the Blessing Redeemer.

The illumination is a typical example of the production of the fourteenth-century Sienese painter and illuminator Niccolò di Ser Sozzo, to whom it was first attributed by Sylvie Béguin (1957, no. 179, pp. 119–20). The career of this artist, who is first documented in 1348, has been reconstructed primarily on the basis of his signature below a large illumination of the *Assumption of the Virgin* inserted at an unknown date in the so-called *Caleffo dell'Assunta,* a register of Sienese public documents transcribed between 1334 and 1336, now in the Archivio di Stato, Siena. On the basis of this work, considered one of the masterpieces of early Sienese painting, Niccolò has been identified as the author of a significant body of manuscript illuminations, in addition to several panel paintings, that attests to his role as one of the preeminent miniaturists in Siena from about the fifth decade of the fourteenth century to his premature death in 1363.

The overriding component in Niccolò's generally homogeneous miniature production, beginning with the Caleffo *Assumption,* is a clear dependence on the work of Pietro Lorenzetti around 1340–42. Despite efforts to discern an early phase of the artist's career in the previous decade (De Benedictis 1979, p. 11; Chelazzi Dini: 1982, pp. 236–38), the date 1342 has recently been proposed as a terminus post quem for Niccolò's activity as both painter and illuminator, following a possible apprenticeship in the Lorenzetti workshop (Levi D'Ancona and Palladino 1997a, pp. 122–23; Palladino 1997b, pp. 13–20, with previous bibliography).

Closely related to the Lehman cutting are Niccolò's illuminations in two antiphonaries in the Biblioteca Comunale degli Intronati, Siena (cod. 1.1.8–9), where we find a slightly reduced version of the same composition, inserted in an initial P instead of a V but identical in concept and execution. Also comparable in style are a series of antiphonary cuttings in Berlin (Kupferstich-

kabinett, 651–59) and Venice (Fondazione Giorgio Cini, 2060, 2061), which, however, do not conform to the present fragment in stave height or musical notation (*pace* Levi D'Ancona and Palladino 1997, p. 127, n. 9).

1. The purchase is recorded in a receipt from Olschki dated October 17, 1924, in the Robert Lehman Collection archives. The date was erroneously reported as 1923 in Levi D'Ancona and Palladino 1997, p. 123.

Master of the Codex Rossiano
Sienese, active circa 1380–1400

30
The Trinity in an Initial B

1387 (?)
Cutting from a gradual
New York, The Metropolitan Museum of Art, Robert Lehman Collection, 1975 (1975.1.2476)

Tempera and gold leaf on parchment. Cutting: 10½ × 10 1/16 in. (26.8 × 25.5 cm). Initial: 10 × 9 5/8 in. (25.4 × 24.3 cm). Stave: 3.6 cm

Verso: ce[m] eius audis al/ sed nescis unde/ aut quo va

PROVENANCE: A. S. Drey, Munich, 1924
LITERATURE: Palladino 1997a, cat. 16, pp. 128–36 (as Master of the Codex Rossiano, 1387[?] with previous bibliography); Levi D'Ancona 2000, pp. 149–61 (as Frate Gregorio da Montalcino, 1384–85)

The initial B marks the beginning of the introit to the mass for Trinity Sunday ("Benedicta sit sancta Trinitas" [Blessed be the Holy Trinity]). Inside the exuberantly foliated initial are the three figures of the Trinity seated on a throne of red seraphim; below them are ten seated angels. In the two upper corners of the square, gold background are two bust-length prophets gesturing toward the Trinity; partially visible despite losses of pigment in the lower left corner is a bust-length white-clad, Olivetan monk.

This cutting is one of eleven surviving fragments from a lost gradual first identified by Mirella Levi D'Ancona (Robert Lehman Collection files) as possibly related to a commission of 1387 for the Olivetan monastery of San Miniato al Monte, Florence. Nine other fragments from the same volume are pasted in a scrapbook of cuttings,

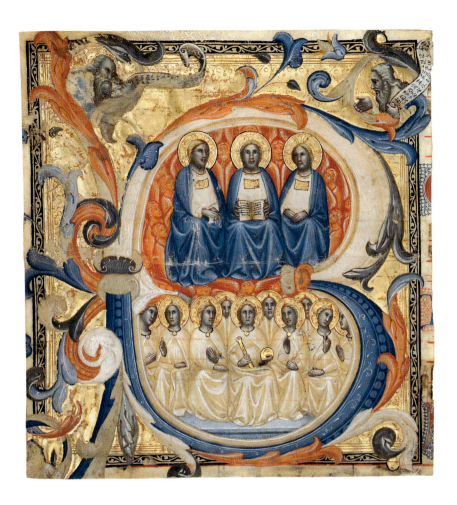

known as Codex Rossiano 1192, in the Biblioteca Apostolica Vaticana, Rome (1192.1, 3–10), while a tenth leaf is in the Bernard Breslauer Collection, New York (Kanter 1994, pp. 128–36; Palladino 1997a).

As pointed out by Laurence Kanter *(loc. cit.)*, three different artists were responsible for the decoration of this gradual. The Sienese illuminator Don Simone Camaldolese, who is named in the 1387 payment from San Miniato al Monte, was responsible for the floriated borders in all of the initials and for one of the Vatican miniatures. An anonymous assistant of Don Simone executed three other Vatican miniatures and the leaf with the *Adoration of the Magi* in the Breslauer Collection, after which he was named by Kanter *(loc.cit.)* "Master of the Breslauer Epiphany." A second anonymous illuminator was responsible for the Lehman initial and for the remaining five Vatican miniatures; this artist was christened by Miklós Boskovits (1975, p. 232, n. 120) "Master of the Codex Rossiano." One of the Vatican cuttings by his hand, which contains fragments

of the text begun by the Lehman initial, was originally the *bas de page* of the same folio.

Variously identified as Florentine, Sienese, or Umbrian, the Master of the Codex Rossiano remains an enigmatic personality in Italian manuscript illumination. His work, as represented by the Lehman and Rossiano illuminations, reflects both Sienese formal and compositional elements and a Florentine decorative vocabulary derived from the school of Santa Maria degli Angeli. As a result he has been viewed either as a Florentine artist trained in Siena (Boskovits 1975) or as a Sienese artist active outside his native city and especially receptive to Florentine and Umbrian influences (Boskovits 1983, pp. 265–67; *idem* 1995, pp. 379, 384, n. 11).

Most recently, Pia Palladino (1997a), following Kanter *(loc. cit.)*, has highlighted the distinctively Sienese roots of the Rossiano master's pictorial idiom, pointing specifically to its relationship to Sienese painting after 1350 and the workshop of Bartolomeo Bulgarini. A Sienese context in which to view the artist's activity, as

well as formation, is suggested by evidence of his collaboration with the Sienese painters Andrea di Bartolo and Bartolo di Fredi on a series of antiphonaries for the Augustianian monastery of Lecceto, outside Siena, at present divided among the Biblioteca Comunale degli Intronati, Siena (cod. H.I.7), the Biblioteka Jagiellonska, Cracow (I.R. 1855–63), and various other collections (Boskovits 1983; Freuler 1991, p. 83; Boskovits 1995; Palladino 1997a, pp. 133, 135, n. 9).[1] Efforts to identify the same hand in a choir book from the Abbey of Montemorcino, near Perugia, now in the Archive of Monteoliveto Maggiore, Siena (Boskovits 1983; 1995), are unconvincing (Palladino 1997a, p. 136, n. 13).

1. All of these works were recently rejected from the master's corpus by Levi D'Ancona (2000), who identifies the artist as the "Fra Gregorio Mutii do Montalcino" cited in the San Miniato documents in 1384–85. Kanter (1994, p. 213), however, argued persuasively against the possibility of such an identification.

Martino di Bartolomeo

Sienese, documented 1389–d. 1434/35

31

Two Martyr Saints in an Initial P

Circa 1394–95

Leaf from a gradual

Tempera and gold leaf on parchment. Leaf: 27½ × 16½ in. (57 × 42 cm). Initial: 11 1/16 × 7¼ in. (28 × 18.5 cm). Stave: 4.7–4.8 cm

Recto: [iu]stus in domino et/ sp[er]abit in eo [et] lau/dabuntur omnes recti/corde alleluya al/leluya. [rubr.] *In nat. unius sancti a pascha/ usq[ue] ad pent. ubi aliud spe/tiale no[n] assignetur./ Introit[us].* Verso: Protexisti me/ deus a co[n]ve[n]/tu malignantium/ alleluya a multitu/dine operantium iniq[ui]

Leaf cut on all four sides. On verso, in center left border, fragments of original numeration, in red ink: . . . x. In upper left corner, in a later hand, in black ink: . . . 3

PROVENANCE: Bought in Germany, before 1937[1]
LITERATURE: De Ricci 1937, p. 1707, C.11 (as late 14th century, probably Florentine)

The initial P, excised from a gradual, illustrates the introit to the mass ("Protexisti me deus" [Thou hast protected me, Lord]) for the Common of One Martyr Saint in Paschaltide. This miniature may be attributed to the painter and illuminator Martino di Bartolomeo, one of the dominant figures in Sienese painting between the last quarter of the fourteenth century and the first quarter of the fifteenth century. Although he is first mentioned in the 1389 registers of the Sienese painters' guild, the earliest known records of Martino's activity refer to commissions outside Siena, in Pisa and its surrounding regions, where he appears to have been engaged for some time before returning permanently to his native city in 1405. During the next thirty years he was responsible for several important fresco cycles in the Sienese Duomo and the Palazzo Pubblico, as well as for painted altarpieces and polychrome sculptures, attesting to his prestige as one of the city's official artists.

The principal evidence for reconstructing Martino's activity as a miniaturist is the series of illuminations he executed in a five-volume gradual for Lucca Cathedral (Museo dell'Opera del Duomo, cor. nos. 1, 7, 9, 10; Biblioteca Capitolare, cor. no. 8), recently dated to between 1394 and 1395 (Labriola 1998, pp. 208–11). The style of the Lehman cutting, its identical palette, border decoration, and numeration suggest that it was probably excised from one of these volumes, which were rebound in the seventeenth century and deprived of many of their miniatures. More specifically, the text of the Lehman folio implies that it may originally have been included in Corale 1 in Lucca, the last part of the five-volume gradual containing the Commons of the Saints.

Possibly related to another volume in the Lucca series is a hitherto unpublished cutting by Martino in the Art Institute of Chicago (1923.1682), identical to the Lehman and Lucca miniatures in style and border decoration. This illumination, which shows *Saint Benedict Distributing His Rule in an Initial O,* may have been included in one of the missing sanctoral portions of the gradual covering the Feast of Saint Benedict (March 25).

The Lucca choir books, first attributed to the artist by Luciano Bellosi (1975), are generally considered among Martino's earliest known production, closely related to but preceding his signed and dated 1398 fresco

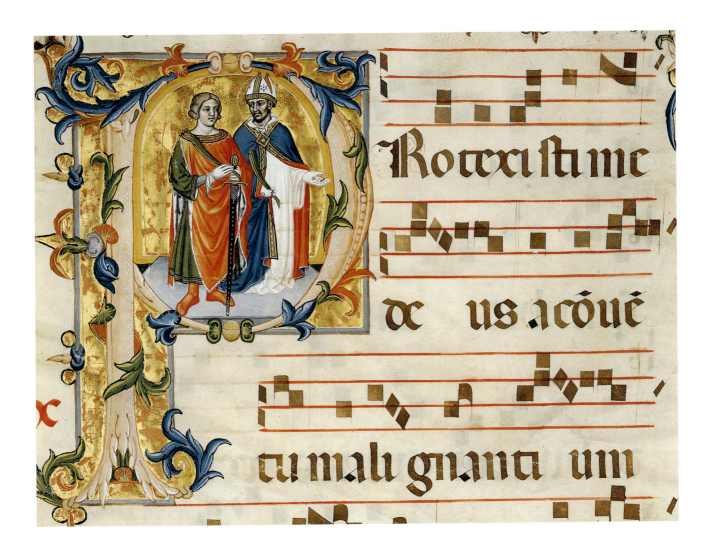

cycle in the Church of San Giovanni Battista di Cascina, outside Pisa. These works have been viewed in relation to the production of the Sienese painter Taddeo di Bartolo, in whose workshop Martino was possibly trained, as well as to that of Antonio Veneziano and Spinello Aretino, both of whom were active in Pisa and Lucca.

Aside from the Lucca graduals, the only other evidence of the artist's activity as an illuminator is provided by the miniatures in a little-known manuscript of the Legend of Saint Agnes in the Biblioteca Comunale degli Intronati, Siena (cod. K.VII.I), tentatively associated with Martino's name by Giulietta Chelazzi Dini (1982, pp. 338–39) but ignored in the subsequent literature. More closely related to the art of Taddeo di Bartolo than are the Lucca choir books, the Legend of Saint Agnes illuminations may represent the earliest

Sienese phase in the artist's career, preceding his activity in Pisa and Lucca. Possibly part of another commission datable to the same moment as the Lucca graduals is an antiphonary cutting by Martino in the National Gallery of Art, Washington, tentatively identified by Carl Nordenfalk (1975, pp. 47–49) as "Tuscan, around 1400."

1. Information reported by De Ricci 1937, p. 1707. No confirmation of this purchase has been found in the Robert Lehman Collection files.

Andrea di Bartolo

Sienese, documented 1389–d. 1428

32

Christ Blessing and a Franciscan Monk in an Initial A

Circa 1413–20
Leaf from an antiphonary

Tempera and gold leaf on parchment. Leaf: 22 × 15 ⅜ in. (55.8 × 39.2 cm). Initial: 6 ⅝ × 5 ½ in. (16.8 × 14 cm). Stave: 3.7 cm

Recto: onem ipse veniet et salva/bit nos [rubr.]*ps.* Salvum. [rubr.] *p.* Usq[ue] quo/ d[omi]ne [rubr.]*ps.* Dixit/ insipiens. [rubr.] *ps./* D [omi]ne quisi/[rubr.] *v./* Ex [s]ion speties decoris e/ius. [rubr.] *R.* Deus noster/ manifeste veniet. [rubr.]*Domi/nica prima de adventu. R.* Verso: Aspi/ciens a/ longe/ ecce video de/i potentiam venien/tem et nebu

Leaf cut on all four sides. On recto, in upper right corner, in black ink: 3

PROVENANCE: Canessa, Paris, 1923
LITERATURE: De Ricci 1937, p. 1708, D.18 (as ca. 1400, probably written at Siena)

The initial A, excised from an antiphonary, illustrates the first response at matins ("Aspiciens a longe" [Long had I been watching]) for the first Sunday of Advent. Inside the letter a monk in Franciscan habit looks up to the bust-length figure of the Blessing Redeemer, suggesting a Franciscan provenance.

The illumination may be attributed to the Sienese artist Andrea di Bartolo, a contemporary of Martino di Bartolomeo (cat. no. 31). Son of the painter Bartolo di Fredi (doc. 1353–d. 1410), Andrea began his career in his father's workshop and collaborated with him on several projects during the last decades of the four-teenth century. A significant number of surviving doc-uments record the many commissions received by Andrea in Siena, for panel paintings, painted sculpture, and drawings for stained glass, as well as his important roles in public office until his death in 1428. The artist was also active in Venice and in the last years of his life may actually have resided in the Veneto, where in addi-tion to works on panel he executed some frescoes in the Church of San Francesco, Treviso (Freuler 1987; *idem* 1992, pp. 486–99).

Andrea's activity as a manuscript illuminator can be reconstructed on the basis of the miniatures that were first attributed to his hand by Giulietta Chelazzi Dini (1982, pp. 316–26) in four manuscripts preserved in the Biblioteca Comunale degli Intronati, Siena: a codex of the *Revelations of Saint Bridget* from the Compagnia dei Disciplinati della Madonna of Santa Maria della Scala (cod. I.V.25), dated 1399; a Roman missal of unknown provenance (G.III.7); and an antiphonary (cod. H.I.7) and a gradual (H.I.7, G.I.14) from the Augustinian monastery of San Salvatore a Lecceto, out-side Siena.[1] The Lehman cutting, however, reflects a later phase in Andrea's career than any of these works. It is distinguished from them by a precision of execu-tion and elongated figural style, most noticeable in the representation of the Blessing Redeemer, that recall Andrea's more mature production beginning with the 1413 altarpiece in the Church of the Osservanza, Siena.

The style of the Lehman leaf, its delicate palette, and lively foliate border animated by birds and playful putti closely resemble a series of little-known illumina-tions recently attributed to Andrea and various anony-mous collaborators (Melograni 1995, p. 135; Bollati 1997a, pp. 212–13) in three antiphonary volumes for Franciscan use in the Museum of the Studium Biblicum Francescanum, Jerusalem (cod. 5[D], 6[K], 7[H]). These books, missing entire leaves as well as painted initials, are all that remain of a multivolume antiphonary set covering the entire liturgical year (Bux 1990, pp. 52–78). Based on an inscription in Antiphonary 5(D) of the set, it may be inferred that the series was donated to the Monastery of Mount Syon by one of the heirs of the English prince John of Gaunt (d. 1399),[2] possibly his son King Henry IV (r. 1399–1413), who may have acquired it in Venice, en route to the Holy Land, or his grandson Henry V (r. 1413–22; Bux 1990, p. 21). Andrea's involvement in this commission could have resulted from his contacts with the Franciscans in the Veneto.

Among the Jerusalem miniatures, the nearest in quality of execution to the Lehman fragment are those in Codex 5(D), in which Milvia Bollati (*loc. cit.*) detected the direct participation of Andrea. One of the leaves excised from this antiphonary, covering the period from Advent through Epiphany, is folio 3 (Bux 1990, p. 52), which would have contained the

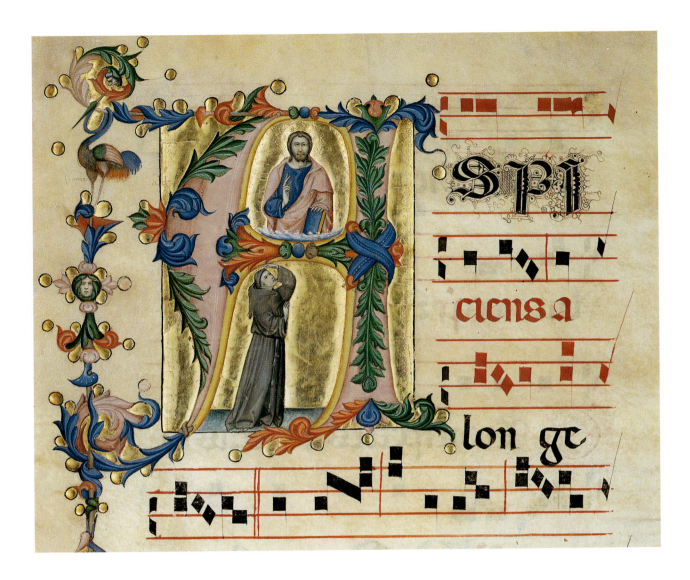

frontispiece for the first Sunday of Advent. It is possible to suggest tentatively that this missing page be identified as the Lehman fragment, which not only corresponds in text and subject matter but also is numbered "3" in the upper right corner, in the same location and same Arabic script as on the pages of the Jerusalem volumes. Identical numbering also occurs on another antiphonary leaf with *Christ in the Garden of Gethsemane* in a private collection, convincingly associated by Bollati with the Jerusalem miniatures, though attributed to a collaborator of Andrea.

1. The latter were decorated by the artist in collaboration with his father and several anonymous illuminators, including the Master of the Codex Rossiano (cat. no. 30).

2. The inscription on folio 1 of Codex 5(D) (Bux 1990, p. 55) refers to prayers in memory of the deceased John of Gaunt, for the well-being of his soul: "Orate pro anima illustrisimi principis Dni Johns quondam ducs [L]ancastre filis regis Anglorum Edwardi tertii, ac patris Henrici quarti (…) factum pro consolatione fratrum sacri montis Sion."

Carl Nordenfalk (1975, pp. 47–48), is by the Sienese painter Martino di Bartolomeo and has nothing to do with this group.

2. In addition to the Beffi Triptych, the artist was responsible for a second panel in the Museo Nazionale d'Abruzzo, first attributed to him by Enzo Carli in 1943 (Carli 1998 [1943], pp. 218–19, 225–26); and a panel recently on the art market, ascribed to him by Andrea de Marchi (sale, Sotheby's, London, December 14, 2000, lot 183). Related in style and border decoration to the present antiphonary fragments is a Roman missal in the Seminario Arcivescovile, Chieti, commissioned about 1400 by Napoleon II Orsini for his chapel in the Church of San Francesco and attributed to the Beffi master by Maria Andaloro (1990, pp. 313, 320). Markedly less refined in execution than the Beffi Triptych or the present illuminations, this work was more convincingly identified by Chierici (1949, p. 125) as a product of the same culture as that of the triptych but by a different hand.

Master of the Brussels Initials

Bolognese, active circa 1390–circa 1420

34
Christ Blessing in an Initial E

Circa 1410–20
Cutting from a gradual (?)

Tempera and gold leaf on parchment. Cutting: 5¼ × 4 in. (13.4 × 10.1 cm). Stave: 3.5 cm

Verso: . . . uruabitur/ . . . bitur om[ne]s

PROVENANCE: Count G. Stroganoff[1]
LITERATURE: De Ricci 1937, p. 1705, D.28A (as probably Siena, 14th century)

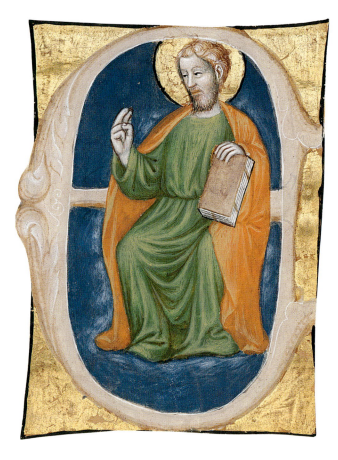

This miniature, possibly excised from a gradual, may be attributed to the so-called Master of the Brussels Initials, one of the dominant personalities in Bolognese manuscript illumination between the end of the fourteenth century and the first decades of the fifteenth century. It is identical in execution, palette, and border decoration to six other fragments by the same hand, dispersed among various collections, that were probably excised from a single volume or gradual series: an initial A with a prophet in the Cini Collection, Venice (2048); an initial E with *Saint Dominic* formerly at Maggs Brothers, London (*Bulletin No. 1*, 1962, cat. 6); an initial D with *Saint Nicholas of Bari* recently sold at Christie's, in London (sale, June 26, 1991, lot 12); an

initial S with *Saint Stephen*, in The Metropolitan Museum of Art, New York (Department of Medieval Art, 31.134.1; fig. 9); an initial D with *Christ Washing the Feet of the Apostles*, formerly in the Holford Collection, London (*The Holford Collection, Dorcester House* 1927, vol. 1, p. 23, no. 28b); and a *Prophet in an Initial I* in the Rijksmuseum, Amsterdam (RP–T–1937–1).

The Cini and ex-Maggs cuttings were first linked together by Millard Meiss (1969, p. 245), who recognized their strong resemblance to a manuscript of Lactantius in the library of the earl of Leicester at Holkham Hall, considered a late product of the Master of the Brussels Initials and his workshop. The ex-Christie's and The Metropolitan Museum of Art cuttings were subsequently determined to be part of the same series by Robert Gibbs (1991, pp. 317–21) and Elliott Nesterman (Metropolitan Museum files), respectively. Following Meiss, Gibbs also dated the cuttings to the last phase of the master's activity, in close proximity to his frontispiece for the statutes of the Compagnia dei Devoti Battuti di Santa Maria della

Vita, Bologna (Biblioteca Comunale dell'Archiginnasio, Fondo Ospedali 6), dated 1408.

The Master of the Brussels Initials takes his name from a series of illuminations in a Book of Hours in the Royal Library in Brussels (MS 11060–1). He was first identified by Otto Pächt (1948, p. 15, n. 19), followed by Meiss (1969, pp. 229–46), as a Bolognese artist active in Paris from the last decade of the fourteenth century to about 1408, and then in Bologna until at least the middle of the next decade. His formation has been traced to the workshop of Niccolò da Bologna, from whom he derived the broad figural style, incisive, calligraphic approach, and brilliant palette that characterize his early works. Additional sources for his idiom have been found in the production of the Paduan illuminator known as Master of the Novella, with whom the artist may have come in contact during a possible sojourn in the Veneto prior to his departure for Paris (Bollati 1997b).

It is generally accepted that the 1408 book of statutes for Santa Maria della Vita represents the first evidence of the artist's return to Bologna after his French sojourn and that it introduces a new phase in his development. Compared to the works produced by his Paris workshop, which are characterized by an exuberantly decorative approach and lively narrative style, the 1408 statutes volume and the miniatures grouped around it—such as the present series of cuttings and the Holkham Hall

Lactantius—reflect a decorative restraint, summary quality of execution, and general stiffening of the figures sometimes viewed as indicative of increased workshop participation (Meiss 1969, Medica 1999, pp. 190–91). A dating for this last phase in the master's activity, during the second decade of the fifteenth century, is suggested by Milvia Bollati's recent attribution to his hand of the illuminations in a manuscript, dated 1416, of the *Fioretti* of Saint Francis in a private collection (1997b, pp. 135–38). This work is convincingly related by Bollati to the 1408 statutes and, among others, to the ex-Christie's initial included in the present series.

1. The Stroganoff seal is on the back of the cutting.

Master of 1446
Bolognese, active second quarter of the fifteenth century

35a
Dominican Hymnal
Circa 1430–40

Tempera and gold leaf on parchment. 124 folios. Page: 22¼ × 15⅝ in. (56.5 × 39.6 cm). Stave: 4.5 cm. Binding: 23¾ × 16½ in. (60.5 × 42 cm). Pages are marked according to two different numbering systems: large Arabic numerals in black ink, in center top margin of verso of each leaf; smaller Arabic numerals in black ink, in top right margin of recto of each leaf.[1]

Contents: Temporale (fols. 1–41); Proper (fols. 41r–87); Commons (fols. 88–110). The original volume ends on folio 110r. Subsequent pages are later additions. Five leaves are missing: folios 35, 49, 75 (see cat. nos. 35b–d), 97, 98. Between folio 96 and folio 99 is an eighteenth-century insert (bifolium), replacing the missing leaves.

Includes numerous decorated letters and the following illuminations: fol. 1r: *Prophet in an Initial C* ("Conditor alme"); fol. 4r: *Nativity in an Initial V* ("Veni redemptor"); fol. 7v: *Adoration in an Initial H* ("Hostis herodes"); fol. 24v: *Resurrection in an Initial A* ("Ad cenam"); fol. 29r: *Ascension in an Initial E* ("Eterne rex"); fol. 31r: *Ascension in an Initial B* ("Beata nobis"); fol. 37r: *Altar Table in an Initial P* ("Pange lingua"); fol. 45v: *Saint Thomas Aquinas in an Initial S* ("Superna mater"); fol. 52r: *Saint Thomas Aquinas in an Initial E* ("Exultet mentis"); fol. 55r: *Saint Peter Martyr in an Initial M* ("Magne dies"); fol. 62r: *Saint John the Baptist in an Initial U* ("Ut queant"); fol. 66v: *Saints Peter and Paul in an initial A* ("Aurea luce"); fol. 71v: *Saint Mary Magdalen in an Initial L* ("Lauda mater"); fol. 78r: *Saint Augustine in an Initial M* ("Magne pater");

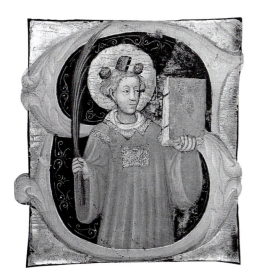

Fig. 9 Master of the Brussels Initials, *Saint Stephen in an Initial S.* The Metropolitan Museum of Art, New York, Bequest of Gwynne M. Andrews, 1931 (31.134.1)

vi[r]/tute firma[n]s perpeti./ Hoste[m] repellas longius./ pace[m] q[ue] dones p[ro]tinus./ ductore sic te p[rae]vio vite/mus om[n]e noxium.

On verso, in center top margin, in black ink: 35

PROVENANCE: Unknown

LITERATURE: De Ricci 1937, p. 1709, A.37 (as early 15th century, probably written in Venice)

This leaf and the two that follow (35c–d) were listed by De Ricci as from a single choir book written in Venice. They are actually three of the five missing pages from the Lehman Hymnal (cat. no. 35a)—this volume was apparently unknown to De Ricci—with which they correspond in style, decoration, stave height, and numbering. The present fragment is the missing folio 35.

35c
Virgin and Child in an Initial A

Leaf from Lehman Hymnal

Tempera and gold leaf on parchment

Verso: AVE/MA/RIA/stella dei mater alma/atque semper virgo felix celi.

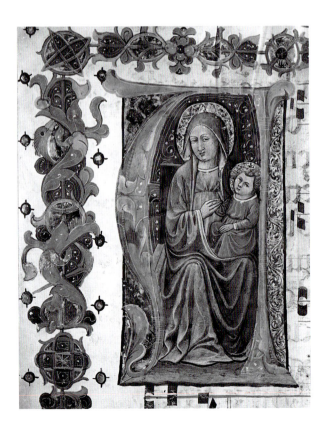

On verso, in center top margin, in black ink: 49

PROVENANCE: Unknown

LITERATURE: De Ricci 1937, p. 1709, A.37 (as early 15th century, probably written in Venice)

This leaf, published by De Ricci together with pages 35b and 35d as from a single choir book, is the missing folio 49 of the Lehman Hymnal.

35d
Glorification of Saint Dominic in an Initial G

Leaf from Lehman Hymnal

Tempera and gold leaf on parchment. Leaf: 22½ × 16 in. (57 × 40.7 cm). Initial: 9½ × 7 in. (24 × 17.8 cm). Stave: 4.5 cm

Recto: testas atq[ue] iubilatio in/ unitate cui manet impe/riu[m]. Extu[n]c [et] modo p[er] eter/na secula Am[en]. [rubr.] *In lau/dibus/ymnus/ Et[er]na c[hrist]i. / r[rubr.] In festo Beati dominici/ pri[mus][1] n[ost]ri ad vesp[er]as Ymn[us].* Verso: Gau/de/ ma/ter ecclesia letam age[ns]/ memoria[m] q[uae] nove p[opu]lis (?)

On recto, in center top margin, in black ink: 75

PROVENANCE: Unknown

LITERATURE: De Ricci 1937, p. 1709, A.37 (as early 15th century, probably written in Venice)

This leaf, published by De Ricci together with pages 35a and 35b as from a single choir book, is the missing folio 75 of the Lehman Hymnal. Inside the initial G is Saint Dominic ascending a ladder to heaven, at the foot of which is a group of Dominican monks. The coat of arms in the lower border of this page, referring to the patron of the hymnal or the institution for which it was commissioned, remains unidentified.

1. Or *"pri[oris]."*

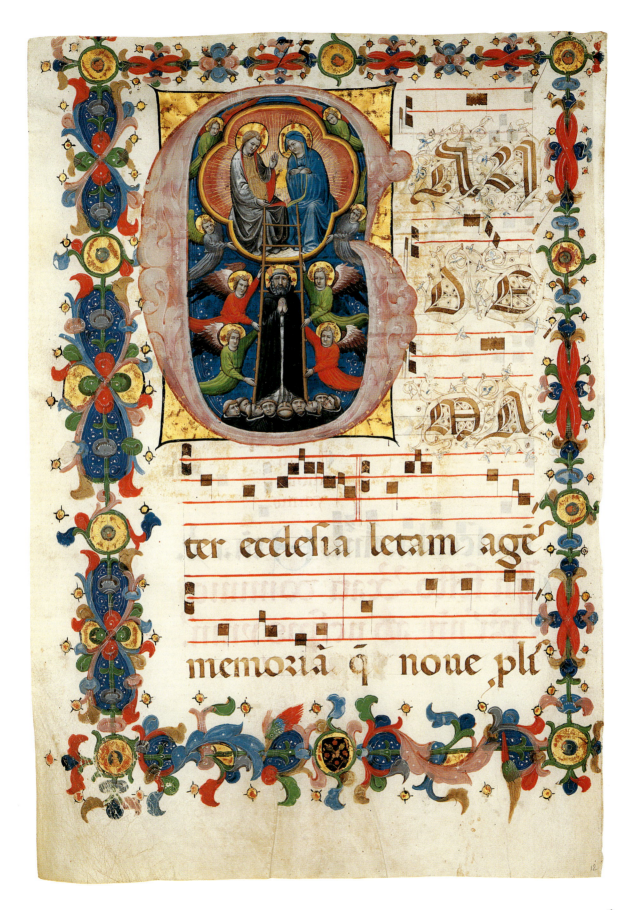

ter ecclesia letam age

memoria q̃ noue plr

Bologna or Veneto

Circa 1430–40

36

Investiture of Saint Clare in an Initial F (?)

Cutting from an antiphonary

Tempera and gold leaf on parchment. Cutting: 11 ⅜ × 9 in. (29 × 22.9 cm). Stave: 4.7–4.8 cm

Verso: e tonso coram/ ri domine nu/ [e]terno sponso [rub.]*ps.*

PROVENANCE: Canessa, Paris, 1923
LITERATURE: Comstock 1927, p. 52 (illustration), p. 57 (as Umbrian); De Ricci 1937, p. 1710, D.27 (as Umbria, ca. 1420)

This cutting is one of two fragments, identical in style and border decoration, that were acquired by Robert Lehman as a pair and were probably excised from the same antiphonary volume or series. The second cutting, the present location of which is unknown (Appendix, no. 7), shows the *Nativity in an Initial H* (fig. 10), possibly illustrating the first response of the first nocturn ("Hodie nobis caelorum" [Unto us this day from the

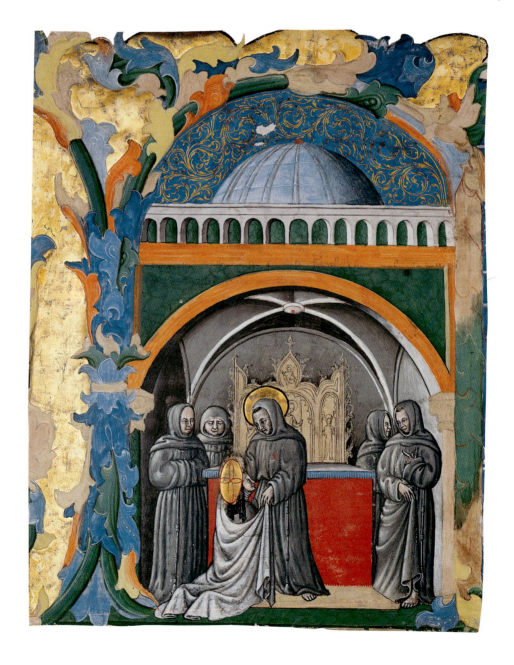

heavens]) for Christmas Day (December 25). A Franciscan provenance is suggested by the representation in the present miniature of the investiture of Saint Clare with the habit of the Franciscan order.[1] The episode takes place in front of an altar in a monumental church interior, with Saint Clare kneeling before Saint Francis, shown with the wounds of the stigmata on his chest. Witnessing the event are four Franciscan brothers, dressed, like Francis, in the hooded gray habit with a knotted cord typical of the order.

Although these miniatures were catalogued by Helen Comstock and De Ricci as Umbrian, both their style and decoration reflect late Gothic painting and manuscript production in the Veneto and in Bologna. A Bolognese context is suggested by the exuberantly articulated, thick foliage of the initials, painted in a brilliant palette of greens, blues, and reds, and by the filigree decoration set against a blue background. Similar decorative elements, ultimately rooted in a tradition going back to Niccolò da Bologna, are found in the work of some of the dominant artistic personalities active in Bologna in the first decades of the fifteenth century, such as the so-called Master of the Orsini Missal and the Master of the Servi Missal (Medica 1992).

The figural style and execution of the Lehman miniatures, on the other hand, have little in common with the incisive, expressive vocabulary—influenced by the work of Giovanni da Modena—of these Bolognese illuminators. The present works reflect, instead, compositional and formal elements derived from the production of those painters active in the Veneto in the wake of Gentile da Fabriano, such as Zanino di Pietro (act. 1389–1448) and Niccolò di Pietro (doc. 1394–1427). Zanino's 1429 *Madonna and Child* in the Museo di Palazzo Venezia, Rome, in particular, provides a direct source for the plump, softly modeled types, with rounded heads and heavy-lidded eyes, that figure most prominently in the *Nativity* miniature. The composition of the *Investiture of Saint Clare in an Initial F,* in turn, may be directly inspired by a work such as the predella scene with *Saint Benedict Exorcising a Monk,* in the Uffizi, Florence, recently attributed to Niccolò di Pietro, after a design by Gentile (De Marchi 1992, p. 103). Gentile's Venetian production may also be the source for the unusual gold stippling of the Virgin's

mantle in the *Nativity* miniature, possibly in imitation of the dotted, punched decoration used by Gentile in paintings such as the *Virgin and Child* in the Philbrook Museum of Art, Tulsa.

No other miniatures by the hand that executed the Lehman fragments are known. A superficial resemblance may be found in a cutting with the *Funeral of Saint Francis* in the Museo Civico Amedeo Lia (inv. no. 510), which also reveals a combination of Bolognese and Venetian elements and is attributed by Filippo Todini (1996, pp. 148–49) to a Bolognese artist influenced by the Venetian works of Cristoforo Cortese. Although datable to the same moment as the Lehman initials and characterized by similar decorative elements, this initial is nevertheless distinguished by a more meticulous execution and expressive figural style more clearly rooted in a Bolognese milieu.[2]

1. I have not been able to determine what text is illustrated by the investiture scene.
2. The possibility of a common Franciscan provenance for the three fragments, despite their differences in execution, is to be excluded by virtue of the fact that in the Lia initial the Franciscan habit is painted the more traditional brown color instead of gray.

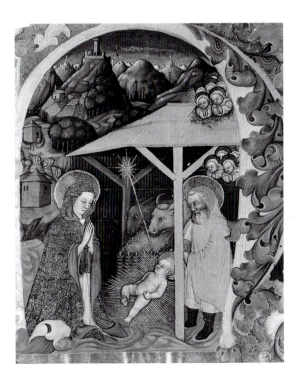

Fig. 10 Bologna or Veneto, *Nativity in an Initial H.* Location unknown

Cristoforo Cortese

Venetian, active circa 1390–d. before 1445

37a
Resurrection in an Initial A

Circa 1401–7
Cutting from an antiphonary

Tempera and gold leaf on parchment. Cutting: 7¾ × 6⅝ in. (19.8 × 16.8 cm). Initial: 6 × 6 in. (15.7 × 15.7 cm). Stave: 3.9–4 cm

Verso not visible (cutting glued on board)

PROVENANCE: Convent of Corpus Domini, Venice; Madame Fould (sale, Galerie Georges Petit, Paris, December 26, 1926, lot 40)
LITERATURE: De Ricci 1937, p. 1707, C.11 (as Venice or Ferrara, late 14th century)

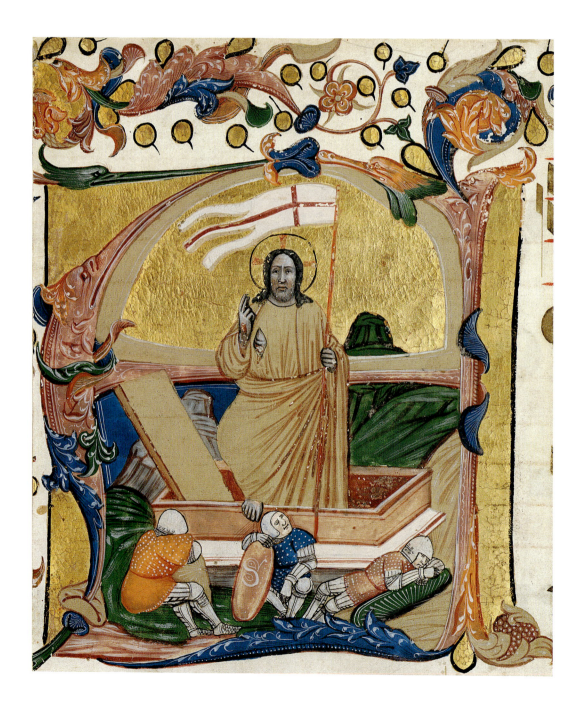

37b
Angel with Portative Organ

Fragment from a decorative border
New York, The Metropolitan Museum of Art, Robert Lehman
Collection, 1975 (1975.1.2465a)

Tempera and gold leaf on parchment. Cutting: 2⅜ × 1¾ in. (6.1 ×
4.4 cm, with border); 1⅞ × 1 in. (4.9 × 2.4 cm, without border)

Blank verso

PROVENANCE: Convent of Corpus Domini, Venice
LITERATURE: Palladino 1997a, cat. no. 23, pp. 173–74 (as Veronese-
Paduan Artist, ca. 1400–1410); Freuler 2001 (as Cristoforo Cortese,
ca. 1401–5)

37c
Angel with Harp

Fragment from a decorative border
New York, The Metropolitan Museum of Art, Robert Lehman
Collection, 1975 (1975.2465b)

Tempera and gold leaf on parchment. Cutting: 2⅜ × 1¾ in. (6.1 ×
4.5 cm, with border); 1⅞ × 1 in. (4.9 × 2.4 cm, without border)

Blank verso

PROVENANCE: Convent of Corpus Domini, Venice
LITERATURE: Palladino 1997a, cat. no. 23, pp. 173–74 (as Veronese-
Paduan artist, ca. 1401–7); Freuler 2001 (as Cristoforo Cortese,
ca. 1401–5)

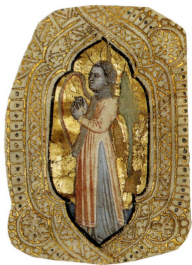

Previously published (Palladino 1997a) as products of a
Veronese-Paduan artist, the two Lehman angels were
recently associated by Gaudenz Freuler (2001, p. 72)
with the gold filigree border of a fragmentary antiph-
onary leaf showing *Christ Enthroned and David Playing
the Psaltery in an Initial B* in a private collection (*Les
Enluminures* 2001, no. 29).[1] This miniature (fig. 11) and
a second fragment in the same private collection, with
*Christ before a Group of Kneeling Worshipers in an Initial
D* (*Les Enluminures* 2001, no. 30, pp. 74–75), were
identified by Freuler as the earliest known works of
Cristoforo Cortese, the most famous and prolific
Venetian illuminator of the first half of the fifteenth
century. Based on the presence of a Dominican nun at
the feet of King David in the initial B, all four cuttings
were convincingly related by the same author to a

missing antiphonary commissioned in 1401 for the
newly founded Dominican convent of Corpus Domini,
Venice. The worshipers in the initial D were identified
by Freuler as the patrons of the Church of Corpus
Domini, their novice daughters, and its foundress and
first prioress.

The Lehman *Resurrection,* previously associated by
De Ricci with Venice or Ferrara, but virtually identical
in style, execution, and palette to the two cuttings pub-
lished by Freuler, may be identified as another fragment
in the Corpus Domini series decorated by Cortese. The
initial A, which illustrates the first response ("Angelus
Domini descendit" [An Angel of the Lord came down])
of the Easter nocturn, was probably inserted in the
temporale of a multivolume antiphonary set.

In addition to the Lehman fragments and the two

11 12 13

Fig. 11 Cristoforo Cortese, *Christ Enthroned and David Playing the Psaltery in an Initial B.* Private collection

Fig. 12 Cristoforo Cortese, *Vestiture of a Princess-Saint in an Initial T.* Free Library, Philadelphia, M25:27

Fig. 13 Cristoforo Cortese, *Saint Dominic* and the *Translation of Saint Peter Martyr (?) in an Initial F.* Free Library, Philadelphia, M45:11

Fig. 14 Cristoforo Cortese, *Finding of the True Cross in an Initial O.* Free Library, Philadelphia, M25:28

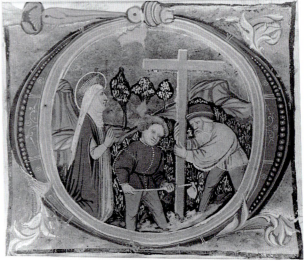

14

private collection miniatures, three other cuttings variously attributed to Cortese or to his workshop may be associated with the same Corpus Domini series: an initial M with the *Annunciation* in the Martello Collection, Florence (Parenti 1992, pp. 48–50);[2] and two cuttings, an initial D with *Saint Agatha Enthroned* and a fragment with *Christ in Prayer,* both recently on the art market in London (Sotheby's, June 20, 1995, lot 31; Christie's, June 3, 1998, lot 9). To these may be added eight more fragments dispersed among various collections or on the art market, which have been previously listed as fourteenth-century Bolognese, in the style of Niccolò da Bologna, or as fourteenth-century Venetian.

These miniatures are in fact also by Cortese and related to the Corpus Domini series. Four fragments are in the Free Library, Philadelphia: an initial T with the vestiture of an unidentified princess-saint (M25:27);[3] an initial O with the *Finding of the True Cross* (M25:28); an initial F with *Saint Dominic* and the *Translation of Saint Peter Martyr (?)* (M45:11) (figs. 12–14); and an initial M with Saint Dominic surrounded by kneeling Dominican nuns (M26:33). Four more cuttings (present locations unknown) appeared in the same sales as the Lehman and Free Library miniatures: an initial S with the *Conversion of Saint Paul* (Mme Fould sale, 1926, lot 57; ex-Mortimer Brandt Collection[4]); an initial V with

the *Death of the Virgin* (George de Grey Collection, sale, Sotheby's, London, April 29, 1927, lot 712; Sotheby's, London, November 26, 1985, lot 17); an initial L with the *Martyrdom of Saint Lawrence* (George de Grey Collection, sale, 1927, lot 733); and an initial S with the *Calling of Saints Peter and Andrew* (George de Grey Collection, sale, 1927, lot 735).[5]

The illuminations for the Corpus Domini choir books, as noted by Freuler *(loc. cit.),* must be counted among Cristoforo Cortese's earliest known production, in the first decade of the fourteenth century. In both figural style and foliate borders they compare closely to the miniatures by Cortese in a register of possessions of the Monastery of San Mattia of Murano, in the Seminario Patriarcale, Venice (MS Busta 956), datable to around 1407, and to those in two other manuscripts of about the same time, a copy of Petrarch's *Uomini Famosi* in the Pierpont Morgan Library, New York (MS G.36), and a volume of the *Life of Saint Catherine of Siena* and other Dominican tracts in the Bodleian Library, Oxford (MS Canon. Misc. 205), also illuminated for the Dominicans of Venice. These works, first attributed to the artist by Carl Huter (1980, p. 13), followed by Giordana Mariani Canova (1989, p. 204; 1993), reflect Cortese's roots in late-fourteenth-century manuscript production in Bologna and the Veneto, as well as his debt to the decorative vocabulary introduced into Venice by the Florentine illuminators associated with the Camaldolese scriptorium of Santa Maria degli Angeli. Freuler has pointed out that in 1401 the nuns of Corpus Domini were advised to base their newly projected series of choir books on those in the Camaldolese monastery of San Michele, Murano, which possessed a celebrated series of choir books decorated in Florence by Don Silvestro dei Gherarducci. Among these may have been a psalter illuminated in Florence by Don Simone Camaldolese and Don Silvestro, now in the Museo Correr, Venice (MS CL. V.129), since Cortese's initial B with *King David* in a private collection is an exact copy of the same letter illuminated by Don Simone in that book.[6]

1. This cutting was at one point in the possession of Pierre Berès, Paris (*Livres et Manuscrits*, cat. 57, no. 31, as fourteenth-century, North Italian school).
2. This fragment was also included in the Mme Fould sale (lot 50).

3. This unusual representation might relate to a legend surrounding the foundation of the Convent of Corpus Domini, with the initial T introducing the response ("Terribilis est") for the Feast of the Dedication of the Church.
4. Illustrated in Bober 1970, pp. 42–43.
5. Also included in the George de Grey sale were three of the four Free Library cuttings: M45:11 (lot 715); M25:28 (lot 717); M25:27 (lot 721). Except for the Free Library initial T, possibly excised from a commons, all of the above fragments were probably excised from a sanctorale. Other cuttings in the George de Grey sale, primarily derived from a temporale and commons, might have been part of the same series, but in the absence of reproductions they have been omitted from the present list. Another possible fragment from a commons in the same series may be an initial B with a martyr saint, whose face appears heavily repainted, that was sold at Sotheby's, London, on December 5, 1989 (lot 40). This miniature could have illustrated the response ("Beatus vir") for the Common of One Martyr in Paschaltide.
6. First attributed to Don Simone by Mirella Levi D'Ancona, the initial in the Museo Correr psalter was subsequently given to Don Silvestro by Freuler (1997, pp. 515–21). Levi D'Ancona's original attribution was reiterated by the present author in a review of Freuler's study (Palladino 1999, p. 290).

Cristoforo Cortese

38
Saint Mark the Evangelist and Saint Sinibaldus Venerated by Members of a Lay Confraternity

Circa 1425–34
Leaf from a *mariegola*
New York, The Metropolitan Museum of Art, Robert Lehman Collection, 1975 *(1975.1.2468)*

Tempera and gold leaf on parchment. Leaf: 11 3/8 × 8 1/4 in. (29 × 21.1 cm). Miniature: 8 1/2 × 5 3/4 in. (21.6 × 14.6 cm)

Blank verso

PROVENANCE: Kalebdjian, Paris, 1924
LITERATURE: Levi D'Ancona, Palladino, Saffiotti 1997, pp. 177–80 (with previous bibliography, as Cristoforo Cortese, ca. 1425–34)

This leaf was one of the opening pages of a *mariegola,* the register of a Venetian lay confraternity, or *scuola,* whose members are shown kneeling at the feet of the two standing saints. On the left is Saint Mark, patron

38

saint of Venice, who is often included in *mariegola* decorations. On the right is Saint Sinibaldus, patron saint of Nuremberg, depicted with his characteristic attribute of the pilgrim's staff and a model of the church dedicated to him in Nuremberg.

This fragment was first attributed to Cristoforo Cortese by Mirella Levi D'Ancona (Robert Lehman Collection files, 1986), who convincingly compared it in both style and execution to a miniature of the *Virgin of Mercy* from the *capitolare* of the Scuola della Santissima Trinità dei Frati Teutonici in the Wildenstein Collection, Paris (Musée Marmottan, no. 78). With respect to the more controlled execution of the previous series of cuttings (cat. nos. 37 a–c), both these works reflect the looser calligraphic idiom that is the hallmark of Cortese's mature production. The Wildenstein cutting

has been generally dated to about or after 1422, the year recorded in the text on its verso. Accordingly, Levi D'Ancona (Robert Lehman Collection files) suggested a date between 1425 and 1430 for the closely related Lehman miniature.

Based on the identification of the saint next to Mark, previously thought to be Petronius, as Sinibaldus, Pia Palladino (D'Ancona, Palladino, Saffiotti 1997) proposed associating the Lehman fragment with a German *scuola* dedicated to him in Venice. The headquarters of such a confraternity may have been located in the Church of San Bartolomeo, the official German church in Venice, which had an altar dedicated to Saint Sinibaldus in 1434. This could indicate a date for the Lehman miniature between 1425, the year of canonization of Sinibaldus, and 1434.

Cristoforo Cortese

39
Prophet in an Initial V

Circa 1430–35
Leaf from an antiphonary

Tempera and gold leaf on parchment. Leaf: 19 × 13 ¾ in. (48.1 × 34.9 cm). Initial: 3 ⅝ × 3 ½ in. (9.2 × 9 cm). Stave: 2.3–2.4 cm

Recto: estote quomodo salvi facti sunt patres nostri et/ nunc clamemus in celum et miserebit[ur] nostri deus/ noster. Euouae. [rubr.]*a.*Congregate sunt gentes in/ multitudine ut dimicent [con]tra nos et ignoramus/ quid agere debeamus domine deus ad te sunt occu/li nostri adiuva nos ut non pereamus. Euoue. [rubr.] *a./*Iudas machabeus et ionathas frater eius tran. Verso: sieru[n]t iordane[m] via[m] trium dier[um] per des[er]tum./ euouae. [rubr.] *Sab.:ante/ Dom:prim./ Novembris.* Vidi dominu[m] sedente[m] sup[ra] so/liu[m] excelsu[m], et plena erat omnis terra maiestate eius/ et ea que sub ipso era[n]t repleba[n]t templu[m]. Euouae. [rubr.] *R[esponsu]m./*Vidi dominu[m] sedente[m] sup[ra] soliu[m] ex/celsu[m] et elevatu[m] et plena e/rat omnis terra maiestate eius. Et ea que. On recto, in lower right margin, in red ink: cxxxxvi.

PROVENANCE: Unknown
LITERATURE: Unpublished

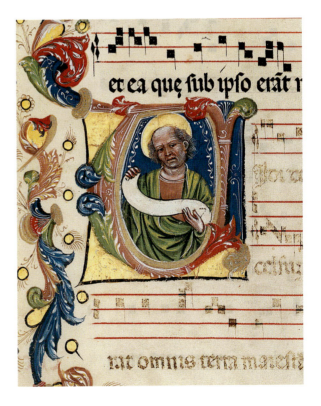

This leaf was excised from an unidentified antiphonary. As stated in the rubric preceding it, the initial V with a prophet illustrates the antiphon ("Vidi dominum" [I saw the Lord]) for the Saturday before the first Sunday of November.

The decoration of this hitherto unpublished miniature reflects Cristoforo Cortese's production at a slightly later phase of his activity than the Lehman *mariegola* (cat. no. 38). The lively foliate border and quicker, more expressive calligraphic idiom most closely approach the works executed by the artist in the fourth decade of the fifteenth century, such as the miniatures in a two-volume gradual from the Certosa of Sant'Andrea al Lido in the Biblioteca Marciana, Venice (MS Lat.III., 18=2283–2284), first published by Giordana Mariani Canova (1970), with a date of between 1430 and 1435. Also closely related to the Lehman leaf and datable to the same period are four cuttings in the Galleria Estense, Modena (inv. nos. 2284–2287; Ferretti 1985); and a series of ten fragments in the Bodleian Library, Oxford (MS Douce a.1).

Cristoforo Cortese

40
Bearded Saint in an Initial C

Circa 1435–40
Cutting from a gradual (?)
New Haven, Yale University Art Gallery, 1957.42

Tempera and gold leaf on parchment. Cutting: 4½ × 5⁹⁄₁₆ in. (11.4 × 14.1 cm). Stave: 5 cm

Verso: te ora

PROVENANCE: Unknown; gift of Robert Lehman to Yale University, 1957
LITERATURE: Seymour 1970, p. 137, no. 94 (as Florentine school, early 15th century)

This cutting may be included among the works generally associated with the last phase of Cristoforo Cortese's activity, toward the end of the fourth decade of the fifteenth century. The broadly defined forms and heavily marked features, as well as the increasingly fluid line, closely recall the choir book fragments in the Library of Santa Giustina, Padua (MS inv. gov. 11), first published by Giordana Mariani Canova (1970) with a date of between 1435 and 1440. The correspondence of details such as the punched decoration and white outline of the halos between the Yale fragment and the Santa Giustina miniatures, as well as their stylistic uniformity, suggests that they may have been part of the same series.

Circle of Leonardo Bellini (?)

Venetian, circa 1476

41
Portrait of Virgil in an Initial V

Leaf from Vergilius Maro, *Opera*

Tempera and gold leaf on parchment. Leaf: 11 × 17 in. (27.8 × 17.7 cm). Initial: 1¹³⁄₁₆ × 1⅝ in. (4.6 × 4.1 cm)

Pasted to back of leaf is a sixteenth-century sheet of lined paper, with the following handwritten text, in black ink: Nel nome di Dio. 1575 ad di . . . [a]gosto in giorno/ di Lunedi a hore sedici . . . del Corpo/ di Madonna Christina mia Consorte che fu il glorioso/ giorno dell'Assontione della Vergine Maria nostra/ amorevolissima Avocata. Et a di 19 detto fu battezata in Chiesa di/ Santo Giuliano per il Rev[eren]do M[esser] Thomaso Dig[nissi]mo Piovano di Santo Giuliano./ Et per Compadri si tolsero. Il Mag[nifi]co M[esser] Giulio Ziliolo, et M[esser] Zuanbattista/ Brambilla. Che Iddio per sua bontà mantenga. Et li furò posti li nomi/ Maria et Isabetta. IHS a di 20 Zugno 1576 fu Chrismata d[al]/ Rev[erendissi]mo Giovanni Trivisano Dignissimo Patriarcha di Venetia. Essen[do]/ stata tenuta alla Chrisma dal Mag[nifi]co M[esser] Marco Grilo, et

Madonna/ Anzola Consorte di M[esser] Thomaso de gli Artesini gli lavò la Cresima./ Nel nome di Dio 1579 a di 16 Decembrio./ In giorno di Mercore à hore quatordeci Nacque uno fantolino/ del Corpo di Madonna Franceschina mia consorte di/ secondo Matrimonio. Et fu battezato, et postogli nome/ Zuandomenego per il Rev[eren]do M[esser] Pre Gasparo prete Titolato di Santo/ Giuliano, et furono suoi santoli il Mag[nifi]co M[esser] Piero Contarini Nodaro/ et M[esser] Hieronimo Meno, et M[esser] Simon de Cecha. Et fu a di 20./ detto. IHS. A di 2 Zugno 1581 fu Chrismato dal Rev[erendissi]mo et Ill[ustrissi]mo/ Vescovo di Trau in Chiesa di S[an]to Hyeremia. Essendo stato tenuto/ alla Chrisma da M[esser] Bernardo Savioni, et Madonna Lucidaria/ consorte di M[esser] Pasqualin Moretti gli lavo la cresima./ Io Giovanbattista di Vidali Bresciano Padre delli soprascritti/ figliuoli scrise, essendo in contra di San Thomao, a di 20/ di Aprile 1586.

PROVENANCE: Bruscoli, Florence (?)

LITERATURE: De Ricci 1937, p. 1714, A.34 (as Venice, 1476)

This leaf was originally the frontispiece of a lost, printed compilation of Virgil's works. It was first associated by De Ricci with a fragmentary copy of the same edition, dated 1476 and printed in Venice by Antonio di Bartolomeo da Bologna, in the British Library, London (c.19.e.14). De Ricci tentatively suggested that the Lehman page could be one of the missing leaves of the

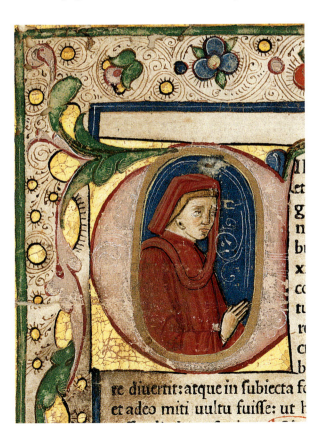

British Library copy. The latter, however, preserves its original frontispiece, the decoration of which, characterized by graceful putti and elegant, classically inspired architectural motifs, has been attributed to the anonymous Venetian miniaturist known as Master of the London Pliny (Armstrong 1994, pp. 182–83). The Lehman leaf, which reflects a more traditional decorative approach, with floriated borders and a simple historiated initial enclosing the portrait of Virgil, may be compared instead to the production of Leonardo Bellini, cousin of the better-known Venetian painters Giovanni and Gentile Bellini and the dominant miniaturist in Venice between about 1460 and 1480.

Leonardo Bellini's vocabulary combines figural and compositional elements derived from the paintings of his uncle Jacopo Bellini (in whose studio he was raised) with a decorative style derived from contemporary Ferrarese manuscript illumination. Typical of Leonardo's production is the flower-and-filigree border surrounding the Lehman frontispiece, as well as the bright palette and general figural style, which recalls the portraits attributed to the artist in a manuscript of Lactantius in the Biblioteca Marciana, Venice (MS Lat. II, 75=2198; Mariani Canova 1969, pp. 142–43). At the same time, however, the subtleties of modeling that normally characterize Leonardo's figures are missing from the Lehman leaf. If not the result of its present, abraded condition and the losses of pigment in the head of Virgil, the more modest quality of execution of the Lehman fragment would seem to suggest the hand of a follower of Leonardo or artist in his circle.

Nothing is known of the original provenance of the Lehman leaf. Glued to the verso is a sixteenth-century sheet of paper on which a certain Giovanni Vidali of Brescia, resident of the parish of San Tomà, Venice, recorded, in 1586, the birth of his two children: a daughter, born in 1575 and christened by the patriarch of Venice, Giovanni Trevisano; and a son, born in 1579 and christened by the bishop of Trau. In the lower border of the frontispiece is a later, possibly eighteenth-century, seal mark, showing *Saint Margaret and the Dragon,* perhaps that of the Church of Saint Margaret, Venice.

The Choir Books of Cardinal Bessarion

The following seven cuttings are fragments of a famous series of choir books commissioned by the Greek cardinal Bessarion (ca. 1399/1408–1472), one of the most prestigious and influential church personalities of the fifteenth century during his years as papal legate in Bologna between 1450 and 1455. The series was originally intended as a gift to the Franciscan convent of Saint Anthony of Padua, Constantinople, but as a result of the fall of this city to the Turks in 1453, it did not leave Italy and was eventually bequeathed to the Franciscan church of Santa Maria Annunziata dell'Osservanza, Cesena, founded in 1460 by Novello Malatesta. Following the Napoleonic suppression of this convent in the nineteenth century, most of the choir books in the Bessarion series, which may have included as many as twenty volumes, were dispersed and individual leaves sold to collectors. Of the fifteen volumes listed in 1812 in a partial inventory of the convent's library, seven, all bearing Bessarion's coat of arms, survive in the Biblioteca Malatestiana, Cesena (MSS Bessarion 1–7). To these may be added numerous illuminated fragments in private and public collections, many of which were identified by Giordana Mariani Canova (1978b) in a first attempt to reconstruct the entire series.

The decoration of the Bessarion choir books was probably begun around 1452 or 1455, the dates recorded in two of the Malatestiana volumes (MSS Bessarion 5, 6) and carried out over a number of years. The commission was entrusted to a team of Lombard and Emilian illuminators, whose work reflects late Gothic manuscript production in Lombardy and the Veneto, as well as the more advanced, early Renaissance vocabulary of painters and illuminators active at the Este court in Ferrara. At least one of the six hands involved in the series, and that of the author of the Lehman frontispiece (cat. no. 43, fig. 15), may be identified with Franco dei Russi, who was engaged between 1455 and 1460 in the decoration of the celebrated Bible of Borso d'Este. The extent to which Bessarion's project may also have involved the direct participation of Borso d'Este, whose coat of arms appears on two frontispieces generally associated with the series (ex-John Murray Collection, Florence; Cini Collection, Venice, 2124), remains to be ascertained. Iconographic and stylistic evidence, as well as the fact that the Malatesta arms do not appear in any of the surviving volumes or cuttings, suggests that the series was completed in a Ferrarese scriptorium, before entering the Osservanza in Cesena.[1]

Based on the description of the fifteen volumes in the 1812 inventory (Mariani Canova 1978b, pp. 13–14), the original content of the Bessarion series may be partially reconstructed as follows:

Gradual in four volumes

Vol. I. Temporale, Advent to Saturday before
Passion Sunday
Cesena, Bibl. Mal., MS Bess. 2

Vol. II. Temporale, Passion Sunday to Vigil
of Ascension
Cesena, Bibl. Mal., MS Bess. 5 (dated 1452)[2]

Vol. III. Temporale, Ascension to twenty-fourth
Sunday after Pentecost
Cesena, Bibl. Mal., MS Bess. 1

Vol. IV. Sanctorale, Vigil of Feast of Saint Andrew
(November 29) to Feast of Saint Joachim (December 9)
Cat. nos. 42a–c

Antiphonary in nine volumes

Vol. I. Temporale, Saturday before Advent to first
Sunday of Lent[3]
Cat. no. 43

Vol. II. Temporale, second Sunday of Lent to Easter Vigil
Cat. no. 44

Vol. III. Temporale, Easter Sunday to Corpus Domini
Cesena, Bibl. Mal., MS Bess. 3[4]

Vol. IV. Temporale, Pentecost to Advent
Frontispiece: Venice, Cini Collection, 2096, *David with God the
Father in an Initial L*

Vol. V. Sanctorale, Common of Apostles and Propers,
Feast of Saint Andrew (November 30)–(?)
Frontispiece: Venice, Cini Collection, 2122, *Trial of the Apostles
in an Initial T* and *Stigmatization of Saint Francis*

Vol. VI. Sanctorale, Common of Martyrs and Propers,
Feast of Saint Mark (April 25) to Feast of Saint
Lawrence (August 10)
Cesena, Bibl. Mal., MS Bess. 6 (dated 1455)[5]

Vol. VII. Sanctorale, Vigil of the Assumption (August 14)
to Feast of Saint Clement (November 23)
Cesena, Bibl. Mal., MS Bess. 4

Vol. VIII. Sanctorale, Franciscan Saints
Cat. nos. 45a–b

Vol. IX. Sanctorale, Commons
Ex-Hoepli Collection (sale, London, Christie's November 20,
2002, lot 27).
Milan, Biblioteca Ambrosiana, F277 inf. n. 11, *Resurrected Christ
in an Initial D (?)*

Opposite
Fig. 15 Franco dei Russi, *Bas de page with Coat of Arms of Cardinal
Bessarion* (detail of cat. no. 43)

Hymnal

October to First Sunday of Quaresima
Frontispiece: Venice, Cini Collection, 2124, *God the Father in
an Initial P*
Folio 3: Philadelphia, Free Library, M70:3, *King David in an
Initial B*

In addition to these fourteen volumes, the series may
also have included a gradual with the Commons of
Saints and two additional hymnals covering the rest of
the liturgical year, although these do not appear on the
inventory and no pages or fragments associated with
them have yet been identified. It is equally uncertain
whether a Franciscan psalter executed for Cardinal
Bessarion in the Vatican Library, Rome (Barb. Lat. 585),
was part of the series, as suggested by Mariani Canova
(1978b, p. 16), or part of a different commission datable
to the same period (Manfredi 1995, pp. 136–41).

1. For the suggestion that the series was a gift of Bessarion to the
 wife of Novello Malatesta, Violante, who shared the cardinal's
 devotion to the Franciscans, see Lollini 1989, pp. 23–24.
2. Presently missing from this volume is folio 121, covering Good
 Friday.
3. The 1812 inventory lists five volumes of an "Antifonario feriale."
 The contents of the last three of these (inv. nos. 9, 10, and 11)
 are continuous, covering the liturgical year from the second
 Sunday of Lent through the twenty-fourth Sunday after Pente-
 cost. The first volume (inv. no. 7) is described as beginning with
 the Saturday before Advent and ending with the Christmas
 Vigil; and the second volume (inv. no. 8) is described as run-
 ning from the Christmas Vigil through the Octave of Epiphany.
 It will be shown elsewhere (Palladino, forthcoming) that this
 second volume, now Biblioteca Malatestiana, Cesena, Bessarion 7,
 which contains no historiated initials, is an apocryphal addition
 to the series, and that the temporale was complete in four not
 five volumes, the first of which (see cat. no. 43) probably con-
 tained all the missing offices for Advent through the first
 Sunday in Lent.
4. Presently missing from this volume are folio 59 (second Sunday
 after Easter) and folio 160 (Corpus Domini).
5. Presently missing from this volume is folio 112 (Vigil of Saint
 Lawrence).

Third Bessarion Master

Lombard, active middle of the fifteenth century

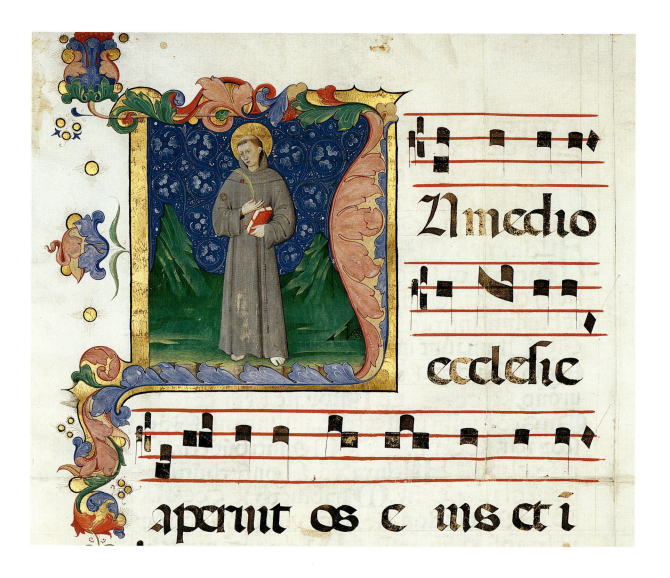

42a

Saint Anthony of Padua in an Initial I

Circa 1455–60
Leaf from a gradual

Tempera and gold leaf on parchment. Leaf: 22 ¼ × 16 in. (56.5 × 40.5 cm). Initial: 6 ⅜ × 5 ½ in. (16 × 14.6 cm). Stave: 3.9 cm

Recto: [rubr.] . . . *In s[an]c[t]i urbani p[ontifex et] m[arti]ris.*
Introitus . . . / In s[an]c[t]or[um] m[arti]ri marcellini pet[r]i/ et
herasmi Introitus . . . / In s[an]c[t]or[um] m[arti]ri p[ri]mi et feliciani
Introitus . . . / In s[an]c[t]i Bar/nabe Ap[osto]li Off[iciu]m misse . . . /
. . . In s[an]c[t]or[um] m[arti]ri Basi/lidis. Cirini. Naboris et Nazarii

Introitus . . . / In festo b[ea]ti Antonii [con]fe[ssore]./ De ordi[n]e
minoru[m] fr[atr]um./ Int[r]oitus. Verso: *In medio/ ecclesie/ aperuit*
os eius et i[n]/plevit eum dominus/ spiritu sapientie [et] in

On recto, in center right margin, in red ink: xlvi

PROVENANCE: Kalebdjian, Paris, 1924
LITERATURE: De Ricci 1937, p. 1709, A26 (as early 15th century, written in northern Italy); Mariani Canova 1978a, p. 32, n. 4 (as Lombard, first to second half of the 15th century); Mariani Canova 1978b, p. 17, fig. 17 (as Third Bessarion Master, ca. 1450–55); Lollini 1989, pp. 104–5 (as Third Bessarion Master); Melograni 1994, p. 295 (as Third Bessarion Master); Lollini 1998a, p. 324 (as Third Bessarion Master)

42b

Saint Clare in an Initial O

Circa 1455–60
Leaf from a gradual
Oberlin, Allen Memorial Art Museum, 43.15

Tempera and gold leaf on parchment. Leaf: 22 ⅜ × 16 in. (56.8 × 40.7 cm). Stave: 3.9 cm

Recto: O vir/ginale lilium et/ paupertatis specu/ lum Clara [con]te[m]p[latio]nes se/ culu[m] viam. Verso: secuta christi/ ora spretis/ divitiis hic nos/ sivi delitiis

On recto, in center right margin, in red ink: lxxv

PROVENANCE: Kalebdjian, Paris, 1924; Gift of Robert Lehman to Oberlin College, 1943
LITERATURE: De Ricci 1937, p. 1709, A15 (as early 15th century, written in northern Italy); Mariani Canova 1978a, p. 32, n. 4 (as Lombard, first to second half of the 15th century); Mariani Canova 1978b, p. 17 (as Third Bessarion Master, ca. 1450–55); Lollini 1989, pp. 104–5 (as Third Bessarion Master); Melograni 1994, pp. 295, 302, n. 77, fig. 21 (as Third Bessarion Master); Hamburger 1995, no. 30, pp. 30–31 (as Italian, 15th century); Lollini 1998, p. 324 (as Third Bessarion Master)

42c

Saint Francis Receiving the Stigmata in an Initial G

Circa 1455–60
Leaf from a gradual

Tempera and gold leaf on parchment. Leaf: 22 ½ × 16 in. (57.2 × 40.5 cm). Initial: 5 ¾ × 6 ½ in. (14.6 × 16.5 cm). Stave: 3.9 cm

Recto: cite om[n]es angeli/ domini dominu[m] ym[n]um/ dicite et super ex/altate eum in/ secula alle. Verso: luya.[rubr.] *In natale beat./ francisci con/fessoris. Introitus/* Gaude/amus/ omnes in domino/ diem festum celebrantes

On recto, in center right margin, in red ink: ciii

PROVENANCE: Kalebdjian, Paris, 1924
LITERATURE: De Ricci 1937, p. 1712, C.1 (as ca. 1460, written in northern Italy); Mariani Canova 1978a, p. 32 n. 4 (as Lombard, first to second half of the 15th century); Mariani Canova 1978b, p. 17, fig. 18 (as Third Bessarion Master, ca. 1450–55); Lollini 1989, pp. 104–5 (as Third Bessarion Master); Melograni 1994, p. 295; Lollini 1998, p. 324 (as Third Bessarion Master)

These three leaves are part of a group of ten surviving fragments from the missing sanctoral volume of a gradual included in the Bessarion series. Seven other fragments from this volume, which, according to the 1812 inventory, began with the Vigil of the Feast of Saint Andrew (November 29) and ended with the Feast of Saint Joachim (December 9),[1] are dispersed among various public and private collections. Together with the Lehman and Oberlin pages, to which they conform in style, stave height, and foliation, these leaves allow for a partial reconstruction of the original sanctorale, as follows:

1. Cleveland, Museum of Art, 43.386 (bifolium): *Calling of Saint Peter and Andrew in an Initial D* ("Dominus secus mare Galilei" [The Lord walking by the Sea of Galilee]). Introit for Vigil of Feast of Saint Andrew (November 29). Frontispiece with Bessarion coat of arms. [fol. 1]
2. Cat. no. 42a: *Saint Anthony of Padua in an Initial I* ("In medio ecclesie" [In the gathering of the

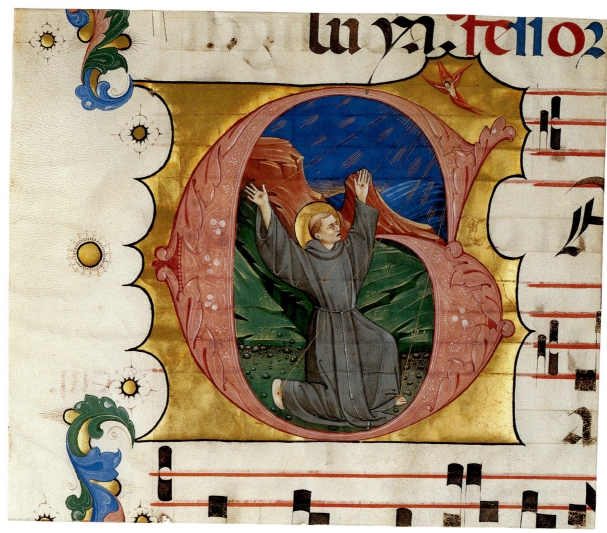

42c

Church]). Introit for Feast of Saint Anthony of Padua (June 13). [fol. 46]

3. Honolulu, Academy of Arts, 13.160 (bifolium): *Saint John the Baptist in an Initial D* ("De ventre matris meae" [Out of my mother's womb]). Introit for Feast of Nativity of Saint John the Baptist (June 24). [fol. 52]

4. Honolulu, Academy of Arts, 13.159 (bifolium): *Saints Peter and Paul in an Initial N* ("Nunc scio vere" [Now I know for certain]). Introit for Feast of Saints Peter and Paul (June 29). [fol. 59]

5. Oberlin 43.15: *Saint Clare in an Initial O* ("O virginale lilium" [O purest lily]). Introit (?) for Feast of Saint Clare (August 12). [fol. 75]

6. Cleveland, Museum of Art, 28.652: *Assumption of the Virgin in an Initial G* ("Gaudeamus omnes" [Let us all rejoice]). Introit for Feast of the Assumption (August 15)

7. Cleveland, James D. Ireland Collection (bifolium): *Virgin of Humility in an Initial S* ("Salve sancta parens" [Hail, Holy Mother]). Introit for Feast of the Birth of the Virgin (September 8). [fol. 85]

8. Private collection: *Saint Michael in an Initial B* ("Benedicite Dominum" [Bless the Lord]). Introit for Feast of Saint Michael (September 29)

9. Cat. no. 42c: *Saint Francis Receiving the Stigmata in an Initial G* ("Gaudeamus omnes" [Let us all rejoice]). Introit for Feast of Saint Francis (October 4).[2] [fol. 103]

10. Oberlin 40.96: *Saints and Martyrs in an Initial G* ("Gaudeamus omnes" [Let us all rejoice]). Introit for Feast of All Saints (November 1). [fol. 108][3]

The Cleveland frontispiece, showing the Bessarion arms in the lower border, was first associated with the gradual listed in the 1812 inventory by Giordana Mariani Canova (1978b, pp. 13, 17), who attributed it to an anonymous, late Gothic Lombard illuminator she christened "Third Bessarion Master." Mariani Canova identified the same artist as the author of the Lehman, Honolulu, and two remaining Cleveland fragments but divided these between two other volumes in the Bessarion series (see below, cat. nos. 45a–b). Subsequently, Anna Melograni (1994, pp. 293–95) recognized the Oberlin *All Saints* and the private collection *Saint Michael* as additional works by the Third Bessarion Master and correctly associated them with the same book as the Oberlin *Saint Clare* and Cleveland *Assumption.*

In addition to the present gradual, the Third Bessarion Master was involved in the decoration of three antiphonary volumes in the Bessarion series: vol. III of the temporale (Biblioteca Malatestiana, Cesena, Bessarion 3), which he illuminated with the so-called Master of the Franciscan Breviary (Mariani Canova 1978b, pp. 15, 17; Lollini 1998, pp. 324–25); vol. VIII of the sanctorale, showing the Este arms and illuminated with Franco dei Russi (cat. nos. 45a–b); and vol. XI of the sanctorale (ex-Hoepli Collection[4]). These works attest to the artist's prominent role in this commission, alongside Franco dei Russi, whose activity may be traced in at least six volumes of the series (see below, cat. no. 43).

The production of the Third Bessarion Master was placed by Mariani Canova (1978b, p. 14) within the milieu of late Gothic painting in Lombardy, around the middle of the fifteenth century, and viewed as representative of the artistic exchanges between Lombardy and Emilia during this period. More specifically, Fabrizio Lollini (1989, p. 26) located the master's activity in Bologna and dated his contribution to the Bessarion series to about 1451 or 1452, during the early years of the cardinal's posting in that city. A later dating, however, is suggested by the artist's spatial and formal concerns, which, as often noted, distinguish his style from the more typically decorative late Gothic vocabulary of Lombard illuminators such as Belbello da Pavia (cat. nos. 58a–d). The closest points of reference for the early Renaissance idiom of the Third Bessarion

Master's production may be found in a series of panels from the Church of San Silvestro, Mantua, now in the Museo Poldi Pezzoli, Milan, which are attributed to an anonymous Lombard painter and unanimously dated to around 1460 (Natale 1982, pp. 70–71). If not actually by the same hand that executed the miniatures, these works may provide evidence of the Third Bessarion Master's presence in Mantua, the same city from which Franco dei Russi originated. Beyond such stylistic evidence, a later date than the one thus far proposed for the Third Bessarion Master's illuminations is suggested by the presence of the Este arms in the volume decorated by him in collaboration with Franco. This would appear to indicate that the two artists were contemporaneously engaged in the decoration of the Bessarion choir books in Ferrara between about 1455 and 1460 (see below, cat. no. 43).

1. The Feast of Saint Joachim is presently celebrated on July 26. In the Eastern Church, however, where his cult was strongest, the celebration is recorded on various dates: September 9, July 25, and December 9 *(Acta Sanctorum. . . .).* Since the sequence of the foliation on the ten fragments discussed here implies that the sanctorale was complete in one volume, the reference to Saint Joachim is most likely to indicate a date for the celebration of his feast on December 9, according to the Eastern calendar—a circumstance probably resulting from the series' original destination for Constantinople.

2. For the interpretation of the word "natale" in the rubric "In natale beat. francisci," as a reference to the day of a saint's death (October 4 in the case of Saint Francis), see Carapelli 1988, p. 119. For another example of the Stigmatization used to illustrate the same text, introduced by the same rubric, see Perugia and other cities 1982, cat. no. 80, pp. 328–29.

3. The five fragments divided between Cleveland and Honolulu were formerly owned by Jacob Hirsch, who, in a letter to Robert Lehman dated December 16, 1931, wrote that they "came from a book I got many years ago in Bologna" (Robert Lehman Collection archives).

4. For a discussion of this volume, attributed to the Master of the Franciscan Breviary by Mariani Canova (1978b, p. 16) and Lollini (1989, pp. 105–6), but inserted among the Third Bessarion Master's oeuvre by Melograni (1994, p. 295), see Palladino, forthcoming. The manuscript was actually another collaborative effort between the two artists.

Franco dei Russi

Ferrarese, documented 1453–82

43
David Lifting up His Soul to God in an Initial E

Circa 1455–60/63
Frontispiece from an antiphonary

Tempera and gold leaf on parchment. Leaf: 28 × 20¼ in. (71.1 × 51.5 cm). Initial: 8 × 7½ in. (20.2 × 19 cm). Stave: 5 cm

Recto: [rubr.] *Ad honorem dei et beatissime virginis marie et sancti/ francisci. Incipit antiphonarium ordinis minoris/ fratrum. secundum consuetudine romane curie. Sabbato/ de adventu ad vesperas.* V. Rorate celi de super et nubes/ pluant iustus. Aperiatur terra et germinet salvatorem./[rubr.]*Ad/M./An./*Ecce no/men domini/ venit de longinquo/ et claritas eius replet. Verso: orbem terrarum [rubr.]*ps.* mag. [rubr.] *In/vit.* Regem venturum dominum/ Venite adore/mus [rubr.]*ps.*venite.[rubr.] *In primo noct./An./*Veniet ecce rex excel

On recto, in top right margin, in black ink: i
In lower border: Coat of arms of Cardinal Bessarion

PROVENANCE: John F. Murray, Florence, 1925
LITERATURE: De Ricci 1937, p. 1713, B.4 (as probably Venetian, ca. 1470); Mariani Canova 1973, p. 62, no. 54 (as part of the Bessarion series without attribution)

The present leaf, showing the coat of arms of Cardinal Bessarion in the lower border, was originally the frontispiece of the first volume of a four-part antiphonary temporale from the Bessarion series. This volume, already missing by the time of the 1812 inventory (which makes no reference to it), covered the temporal cycle from the Saturday before Advent to, possibly, the first Sunday of Lent. Two other fragments from the same book, identical to the Lehman page in style, overall dimension, stave height, and numeration, may be identified with the following miniatures in the Cini Collection, Venice: a leaf with the *Resurrected Christ in an Initial R* (2121), introducing the antiphon at lauds ("Rex pacificus" [The King of peace]) for the Christmas Vigil (December 24); and a leaf with the *Stoning of Saint Stephen in an Initial L* (2120), illustrating the antiphon at lauds ("Lapidaverunt Stephanum" [While they were stoning Stephen]) for the Feast of Saint Stephen (December 26; fig. 16).[1]

Based on the discovery of the word "FRANCHO" in an inscription along the borders of Saint Stephen's dalmatic, the two Cini fragments, previously listed as Ferrarese by Pietro Toesca, were first attributed by Giordana Mariani Canova (1978a, pp. 32–33) to the Mantuan illuminator Franco dei Russi, one of the principal artists engaged in the decoration of the Bible of Borso d'Este, completed between 1455 and 1461 (Biblioteca Estense, Modena, MS Lat. 422–23). Mariani Canova drew convincing comparisons between Franco's illuminations in the Bible, the artist's earliest documented work, and the Cini fragments, and associated the latter with a Ferrarese commission datable to the same phase of his activity. More recently, Federica Toniolo (1998, pp. 128–29), while concurring with Mariani Canova's identification of the author of the Cini leaves and also noting their relationship to the Bible, advanced the possibility that they may have been one of the first works executed by Franco in the Veneto in the early 1460s, immediately following his Ferrarese sojourn.

The Lehman frontispiece, tentatively classified by De Ricci as Venetian, has been ignored in the literature on the Bessarion choir books, except for a brief mention without attribution by Mariani Canova (1973),

Fig. 16 Franco dei Russi, *Stoning of Saint Stephen in an Initial L.* Fondazione Giorgio Cini, Venice, 2120

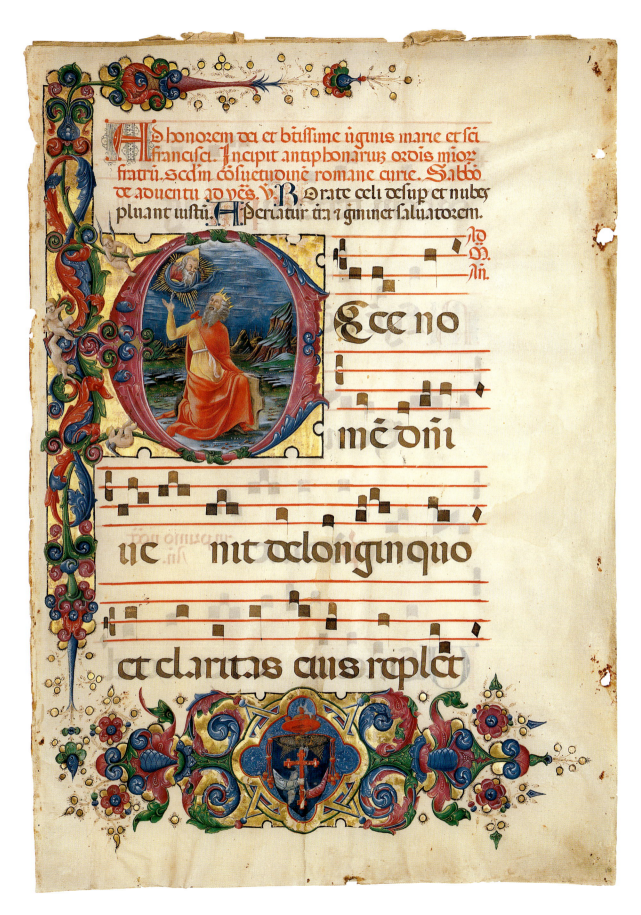

Ad honorem dei et btissime virginis marie et sci
francisci. Incipit antiphonaruz ordis mioz
fratrũ. sedm cõsuetudine romane curie. Sabbo
de aduentu ad ves. V. B Orate celi desup et nubes
pluant iustu. A speriatur in 7 gminet saluatorem.

Ad
M.
An.

Ecce no

men dni

ue nit delonginquo

et claritas eius replet

who, based on the coat of arms, listed it as a possible fragment from the Cesena series. Beyond its relationship to the Cini fragments, Franco dei Russi's authorship of the Lehman frontispiece is supported by a comparison to the miniatures unanimously attributed to the artist in the Bible of Borso d'Este. The lively figure of David kneeling against a surreal landscape highlighted in gold may be read as a monumental version of the various small scenes of biblical figures kneeling in prayer or inspired by God, which were executed by Franco in the margins of the first volume of the Bible (Book of Leviticus, fols. 44v–46r). Typical of his style in these works, as in the Lehman miniature, are the unnaturally elongated body types and sinuously flowing draperies, as well as the luminous palette and effects of *changeant couleur*. These elements, as noted by scholars, demonstrate the artist's debt, above all, to the Lombard, late Gothic idiom evolved by Belbello da

Fig. 17 Franco dei Russi, *Trial of the Apostles in an Initial T* and *Stigmatization of Saint Francis.* Fondazione Giorgio Cini, Venice, 2122

Pavia (cat. nos. 58a–b) and by Pisanello, both active at the Este court in the 1430s and later at the Gonzaga court in Mantua during the years of Franco's putative formation in that city prior to his departure for Ferrara.[2]

The exuberantly ornate initial and foliate border set against a gold band in the Lehman frontispiece also find precedents in Franco's portions of the Bible of Borso d'Este, especially those in the second volume (Gospel of Saint John, fol. 172v), where, as noted by Toniolo (1997, p. 410), the artist's decorative idiom is increasingly influenced by that of the Ferrarese illuminator Taddeo Crivelli, who, alongside Franco, was the leading illuminator engaged in the prestigious commission for the Bible.[3] Entirely typical of Franco, however, are the playful putti climbing in and out of the Lehman border, a signature device that first appears in the Bible and that will remain characteristic of the artist's later production.

If the Lehman frontispiece and related Cini fragments confirm Franco's involvement in the decoration of the Bessarion choir books, the full extent of his participation in this commission is attested to by the identification of his hand in four other antiphonary volumes in the series: vol. II of the temporale (cat. no. 44); vol. V of the sanctorale, the frontispiece of which may be associated with a leaf in the Cini Collection, Venice (2122), showing the *Trial of the Apostles in an Initial T* and the *Stigmatization of Saint Francis* in the lower border (fig. 17); vol. VI of the sanctorale, dated 1455 (Biblioteca Malatestiana, Cesena, Bessarion 6); and vol. VIII of the sanctorale, showing the Este arms and also involving the participation of the Third Bessarion Master (cat. nos. 45a–b). To these may be added the decoration of a hymnal that included the frontispiece with the Este arms in the Cini Collection, Venice (2124), and a previously unpublished leaf with *King David in an Initial B* in the Free Library, Philadelphia (M70:3; fig. 18).

The attribution to Franco of the miniatures in the above volumes, until now variously considered the products of unidentified Ferrarese illuminators,[4] reflects the artist's central role in the Bessarion series. The direct comparisons that may be drawn between these works and Franco's illuminations in the Bible of Borso d'Este, as well as the date 1455 recorded in Corale Bessarion 6, suggest a virtually contemporary dating

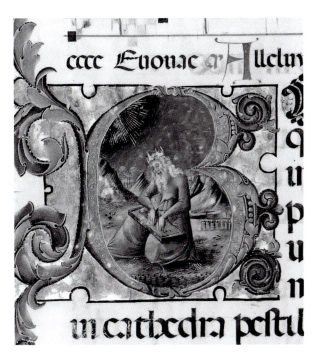

Fig. 18 Franco dei Russi, *King David in an Initial B*. Free Library, Philadelphia, M70:3

for his activity on behalf of Cardinal Bessarion, between about 1455 and 1460/63, before his departure from Ferrara.[5] It could be surmised that the same factors that motivated the choice of Franco as one of the leading illuminators of the Bible would have prompted the Este, whose involvement in the Bessarion series is suggested by their coat of arms in two of the volumes decorated by the artist, to recommend him for this other important commission.

1. The Cini leaves are marked, respectively, folio 97 and folio 124. Like the Lehman page, they were formerly included in the John F. Murray Collection.
2. For a full biography of the artist see Federica Toniolo, in Hermann 1994, pp. 211–30 (with previous bibliography).
3. Archival evidence suggests that Franco may actually have been engaged in a business partnership with Crivelli before their collaboration on the Bible. In the earliest mention of his name, in a Ferrarese document of 1453, Franco is cited as a witness to a payment to Taddeo Crivelli for miniatures painted by the latter in a *salmista* for Antonio da Pesaro (Franceschini 1993, 1, App. 28, p. 832). Two years later, in 1455, Franco and Crivelli were selected by Borso to decorate his two-volume Bible, one of the most important artistic undertakings ever carried out in Ferrara. The contract for this commission states that the two artists are to be given, for the duration of their work, a comfortable

house, as sufficient for their needs, "as the one they have at present" (Franceschini 1993, 1, App. 32, pp. 850–51). This would seem to imply that Franco had already been sharing a house with Crivelli (and probably a workshop).
4. For a full discussion of the Cini leaves and the illuminations in Corale Bessarion 6, attributed to unidentified Ferrarese illuminators by Mariani Canova (1978a, pp. 31–33; 1978b, pp. 19–20) and Lollini (1989, pp. 112–13; 1991, pp. 278–79), see Palladino, forthcoming.
5. In 1460 Franco is last recorded as actively engaged in the illumination of the Bible. The next and last mention of his name in Ferrara is in the general accounts of payments for the Bible in 1465 (Franceschini 1993, doc. 1032, pp. 636–37; Toniolo 1994, p. 221). By this time, however, Franco may already have left for Padua, where between 1463 and 1465 he illuminated a copy of the *Oratio* of Bernardo Bembo, now in the British Library, London (Mariani Canova 1994, pp. 83–84, with previous bibliography).

Franco dei Russi

44
Isaac and Esau in an Initial T

Circa 1455–60/63
Leaf from an antiphonary

Tempera and gold leaf on parchment. Leaf: 22 ⅞ × 16 ⅜ in. (58.1 × 41.5 cm). Initial: 5 ½ × 5 ½ in. (14 × 14 cm). Stave: 3.9 cm

Recto: [rubr.]*do[meni]ca.ii in xl.*/ *Invit.*/Non repellet dominus/ plebe[m] sua[m].C[ui]a i[n] manu eius/ sunt om[ne]s fines t[er]re. Venit./ [rubr.]/*R.* Tolle ar/ma tua. Verso: pharetra[m] et ar/cu[m] et affer de venatione / tua ut come/da[m]. Et benedicat ti/bi anima me

On recto, in upper right corner, in black ink: 1

PROVENANCE: De Clemente, Florence, 1924
LITERATURE: De Ricci 1937, p. 1711, D.24 (as 15th century, written in northern Italy).[1]

The present leaf, numbered folio 1, may be the frontispiece of the missing second volume of the antiphonary in the Bessarion choir book series. According to the 1812 inventory, this book covered the temporal cycle from the second Sunday in Lent (Quaresima) to Easter and did not include a coat of arms. The Lehman page, as stated by the rubric, contains the invitatory and the first response at matins ("Tolle arma tua" [Take your weapons]) for the second Sunday in Lent. Inside the

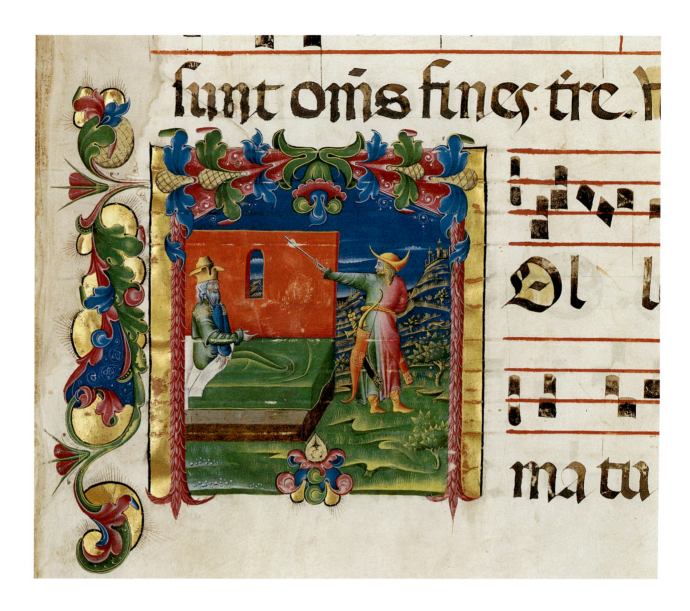

initial T is an illustration of the first episode of the Old Testament story of the Stolen Blessing. The old and nearly blind Isaac, sitting up in his bed, is shown dispatching Esau, his eldest son and a hunter, to catch venison and cook it for him, that he may give Esau his last blessing before dying (Genesis 27:1–5). This blessing will be stolen before Esau's return by his brother Jacob disguised as a hunter.

In style, execution, and border decoration the Lehman miniature conforms to the other illuminations in the Bessarion volumes by Franco dei Russi. Particularly relevant is a comparison between the figures in the present leaf and those by Franco in the signed Cini Collection fragment (2120; fig. 16) and in the Lehman

frontispiece (cat. no. 43), here associated with the first antiphonary volume in the series. Also comparable to the above miniatures are the fantastic landscape background and border decoration. The simple architectural prop meant to signify Isaac's chamber closely recalls the structures painted by Franco and his collaborators in the Bible of Borso d'Este.

1. According to De Ricci, this leaf was obtained from De Clemente "(with the bulk of the Chorale)." Nothing is known of the whereabouts of this volume, possibly unidentified because it was deprived of all the historiated initials.

Franco dei Russi

45a
Saint Clare in an Initial N

Circa 1455–60/63
Leaf from an antiphonary

Tempera and gold leaf on parchment. Leaf: 28 ¾ × 21 in. (73 × 53.5 cm). Initial: 7 ¼ × 6 ½ in. (18.5 × 16.5 cm). Stave: 4.9 cm

Recto: Nam sancte/ clare cla/ritas splendore mundi/ cardines mirifices comple/ vit cuius perfecta sanctitas in. Verso: devotas propagines velo/ cuius excrevit.[rubr.]*ps.*Dixit Dominus./[rubr.]*Ant./* Mundi totius glori/am ut christum lucri faceret/ vile quod orbitrata finibi

On recto, in upper right corner, in black ink: 25

PROVENANCE: Kalebdjian, Paris, 1924[1]
LITERATURE: De Ricci 1937, p. 1710, D.15 (together with cat. no. 45b as possibly Umbrian, ca. 1440. Ascribed to northern Italy by Robert Lehman)

45b
Saint Louis of Toulouse in an Initial T

Circa 1455–60/63
Leaf from an antiphonary

Tempera and gold leaf on parchment. Leaf: 28 ¾ × 21 in. (73 × 53.4 cm). Initial: 7 ¼ × 6 ½ in. (18.4 × 16.4 cm). Stave: 4.9 cm

Recto: [rubr.] *In S[an]c[t]i Lu/dovici epi./[et con]f.Antiph./* Tecum fu/it principium beate ludo/vice virtutu[m] chr[istu]s omni/um pro meritorum vice. Verso: [rubr.]*ps.* Dixit dominus. [rubr.]*Ant./M.*Ira magni/ficentia perfulsit virtuali cu/ius mansit iustitia cum gra/du pastorali. [rubr.]*ps.* Confitebor./ [rubr.] *Ant./*Exortus est in tenebris

On recto, in upper right corner, in black ink: 48

PROVENANCE: Kalebdjian, Paris, 1924
LITERATURE: Comstock 1927, pp. 56–57 (illus., p. 57) (as school of Pisanello); De Ricci 1937, p. 1710, D.15 (together with cat. no. 45a as possibly Umbrian, ca. 1440. Ascribed to northern Italy by Robert Lehman); Béguin, 1957, p. 110, cat. no. 159 (as Ferrarese Master, second half of the 15th century); Cincinnati 1959, p. 31 (as Ferrarese Master, second half of the 15th century)

These two leaves, acquired by Robert Lehman as a pair, were excised from the missing volume of an antiphonary sanctorale with Franciscan saints that was included in the Bessarion series. This book was described in the

1812 inventory as an "Antiphonary of St. Anthony, of St. Clare, of St. Louis Bishop, of St. Francis and the Stigmata" and listed as one of two volumes in the series bearing the arms of Borso d'Este. The volume's frontispiece was correctly identified by Giordana Mariani Canova (1978b, pp. 13, 17) with a leaf formerly in the John Murray Collection, Florence (fig. 19). This frontispiece, which includes the Este arms in the lower border, shows Saint Anthony of Padua, the canonized Franciscan preacher, in an initial G, introducing the antiphon ("Gaudeat Ecclesia" [Let the Church rejoice]) for his feast (June 13).[2] The two Lehman fragments correspond to the next two sections of the sanctorale, as listed in the 1812 inventory. The initial N with *Saint Clare* begins the antiphon ("Nam sanctae Clarae" [For Saint Clare][3]) for the feast of this saint (August 11), founder of the Franciscan Second Order of Poor Clares. The initial T with *Saint Louis of Toulouse* introduces the antiphon ("Tecum fuit principium" [He was with you in the beginning]) for the feast of the Franciscan bishop saint Louis of Toulouse (August 19). A fourth fragment from the sanctorale, corresponding to

Fig. 19 Third Bessarion Master, *Saint Anthony of Padua in an Initial G.* Formerly in the John Murray Collection, Florence

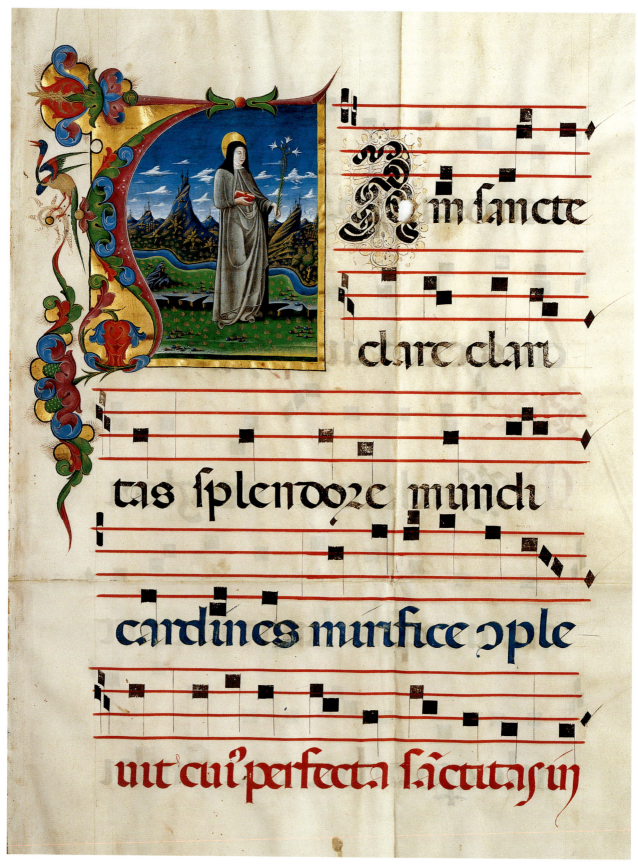

45a

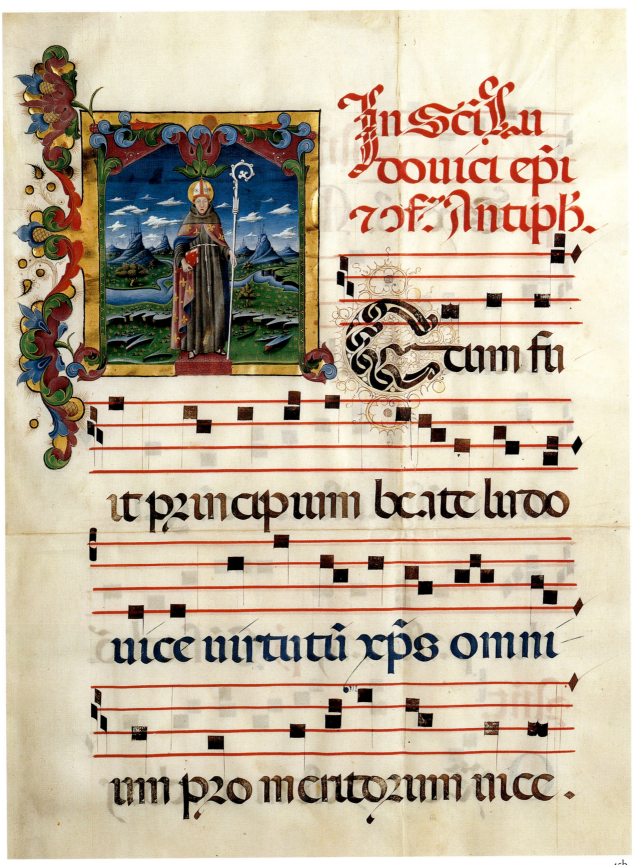

In Sci Lu
douici epi
rof. Antiph.

cum fu

it principium beate ludo

uice uirtutu xps omni

um pro meritorum mcc.

Fig. 20 Franco dei Russi, *Stigmatization of Saint Francis in an Initial F*. Nelson-Atkins Museum of Art, Kansas City, 31-120

the 1812 description, is represented by a leaf in the Nelson-Atkins Museum of Art, Kansas City (31–120), showing the *Stigmatization of Saint Francis in an Initial F* (fig. 20) to illustrate the antiphon ("Franciscus, vir catholicus" [Francis, a most catholic man]) for the Feast of the Stigmatization of Saint Francis (September 17).[4] Although executed by two different hands, all four leaves are identical in size, stave height, and foliation.

Mariani Canova *(loc. cit.)* convincingly attributed the ex-Murray frontispiece to the Third Bessarion Master and associated with it, as parts of the same volume, three leaves by the artist formerly in the Lehman collection and at Oberlin, the subjects of which correspond to those listed in the 1812 inventory. The Lehman and Oberlin leaves, however, were excised from a gradual not an antiphonary and were originally inserted in a different volume in the series (see above, cat. nos. 42a–c). The present antiphonary sanctorale appears instead to have been a collaborative effort between the Third

Bessarion Master and Franco dei Russi, who was responsible for the present two Lehman fragments and the Kansas City leaf.

Previously given to the school of Pisanello (Comstock 1927), the Lehman *Saint Louis of Toulouse* was first identified as Ferrarese by Sylvie Béguin (1957), who aptly compared it to the *Stoning of Saint Stephen* in the Cini Collection (2120), Venice, since recognized as a signed work of Franco dei Russi and here included in the Bessarion series (see above, cat. no. 43; fig. 16). Béguin also related the *Saint Louis of Toulouse* to another Cini leaf, showing the *Trial of the Apostles* and *Stigmatization of Saint Francis* (2122), which was catalogued by Mariani Canova (1978a, p. 33) as Ferrarese, in the circle of Jacopo Filippo Argenta, although it is, in fact, also by Franco and part of another antiphonary volume in the series (see above, cat. no. 43, fig. 17). Clearly related to the Cini leaves and the Lehman *Saint Louis of Toulouse* are the Lehman *Saint Clare* and the Kansas City *Stigmatization,* which share the same figural style, landscape, and decorative borders. Especially relevant is the close correspondence in both style and execution between the Cini *Stigmatization*—the composition of which is divided between the lower and right borders of the page—and the larger, unified version of the same subject in the Kansas City fragment.

Franco dei Russi's involvement in each of the two volumes in the Bessarion series bearing the Este arms confirms the suggestion, first advanced by Mariani Canova (1978a, p. 41), that the decoration of the choir books was carried out in Ferrara and completed during the same years that witnessed the illumination of the Este Bible. It seems logical to conclude that Cardinal Bessarion, who entertained close relationships with Borso and the humanists at the Este court, in accepting the Este participation in the series, would entrust its decoration to one of the principal illuminators engaged in the most ambitious artistic project in Ferrara at the time.

1. This is the same provenance recorded for cat. nos. 42a–c, by the Third Bessarion Master.
2. This antiphon begins the Rhymed Office of Saint Anthony written by the Franciscan friar Giuliano da Spira (d. ca. 1250). (See Sbarleae 1978 [1921], II, p. 156). The leaf's provenance, from the John Murray Collection, is recorded on the back of a photograph in the Robert Lehman Collection archives. Also noted in pencil are the dimensions of the leaf (28 × 20⅛ in.,

71 × 52 cm) and of the illumination (7⅛ × 7⅞ in., 18 × 20 cm).

3. Chevalier, III, 29780.

4. This antiphon begins Giuliano da Spira's famous Rhymed Office of Saint Francis (see above, n. 2). The dimensions of the Kansas City leaf are 28¾ × 20⅝ in. (73 × 52.4 cm). The stave height is 4.9 cm. It is also numbered in the upper right corner of the recto, in black ink: 72. According to records in the Museum's files, the leaf was purchased from A. S. Drey in New York, in 1931, by Harold W. Parsons, who acted as an adviser to this institution. Parsons was also a mutual friend of Robert Lehman and Jacob Hirsch and is mentioned in the 1931 letter from Hirsch to Lehman cited above (cat. nos. 42a–c, n. 3). The ex-Hirsch illuminations by the Third Bessarion Master in Honolulu were bought for that museum by Parsons.

Franco dei Russi (?)

46
Calling of Saints Peter and Andrew in an Initial U

Circa 1455–60/63
Frontispiece from an antiphonary

Tempera and gold leaf on parchment. Leaf: 25 × 17½ in. (63.5 × 43.6 cm). Initial: 6¼ × 5⅞ in. (16 × 15 cm). Stave: 4.4 cm

Recto: Unus ex duo/b[us] q[ui] secuti sunt/ dominu[m] erat andreas/ frater Symonis petri alle/luia [rubr.]*ps.* Mag. [rubr.] *Ad mat. Invitato[rium]*/ Rege[m] apostolor[um]/[rubr.] *In p[ri]mo noct.ant.* Verso: Vidit domin[us] petru[m] et/ andream [et] vocavit eos [rubr.]*ps.*/ Celi e.[rubr.]*a.* Venite post/ me dicit d[omi]n[u]s facia[m] vos fieri/ piscatores ho[m]in[um] [rubr.]*p* D[omi]n[i] [rubr.] *a*

On recto, in lower right margin, in brown ink: i

PROVENANCE: Unknown
LITERATURE: De Ricci 1937, p. 1708, A.4 (as early 15th century, probably written in eastern Lombardy)

The present leaf, numbered folio 1, was the frontispiece of an unidentified antiphonary volume. The initial U with the *Calling of Saints Peter and Andrew* illustrates the first antiphon at vespers ("Unus ex duobus" [One of the two]) for the vigil of the Feast of Saint Andrew (November 30), beginning the Advent season.

In both style and border decoration, this leaf closely approximates the work of Franco dei Russi, as reflected in the Bessarion series (cat. nos. 43–45a–b). A certain weakness of execution, compared to the latter, how-ever, makes a direct attribution to Franco only tenta-tive at present. No other related fragments with the same dimensions and stave height have yet been identified.

Cosimo Tura

Ferrarese, circa 1430–95

47

Saint John the Baptist in an Initial D

Circa 1470–80
Cutting from a gradual

Tempera and gold leaf on parchment. Cutting: 13¾ × 11¾ in. (35 × 30 cm). Initial: 7⅛ × 6¾ in. (18 × 17 cm). Stave: 5 cm

Recto: hic ve/[nit ut] testimonium/ [perh]iberet de lumi/[ne et parare] Domine. Verso: [rubr.] *Offer.* Et hono. [rubr.] *xc . . . /*[rubr.] *Com.* Magna est [rubr.]*ci . . . /*[rubr.]*In festo eius de/* De [ventre]/ mat[ris mea]/ vocavit me de[us]

On recto, in right hand margin, in red ink: xxxvii

PROVENANCE: Edouard Kann Collection, Paris; Wildenstein and Co., New York, 1927

LITERATURE: Boinet 1926, p. 33, no. XXXIX, pl. XXXVII (as 15th century, school of Ferrara); Wescher 1930, n. 4, pp. 79–80 (as style of Cosimo Tura); Wescher 1931, p. 99 (as style of Cosimo Tura, school of Ferrara, ca. 1460–70); De Ricci 1937, p. 1710, B.18 (as probably Ferrara, ca. 1450); Calabi 1938, p. 61 (as Jacopo Filippo Argenta); Nordenfalk 1975, p. 80, fig. 23d (as northern Italy [Ferrara]), ca. 1460s, close to Cosimo Tura); Boskovits 1978, p. 378, n. 36 (as Cosimo Tura, ca. 1470); Lollini 1989, p. 110, n. 3 (as Ferrarese, around 1465); Bollati 1991, p. 330 (as Ferrarese collaborator of Cosimo Tura, ca. 1470–80); Kanter 1998, pp. 149, 153 (as Cosimo Tura, ca. 1470–80); Lollini 1999, pp. 211, fig. p. 212 (as Ferrarese miniaturist, ca. 1465); Manca 2000, pp. 171–72 (as anonymous, Ferrarese)

This cutting, excised from a gradual, illustrates the introit ("De ventre matris mea" [From my mother's womb]) to the mass for the Feast of the Nativity of Saint John the Baptist (June 24). Inside the initial D, the Baptist stands against a barren landscape, holding a scroll with the following text: "EGO VOX CLAMANTIS [IN DESERTO]" (I am the voice crying aloud in the wilderness, Luke 3:4).

The Lehman fragment was recently associated by Laurence Kanter (1998, pp. 148–56) with nine other cuttings from a lost series of choir books decorated by the preeminent painter at the Este court in Ferrara, Cosimo Tura. According to Kanter, four of these cuttings were excised from an antiphonary in the series, while the remaining six, including the Lehman *Saint John the Baptist*, belonged to one or more volumes of a gradual. The two groups were outlined by Kanter as follows:

Antiphonary

1. New York, Metropolitan Museum of Art, 11.50.1: *Assumption of the Virgin in an Initial A*
2. Berlin, Kupferstichkabinett, MS 4493: *Nativity of the Virgin in an Initial N*
3. Ex-Paris, Wildenstein Collection: *Saint Francis in an Initial I*
4. New York, Metropolitan Museum of Art, 11.50.2: *All Saints in an Initial V*

Gradual

5. New York, Metropolitan Museum of Art, 11.50.4: *Presentation in the Temple in an Initial S*
6. Cat. no. 47: *Saint John the Baptist in an Initial D*
7. New York, Metropolitan Museum of Art, 11.50.3: *Assumption of the Virgin in an Initial G*
8. Ex-London, Heseltine Collection: *Birth of the Virgin in an Initial S*
9. Washington, National Gallery of Art, B-13, 524: *Stigmatization of Saint Francis in an Initial G*
10. Ex(?)-Berlin, Fritz Pohlmann Collection: *All Saints in an Initial G*

The Lehman *Saint John the Baptist,* together with three other fragments, was first attributed to the Ferrarese school, in the circle of Cosimo Tura, by Paul Wescher (1930). He was followed by Carl Nordenfalk (1975, pp. 78–83), who associated three more cuttings with

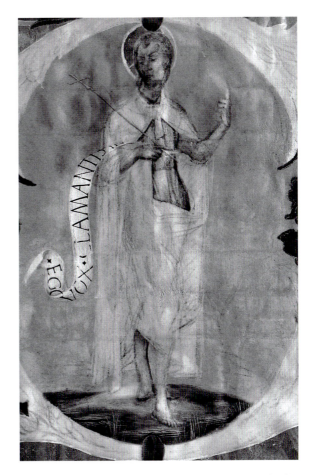

Fig. 21 Cosimo Tura, Infrared reflectography of *Saint John the Baptist in an Initial D* (cat. no. 47)

the same group. An attribution to Tura himself was first proposed by Miklós Boskovits (1978), who recognized the superior quality of execution of all these miniatures and placed them within the artist's mature production, around 1470. While reiterating Boskovits's attribution, Kanter *(loc. cit.)* noted a disparity in execution between the antiphonary and gradual fragments and suggested an interval of a decade or more between the completion of the former, datable to between 1450 and 1460, and the latter, datable toward the middle or end of the 1470s. Among the works compared by Kanter to the gradual fragments are the panels from the predella of Tura's Roverella Altarpiece, divided between New York (Metropolitan Museum of Art, 49.7.17), Boston (Isabella Stewart Gardner Museum), and Cambridge (Fogg Art Museum, 1905.14); and four small panels by the artist in Washington (National Gallery of Art, 1952.2.6), all of which have been dated to the mid- or late 1470s.

Kanter's proposal and the attribution to Tura of many if not all of these fragments have subsequently been called into question by several authors, beginning with Fabrizio Lollini (1998, p. 157; 1999, pp. 206, 211). Lollini has dismissed the possibility of an interval in the decoration of the choir books and accepted the attribution to Tura for the Berlin *Nativity* and possibly the Washington *Saint Francis* only, dividing the remaining eight fragments between a so-called "Miniatore Turiano," also active in the Bessarion series (Biblioteca Malatestiana, Cesena, Bessarion 4) and a third, anonymous Ferrarese artist. Most recently, Joseph Manca (2000, pp. 171–72) and Stephen Campbell (2002, pp. 251–52) have gone as far as rejecting Tura's involvement in any of these fragments, except perhaps the Berlin *Nativity*, and vaguely assigned their execution to several anonymous imitators of the master's style.

These objections, and, above all, the distinctions drawn between different hands, appear entirely artificial in light of the close correspondence in concept and execution that has often been noted, for example,

between the Berlin *Nativity* and the New York *Assumption* (Metropolitan Museum of Art, 11. 50.1), part of the same antiphonary grouping; or between the Berlin *Nativity* and the Washington *Stigmatization,* the latter included by Kanter in the gradual series. Milvia Bollati (1991, p. 332), in particular, in singling out these three miniatures as autograph works by Tura, aptly recognized the master's hand in the carefully studied, individual facial expressions and gestures, as well as in the plastic modeling of draperies, and in the compositional sophistication that distinguish the New York *Assumption* as much as the Berlin *Nativity*.

With respect to the Berlin *Nativity* and the other antiphonary cuttings, however, the Washington *Stigmatization* and its related gradual fragments, including the Lehman *Saint John the Baptist,* betray a simplification of the forms and more somber palette, as well as less exuberantly defined decorative borders. These distinctions may be a function of different stages in execution, although the relative chronology proposed by Kanter is not entirely convincing and a date for the antiphonary in the 1450s seems too precocious. Within the limitations imposed by the uncertainties related to dating Tura's mature production, it seems more plausible to suggest that the commission for these volumes occupied the artist intermittently over the course of the 1470s.

Based on the predominance of Franciscan saints in these cuttings and the possible association between the gourds in the miniatures' borders and one of the emblems of the Este (the so-called *paraduro*—a gourd hanging from a fence), Kanter tentatively suggested a provenence for the series from the Franciscan convent of Corpus Domini, Ferrara, sponsored by the Este. Alternatively, Giordana Mariani Canova (1998, pp. 134–35), who identified one of the figures in the Metropolitan Museum *All Saints* as the Observant friar Blessed John Capistrano, proposed a possible provenance from the Observant Franciscan convent of Santo Spirito, Ferrara.

Jacopo Filippo Medici d'Argenta

Ferrarese, documented 1478–1501

48a
King David in an Initial D

Circa 1490–1500
Cutting from an antiphonary
New Haven, Yale University Art Gallery, 1954.7.6c

Tempera and gold leaf on parchment. 3 ¼ × 3 ⅝ in. (8.3 × 9.2 cm).
No staves visible

Verso: hic requi/ em demo (or domo)/ vite mee

PROVENANCE: Acquired in Paris, 1953[1]; Gift of Robert Lehman to
Yale University, 1954
LITERATURE: Seymour 1970, pp. 224–25 (as North Italian school,
15th century)

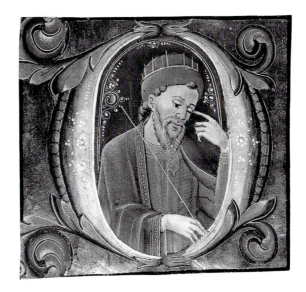

48b
Angel Playing the Timbrel in an Initial C

Circa 1490–1500
Cutting from an antiphonary
New Haven, Yale University Art Gallery, 1954.7.6d

Tempera and gold leaf on parchment. 3 1/16 × 3 7/16 in. (7.8 × 8.8 cm).
No staves visible

Verso: eia omniv [m]/ . . . id demo/ quim [ur] ab

PROVENANCE: Acquired in Paris, 1953; Gift of Robert Lehman to
Yale University, 1954
LITERATURE: Seymour 1970, pp. 224–25 (as North Italian school,
15th century)

48c
Initial E

Circa 1490–1500
Cutting from an antiphonary
New Haven, Yale University Art Gallery, 1954.7.6a

Tempera on parchment. 3 ¼ × 3 ⅛ in. (8.2 × 8 cm). Stave: 4.5 cm

PROVENANCE: Acquired in Paris, 1953; Gift of Robert Lehman to
Yale University, 1954
LITERATURE: Seymour 1970, pp. 224–25 (as North Italian school,
15th century)

Bartolomeo del Tintore (?)

Bolognese, documented 1459–91

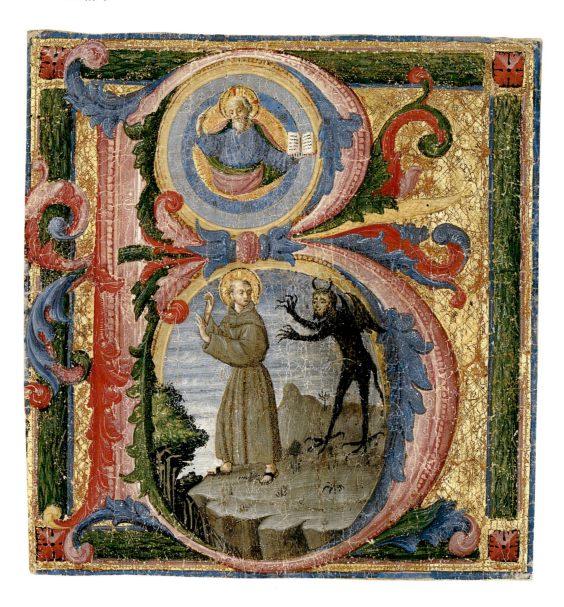

49

Temptation of Saint Francis in an Initial B

Circa 1460
Cutting from an antiphonary

Tempera and gold leaf on parchment. 5⅞ × 5⅝ in. (14.8 × 14.1 cm)

Verso: [Repelle a servis] tuis quicq[ui]d/ [per immunditi]am. aut mori[bus]/ [se sugg]erit aut actib[us]/ [se interserit.] Da gaudio[rum] /[praemia da] gratiarum mu[nera]/ [dissol]ve litis vi[n]cu[la]

No staves on verso

PROVENANCE: John F. Murray, Florence, 1924
LITERATURE: De Ricci 1937, p. 1713, B.14 (as probably Umbria, ca. 1470)

This fragment may originally have been the frontispiece of a Franciscan antiphonary. The initial B introduces the antiphon at vespers ("Benedictus Dominus Deus meus" [Blessed be the Lord, my God]) for the Saturday before the first Sunday of Advent. On the

verso are remnants of the hymn for the same feast. The illustration of this text with the *Temptation of Saint Francis,* rather than with a Marian image (see cat. no. 27), suggests that the missing antiphonary volume was specifically intended for a Franciscan congregation.

The author of the Lehman cutting may be tentatively identified as Bartolomeo del Tintore, the preeminent illuminator in Bologna during the third quarter of the fifteenth century, prior to the arrival in 1473 of the Ferrarese miniaturist Taddeo Crivelli. Bartolomeo's activity was recently reconstructed by Massimo Medica (1997, pp. 71–73; 1999, pp. 104–5, 164–65) on the basis of his only documented work, a miniature of *Saint Thomas Aquinas* in the statutes of the Bolognese notaries for which he received payment in 1459. In contrast to the late Gothic idiom still present in Bolognese manuscripts of the previous decade (see cat. no. 35), this illumination displays a Renaissance figural vocabulary and concern for spatial effects that reflect Bartolomeo's awareness of the most recent innovations in contemporary Ferrarese and Tuscan painting.

Among the works grouped by Medica around the documented *Saint Thomas Aquinas* are the miniature of *Saint Petronius Enthroned* in the 1454 statutes of the Commune of Bologna (Archivio di Stato, Comune-Governo, Statuti vol. XVII) and the frontispiece of a copy of Petrarch's *Triumphs* in the Biblioteca Casanatense, Rome (MS 141). These works provide the closest comparisons for the style, palette, and foliate border of the Lehman fragment.

Master of the Libro dei Notai (Domenico Pagliarolo?)

Bolognese, active last quarter of the fifteenth century

50
Nativity in an Initial P

Circa 1473–76
Bifolium from a gradual
New Haven, Yale University Art Gallery, 1954.7.5

Tempera and gold leaf on parchment. Leaf: 23 ½ × 16 ¾ in. (59.7 × 42.6 cm)

Recto: [rubr.] *Co.* Exulta filia Syon lauda/ filia ierusalem/ ecce rex. Verso: tuus venit s[an]c[tu]s [et] salva/tor mundi. [rubr.]*ad missa[m]/ maiore[m]/ Introit[us]./*Puer na/tus est/ nobis et filius

On recto, in center right margin, in red ink: XXXIV

PROVENANCE: Acquired in Paris, 1953;[1] gift of Robert Lehman to Yale University, 1954
LITERATURE: Seymour 1970, p. 201, no. 151, fig. 151 (as Sienese school, 15th century)

This bifolium was excised from an unidentified gradual containing the temporal cycle beginning with Advent.

harp. The elegant foliate border with putti and other classically inspired decorative motifs is interrupted in the four corners by rectangular inserts with the figures of the Four Evangelists; and in the top and lower border, respectively, by diamond-shaped inserts with the image of the Virgin and Child and of an unidentified bishop-saint. Framed by laurel wreaths in the left and right borders are two monastic saints in Dominican dress, possibly Saints Thomas Aquinas and Dominic.

The Lehman fragment corresponds closely in style, palette, and border decoration to the illuminations in a gradual series from the Duomo in Cesena, currently in the Biblioteca Malatestiana, Cesena (cor. A, B, C, D, E, F, G). Datable to after 1486, the decoration of these volumes was the product of a team of anonymous illuminators, who were influenced by the developments in Bolognese and Ferrarese painting during the last decades of the fifteenth century (Cucciomini 1989, pp. 37–140). Among them, the artist whose work is most closely related to the Lehman page is the so-called Romagnole Master of Duomo C, responsible for most of the illuminations in Malatestiana Corale C and for part of

those in Malatestiana Corale E (Cucciomini 1989, pp. 121–25, 130–33). A slightly coarser version of this master's style, which also reflects points of contact with the Lehman fragment, is found in a series of volumes from the Cathedral of San Cassiano, Imola, leading scholars (Lollini 1994, pp. 201–5) to suggest that the same team of illuminators was active in various centers of the Romagna in the last fifteen years of the fifteenth century.

The strong similarity between the Lehman fragment and the Cesena choir books may indicate a provenance from the same series, although, lacking documents confirming the existence of a psalter besides the graduals, such a suggestion must remain speculative. Undoubtedly missing from the gradual series is the final volume of the temporale containing the masses for the twenty-four Sundays after Pentecost. Also missing are several folios from the existing books. One of these, clearly related in style to the Lehman miniature, may be associated with a gradual leaf formerly in the Kann Collection, showing the *Nativity in an Initial P* (Boinet 1926, p. 31, no. XXXVI, pl. XXXIV). This is the missing folio 44 or 45 of Malatestiana Corale E.

Stefano da Verona

Lombard, circa 1375–1438

52a
Pentecost in an Initial A

Circa 1430–35
Cutting from an antiphonary

Tempera and gold leaf on parchment. 4 11/16 × 4 15/16 in. (12 × 12.5 cm).
Stave: 2.5 cm

Recto: r[u]m alleluia/[rubr.]*[i]n die.ad mat. Invit*

52b
Blessing Christ in an Initial B

Circa 1430–35
Cutting from an antiphonary

Tempera and gold leaf on parchment. 3 9/16 × 3 3/4 in. (9 × 9.5 cm).
Stave: 2.5 cm

Verso: [E]uouae/ Euouae

PROVENANCE: W. Y. Ottley (sale, Sotheby & Co., London, May 11, 1838, lot 45); Lord Northwick (sale, Sotheby & Co., London, Nov. 16, 1925, lot. 155)

LITERATURE: De Ricci 1937, p. 1715, c.27 and 26 (as Lombardy, ca. 1490); Miner 1949, p. 65, no. 178 (as North Italy, early 15th century); Harrsen and Boyce 1953, p. 29, no. 53 (as follower of Michelino da Besozzo); Cipriani 1958, p. 75, no. 235 (as follower of Michelino da Besozzo); Miner and Verdier 1962, p. 77 (as Belbello da Pavia); Mariani Canova 1973, p. 46 ([a], as Second Master of Antiphonary M in San Giorgio Maggiore); Stefani 1985, p. 847, n. 11 ([a], as Second Master of Antiphonary M in San Giorgio Maggiore); Lollini 1989, pp. 97, 98, n. 6 (as Veneto, ca. 1435); 1991, p. 227 (as Veronese, ca. 1435–40); Palladino 2002 (as Stefano da Verona, ca. 1430–35)

These two cuttings, remarkable for their refinement of execution and delicate palette, were probably excised from the same antiphonary volume or set. The splendid initial A, formed by the intertwined heads of two dragons—in the lower half of which is the Virgin

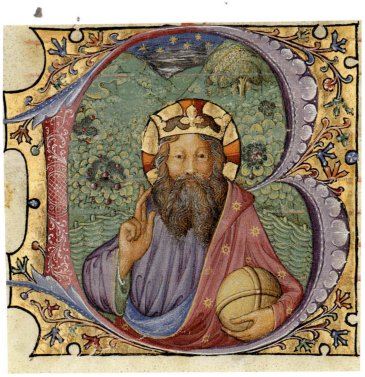

Fig. 22 Stefano da Verona, *Annunciation.* Cleveland Museum of Art, Cleveland, no. 24.431

surrounded by the Twelve Apostles—illustrates the invitatory antiphon at matins for Pentecost Sunday ("Alleluia, Spiritus Domini" [Alleluia, the Spirit of the Lord]). The initial B with a crowned Christ as *Salvator Mundi* (Savior of the World), holding a globe in one hand and in the act of blessing with the other, could illustrate a number of antiphonary texts, including the first antiphon at vespers for Trinity Sunday (Hesbert 1968, p. 1708).[1]

In 1949, when they were included in an exhibition at the Baltimore Museum of Art, the two Lehman miniatures were catalogued by Dorothy Miner (1949, p. 65) as "North Italy, early 15th century" and first associated with a cutting of the *Annunciation* in the Cleveland Museum of Art (no. 24.431, fig. 22), then attributed to the school of Stefano da Verona, one of the leading exponents of the International Gothic style in Italy in the early fifteenth century. Subsequent authors have highlighted the Lombard and Veronese components of these miniatures, dating them to between 1430 and 1440 and grouping around them, in addition to the Cleveland cutting, three other antiphonary fragments, the attribution of which has shifted between

school of Stefano da Verona, follower of Michelino da Besozzo, and Belbello da Pavia: an initial G with the *Trinity* in the Pierpont Morgan Library, New York (M558D); an initial M with *Christ and the Pharisees* in the Victoria and Albert Museum, London (MS 991); and an initial D or O with *Christ Disputing with the Merchants* in the British Library, London (Add. 18196, no. 49).[2] That these six illuminations constitute a homogeneous group is indicated by their similar palette and figural style, by their identical border decoration, and by their common stave height, suggesting a probable origin from the same antiphonary set. A possible Venetian provenance may be inferred from the nineteenth-century inscription in pencil on the verso of the Cleveland *Annunciation,* stating that it came from the church of "SS. Pietro e Paolo in Venice."[3]

While parallels for individual elements in the style and decoration of these illuminations may be found in the work of Michelino da Besozzo and the young Belbello, it is the art of Stefano da Verona, who has not until now been known as a manuscript illuminator, that reflects all of their characteristics combined, suggesting a direct attribution to him. Entirely typical of Stefano, as demonstrated by a comparison with his painting of the *Madonna and Child* in the Palazzo

Fig. 23 Stefano da Verona, *Madonna and Child with Angels*, Palazzo Colonna, Rome

Colonna, Rome (fig. 23), are the slender, insubstantial figures that inhabit these miniatures, whose elongated limbs, stretched out to impossible proportions, disappear behind the elegant folds of ample draperies. The Cleveland *Virgin*, with her perfectly oval face and vanishing chin, long, pinched nose and small pouty mouth, is simply a reduced version of the Palazzo Colonna Madonna; while the latter's brittle, spidery fingers are another hallmark of Stefano's vocabulary that resurfaces, most noticeably, in the raised hand of the Lehman *Christ Blessing*.

Further points of reference for the Lehman cuttings may be found in a number of drawings attributed to Stefano, such as those in New York, Dresden, and Florence (Karet 1999, pp. 5–41), which are characterized by the same linear fluidity and freedom from conventional formal requirements that have often been hailed as distinguishing elements in assessing his art. But the strongest argument for Stefano's authorship must ultimately lie within the exceptional quality of these miniatures, both in their technique and in their visualization—from the meticulous drawing and application of pigment and gold, to the subtle color harmonies of luminous pastels, to the fantastically conceived letters and surreal landscape backgrounds.

1. The same subject is used to illustrate this text in a gradual in the Biblioteca Malatestiana, Cesena (Bessarion 1, fol. 35v), attributed by Giordana Mariani Canova (1973, p. 46) to the so-called Second Master of Antiphonary M in San Giorgio Maggiore (who is also identified by her as the author of the Lehman cuttings).

2. The Cleveland, Pierpont Morgan Library, and Victoria and Albert Museum cuttings appeared in the same Ottley sale as the Lehman fragments (lots 41, 44, 46). Together with the Lehman miniatures, they were listed among a total of 38 cuttings divided between lots 40–48, all thought to be by the same artist.

3. Since the Church of Saints Peter and Paul, no longer extant, was actually a small hospital for the sick and the poor, the present inscription may in fact reflect a confusion with the more famous Dominican convent and church of SS. Giovanni e Paolo, consecrated in 1430, and more likely at that time to have needed a new series of liturgical books (Cornaro 1758, pp. 81–89, 159–60).

Master of the Vitae Imperatorum

Milanese, active second quarter of the fifteenth century

53

Martyrdom of Saint Lawrence in an Initial D

Circa 1430–40
Cutting from a gradual
Oberlin, Allen Memorial Art Museum, 1943.11

Tempera and gold leaf on parchment. Fragment: 13 1/16 × 8 3/4 in. (33.1 × 22.3 cm). Initial: 2 3/4 × 3 in. (7 × 7.5 cm)

Recto: Coniuncti . . . /[rubr.] *[con]frac.* Amen dico.[rubr.] *cic. tr[an]s.* Isti sun[t]/ [*lau*] *re[n]tii. Ingr[e]s.* Iustus no[n con]t[urbabitur] [rubr.] *clxxxvii Can . . . /fo:cxc. [con]fr.* In salutari.[rubr.] *cxci. tr[ans]* . . . /*Mane ad missa[m].l. . . /*Dispersit de[dit pauperi]/bus iusticia e[ius manet]/ in seculum s[eculi]

On verso, center left margin: CXLII

PROVENANCE: Kleinberger, Paris, about 1922; gift of Robert Lehman to Oberlin College, 1943

Milanese

Circa 1440–50

55a
Resurrection in an Initial R

Cutting from a gradual

Tempera and gold leaf on parchment. Cutting: 10 ⅞ × 7 ⅞ in.
(27.7 × 20 cm). Initial: 5 ¾ × 5 ⅝ in. (14.6 × 14.3 cm). Stave: 3.4 cm

Recto: Re[surrexi et]/ ad[huc tecum sum]/ alleluya posuisti
Verso: [Haec dies quam fecit] dominus exulte/[mus et] letemur in
ea./[rubr.] *v.*c onfitemini do

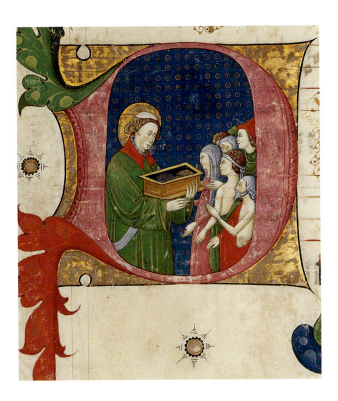

55b
Saint Lawrence Distributing the Treasures of the Church in an Initial D

Cutting from a gradual

Tempera and gold leaf on parchment. Cutting: 11¾ × 8⅛ in. (29.8 × 20.7 cm). Initial: 5 × 4⅞ in. (12.5 × 12.4 cm). Stave: 3.4 cm

Recto: o Que[m] di.[rubr.] *laure* / [rubr.] *ps* / tute / Di/spers[it]. . . .
Verso: [Probast]i domine cor/[me]um et/[visita]sti nocte

PROVENANCE: Kalebdjian, Paris, 1924
LITERATURE: De Ricci 1937, p. 1709, A.22 and 7 (as parts of two folios of the same book, Milanese, early 15th century)

These two fragments, acquired by Robert Lehman as a pair and identical in style, musical notation, and stave height, were excised from the same gradual volume or series. The initial R illustrates the introit ("Resurrexi" [I arose]) to the mass for the Feast of the Resurrection. The initial D illustrates the introit ("Dispersit dedit pauperibus" [Lavishly, he has given to the poor]) to the mass for the Feast of Saint Lawrence (August 10). In addition to the Lehman miniatures, the following three

cuttings may be associated with the same gradual: an initial B with the *Adoration of the Magi* in the Cini Collection, Venice (2100); an initial B with *King David,* recently on the art market in London (Sotheby's, December 6, 2001, lot 40); and a previously unpublished initial O with a group of ecclesiastics in the Free Library, Philadelphia (M28:9; fig. 25). These works are identical to the Lehman fragments in musical notation and stave height, as well as in style and border decoration.

The Cini illumination was first published by Pietro Toesca (1930, pp. 111–12, pl. XCIV), followed by Giordana Mariani Canova (1978a, pp. 50–51), as a Lombard work of the middle to second half of the fifteenth century inspired by the late Gothic idiom of Belbello da Pavia (see cat. nos. 58a–d). While these miniatures include decorative elements derived from Belbello's production, a more specific point of reference for their figural style may be found, as was noted by De Ricci (1937) in regard to the Lehman cuttings, in early-fifteenth-century Milanese manuscript production. In particular, these works reflect an adaptation of the vocabulary of the Master of the Vitae Imperatorum as interpreted by his many collaborators and followers around the middle of the fifteenth century.

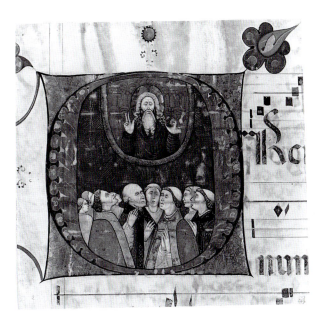

Fig. 25 Milanese, ca. 1440–50, *Ecclesiastics in an Initial O,* Free Library, Philadelphia, M28:9

Lombard

Middle of the fifteenth century

56

Joseph and His Brothers in an Initial V

Cutting from an antiphonary
Oberlin, Allen Memorial Art Museum, 44.38

Tempera and gold leaf on parchment. Leaf: 8¾ × 8¾ in. (22.2 × 22.2 cm)

PROVENANCE: Arnold Mettler of St. Gallen, Switzerland; sale, Sotheby's, London, April 27, 1937, lot 295; gift of Robert Lehman to Oberlin College, 1943
LITERATURE: Melograni 1994, p. 298, n. 21 (mentioned without attribution); Hamburger 1995, p. 27, cat. no. 25 (as possibly Lombardy, ca. 1440)

This cutting is one of five surviving fragments from an unidentified, possibly Lombard antiphonary. The initial V introduces the first response at matins ("Videntes Ioseph a longe" [Seeing Joseph in the distance]) for the third Sunday in Lent. The scene inside the initial, mistakenly described by previous authors (Melograni 1994; Hamburger 1995) as "Elisha in the Mantle of Elijah," actually depicts an episode in the Old Testament story of Joseph and His Brothers (Genesis 37:11–27). In a landscape meant to evoke the fields of Dothain, Joseph

is shown wandering in search of his jealous brothers, pasturing their flocks in the valley below. When they see him coming, the brothers decide to murder Joseph ("They saw him in the distance, and before he drew near them, they plotted to kill him").

The Oberlin miniature, published by Jeffrey Hamburger (1995) as possibly Lombard, about 1440, may be associated with the same antiphonary volume as two other cuttings, identical to it in style and decorative border, that were first grouped together by Anna de Floriani (1996, cat. no. 9, pp. 53–55) as the work of a Lombard illuminator active between the fifth and sixth decades of the fifteenth century: an initial D with *King David* in the Museo Civico Amedeo Lia, Todini 1996 (inv. 508), and an initial T with *Isaac and Esau* in the Cleveland Museum of Art (49.535). To these may be added two more hitherto unidentified fragments by the same hand: an initial I with *Christ's Entry into Jerusalem* in the Free Library, Philadelphia (M27:21; fig. 26), published with a generic attribution to the Lombard school by Angela Daneu Lattanzi (1985, pp. 775–76); and an initial M with the *Stoning of Christ* in the Biblioteca Nacional, Madrid (AB/1923), published by Javier Docampo (1997, pp. 318–19) with an attribution to the Lombard school about 1445–50.

Together these five antiphonary cuttings, including the Oberlin initial, form a homogeneous group covering the temporal cycle from the second Sunday in Lent through the second Sunday after Pentecost as follows:

Fig. 26 Lombard, middle of the fifteenth century, *Christ's Entry into Jerusalem in an Initial I*, Free Library, Philadelphia, M27:21

1. Cleveland Museum of Art 49.535: *Isaac and Esau in an Initial T* ("Tolle arma tua" [Take your weapons]). First response at matins for second Sunday in Lent
2. Allen Memorial Art Museum 44:38: *Joseph and His Brothers in an Initial V* ("Videntes Joseph a longe" [Seeing Joseph in the distance]). First response at matins for third Sunday in Lent
3. Biblioteca Nacional AB/1923: *Stoning of Christ in an Initial M* ("Multa bona opera" [Many good things]). First antiphon at vespers for Wednesday of Passion Week[1]
4. Free Library M27:21: *Christ's Entry into Jerusalem in an Initial I* ("In die qua invocavi te" [When I called to you]). First response at matins for Palm Sunday
5. Museo Civico Amedeo Lia inv.508: *King David in an Initial D* ("Deus omnium exauditor est" [God hears everyone]). First response of first nocturn for second Sunday after Pentecost

As noted by Anna Melograni (1994, p. 290) in relation to the Museo Lia fragment, the style of this anonymous artist typifies the developments in Lombard illumination around the middle of the fifteenth century. While compositional and decorative elements recall the production of the Master of the Vitae Imperatorum, the more schematic, flatter rendering of the forms anticipates the work of a later generation of artists, active in the seventh and eighth decades of the century (see below, cat. nos. 62a–d, 63).

1. The unusual subject of this miniature might have illustrated a number of texts. If it is the Feast of the Dedication of the Temple, at which is read the episode of Christ walking in Solomon's porch and being threatened with stoning by Pharisee extremists (John 10:22–39), the initial M could refer to the beginning of the first antiphon at lauds for that feast ("Mane surgens Jacob" [When Jacob arose in the morning]). The same Gospel passage, however, is also read during Passion Week, in which case the initial could illustrate the texts "Multa bona opera" (Many good things), first antiphon at vespers for Holy Wednesday, or "Multiplicati sunt qui tribulant me" (How many are my adversaries), first response at vespers for the Saturday before Passion Sunday.

Master of the Franciscan Breviary (?)

Lombard, active middle of the fifteenth century

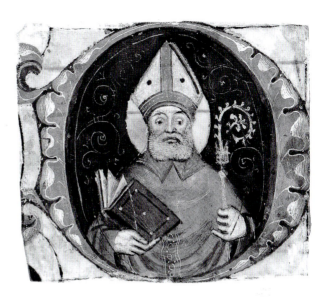

57
Bishop Saint in an Initial D

Circa 1450–60
Cutting from an antiphonary (?)
New Haven, Yale University Art Gallery, 1954.7.6b

Tempera and gold leaf on parchment. $3 \times 3\frac{9}{16}$ in. (7.6 × 9 cm)

Verso: igra

PROVENANCE: Acquired in Paris, 1953;[1] gift of Robert Lehman to Yale University, 1954
LITERATURE: Seymour 1970, pp. 224–25 (as North Italian school, 15th century)

This cutting, possibly excised from an antiphonary, was published by Charles Seymour in the same group as cat. nos. 48a–c with a generic attribution to fifteenth-century "North Italian school." While a more precise attribution is made difficult by the miniature's small scale and cursory handling, parallels may be found in the production of the anonymous, late Gothic, Lombard illuminator known as Master of the Franciscan Breviary. Named after a Franciscan breviary dated 1446 in the Biblioteca Universitaria, Bologna (MS 337), this artist was first identified by Pietro Toesca (1912, pp. 520–21) as a follower of Michelino

da Besozzo, one of the principal personalities active in Lombardy and in the Veneto during the first decades of the fifteenth century. Subsequent authors further defined the master's style in relationship to the work of the Lombard illuminator Belbello da Pavia (cat. nos. 58a–d), from whom are derived many of the decorative elements of his mature production.[2]

Among the increasing number of works attributed to the Master of the Franciscan Breviary, which include numerous cuttings dispersed among various European and American collections, the closest comparison for the Yale fragment is found in the illuminations he contributed to two volumes of an antiphonary in the choir book series of Cardinal Bessarion (Biblioteca Malates-tiana, Cesena, Bessarion 3; Cini Collection Venice, 2096; Mariani Canova 1978a, pp. 40–43; and above, and cat. nos. 42a–c). Datable to the sixth decade of the fifteenth century, these works, like the Yale fragment, reflect a broader execution than the Franciscan breviary and display the same curved-petal motif, derived from Belbello, surrounding the initials.

1. This cutting was listed by Seymour (1970) as sharing the same provenance as cat. nos. 48a–c. As in the case of those miniatures, no records of this purchase have been found in the Robert Lehman Collection archives.

2. For a summary of the extensive literature on the artist, see Stefani 1985, pp. 849–52; and, most recently, Frosinini 1998, pp. 321–23.

The Choir Books of San Giorgio Maggiore in Venice

Between 1467 and 1470, under the abbacy of Cipriano Rinaldini, the Benedictines of San Giorgio Maggiore, Venice, commissioned a new series of choir books for their monastery, entrusting its decoration to a prestigious team of Lombard illuminators headed by Belbello da Pavia, the foremost representative of the late Gothic style in northern Italy. Produced during the last years of the artist's activity, Belbello's illuminations for the series, characterized by an almost excessive decorative exuberance and dazzling coloristic effects, have come to be viewed as the crowning achievement of his career.

Belbello's role in the decoration of the San Giorgio Maggiore choir books was first outlined by Giordana Mariani Canova (1973), who discovered, still preserved in the sacristy of San Giorgio, three surviving volumes and other fragments from this series, believed lost since its last mention in the early nineteenth century. The identification of Belbello's hand in these volumes provided important evidence of a late Venetian phase in the artist's career, following the last mention of his name in documents in 1462 and the official termination of his employment at the Gonzaga court in Mantua.

Fig. 27 *San Giorgio Maggiore Antiphonary P*

Based on a comparison with the artist's illuminations in the San Giorgio Maggiore volumes, Mariani Canova, followed by subsequent authors, went on to associate with the series many of the surviving fragments by Belbello datable to the same period in his career and dispersed in various collections. The reconstruction of this important commission was recently furthered by the discovery (Palladino 2002), in the storerooms of The Metropolitan Museum of Art, of another missing antiphonary volume from San Giorgio, which, together with five other fragments from the series, was formerly included in the collection of Robert Lehman.

Above: Belbello da Pavia, *Antiphonary P* (fols. 3v–4r)

Belbello da Pavia and Collaborators

Lombard, active circa 1420–70

58a
Benedictine Antiphonary

Circa 1467–70
New York, The Metropolitan Museum of Art, The Cloisters Collection, 1960 (60.165)

96 folios. Tempera and gold leaf on parchment. Page: 22 ⅛ × 16 ⅛ in. (56.2 × 41 cm). Stave: 4.2 cm. Binding: 23 × 16 ¾ in. (58.5 × 42.5 cm)

Later binding of tooled brown leather. Marking the back cover is a letter P formed of large metal rivets. The volume was rebound in the seventeenth century. An old folio numeration in ink, in the center right margin, has been erased and is inconsistent. It has been replaced by consecutive modern numeration, in pencil, in the upper

Belbello da Pavia

58b
Christ Blessing in an Initial T

Circa 1467–70
Leaf from an antiphonary

Tempera and gold leaf on parchment. Leaf: 22 × 16⅛ in. (55.9 × 41 cm). Initial: 7⅛ × 6⅛ in. (18 × 15.5 cm). Stave: 4.2 cm

Recto: tum qua[m] laudan/tes om[n]es dicimus/ bendicta tu in/ mulierib[us]. Euouae./[rubr.] v. Videru[n]t om[n]es fines terre./ [rubr.] R. Salutare dei nostri:/[rubr.] Ad vesp[er]as antipho[n]a. Verso: Tecu[m] pri[n]cipiu[m]/ in die virtutis/ tue i[n] sple[n]dorib[us] sa[nc]/toru[m] ex utero ante

PROVENANCE: San Giorgio Maggiore, Venice; Bruscoli, Florence, 1924[1]
LITERATURE: De Ricci 1937, p. 1708, C.33 (as page from A.4, choir book, early 15th century, written in northern Italy); Levi D'Ancona 1970, p. 55 (as Belbello da Pavia); Mariani Canova 1978a, pp. 47–48, n. 15 (as Belbello, possibly from the San Giorgio Maggiore series); Mariani Canova 1988, p. 114 (as Belbello, from the same San Giorgio Maggiore volume as Cini 2093); Melograni 1995, pp. 8, 24, n. 104, fig. 34 (as Belbello, from the same San Giorgio Maggiore volume as Cini 2093); De Floriani 1996, p. 40, n. 12 (as Belbello, from San Giorgio Maggiore Antiphonary M); Toscano 1998, p. 27, n. 93 (as Belbello, from the San Giorgio Maggiore series); Palladino 2002 (as Belbello, from San Giorgio Maggiore Antiphonary P)

Like the following two fragments by Belbello (cat. nos. 58c–d), this leaf was excised at an unknown date from the Metropolitan Museum's Antiphonary P from San Giorgio Maggiore. The association between these cuttings and the Museum's volume was first pointed out by De Ricci but has passed unobserved in the subsequent literature. Following Mirella Levi D'Ancona (1970), who attributed them to Belbello,[2] Giordana Mariani Canova (1978a) first recognized a similarity between these miniatures and those by the artist in the surviving volumes in San Giorgio Maggiore and tentatively suggested that they may have been included in a missing volume in the series. More specifically, Mariani Canova (1988) went on to associate all three fragments with the same volume as the *Annunciation* in the Cini Collection, Venice (fig. 30); which, as noted in the previous entry, is actually the missing frontispiece of Antiphonary P.

The present leaf, showing *Christ Blessing in an Initial T,* illustrates the first antiphon at second vespers ("Tecum principium" [Yours is princely rule]) for Christmas Day (December 25). It may be identified as one of two or more missing folios originally inserted between the present folio 29 and folio 30 of Antiphonary P, the latter of which contains the fourth antiphon at second vespers for Christmas Day.

The monumental quality of the large, powerful figure of Christ, which dominates the Lehman page, and the broadly rendered foliate border and luminous, acidic palette are typical of Belbello's efforts throughout the San Giorgio series. These works reflect the final evolution of his style, from the minutely refined elegance of his earliest efforts in the Visconti Hours, datable to between 1420 and 1430 and still tied to the courtly manner of his Lombard predecessors, into an entirely personal and eccentric monumental idiom with an aggressively immediate visual impact.

1. This provenance is recorded on the back of old photographs of this leaf and three others from the same series formerly in the Lehman collection (cat. nos. 58c and 59a–b). There is no record in the Robert Lehman Collection archives to support De Ricci's statement that they were acquired from Olschki in 1923. An invoice from Olschki, dated 1924, records the purchase of only one leaf by Belbello (cat. no. 58d) among other unrelated manuscripts.
2. Sylvie Béguin (1957, p. 108, no. 156) had previously proposed an attribution to the circle of Belbello for one of these leaves (cat. no. 58d).

58c
Saint Stephen in an Initial T

Circa 1467–70
Leaf from an antiphonary

Tempera and gold leaf on parchment. Leaf: 22¼ × 16 in. (56.5 × 40.7 cm). Initial: 6⅜ × 6⅝ in. (16.4 × 17 cm). Stave: 4.2 cm

Recto: [iu]sti dice[n]tes gloria/ i[n] excelsis deo alle/luia. [rubr.] c. Mag[ni]fic[amus] [rubr.] Pro sa[nc]/to ste/phano/ anty./Tu p[ri]nci/patu[m] te. Verso: nes i[n] choro ma[r]tyru[m]/ similis a[n]gelo q[ue] p[ro] te/ lapida[n]tib[us] deum de/precat[or] es beate Ste/ phane int[er]cede p[ro] no[bis]

PROVENANCE: San Giorgio Maggiore, Venice; Bruscoli, Florence, 1924
LITERATURE: De Ricci 1937, p. 1708, C.33 (as page from A.4, choir book, early 15th century, written in northern Italy); Levi D'Ancona

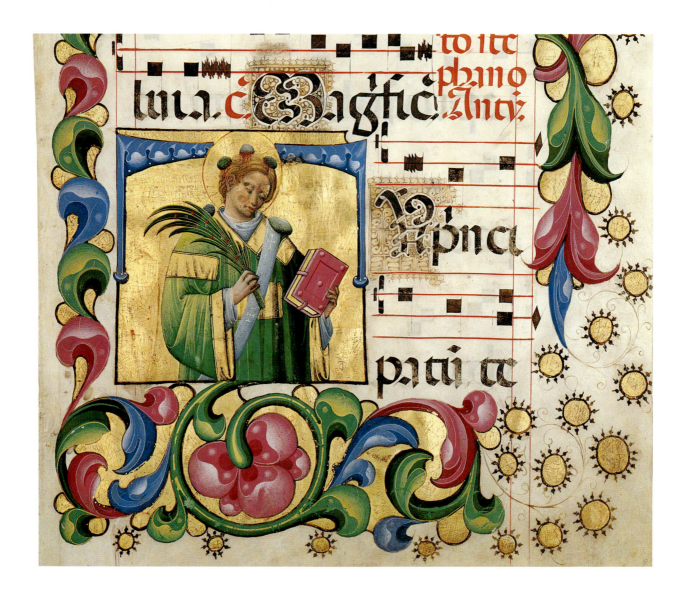

1970, p. 55 (as Belbello da Pavia); Mariani Canova 1978a, pp. 47–48, n. 15 (as Belbello, possibly from the San Giorgio Maggiore series); Mariani Canova 1988, p. 114 (as Belbello, from the same San Giorgio Maggiore volume as Cini 2093); Melograni 1995, p. 24, n. 104 (as Belbello, from the same San Giorgio Maggiore volume as Cini 2093); De Floriani 1996, p. 40, n. 12 (as Belbello, from San Giorgio Maggiore Antiphonary M); Palladino 2002 (as Belbello, from San Giorgio Maggiore Antiphonary P)

The initial T illustrates the first antiphon at first vespers ("Tu principatum tenes in choro martyrum" [You are first among the choir of martyrs]) for the Feast of Saint Stephen (December 26). This leaf is one of two surviving fragments by Belbello, illustrating the same feast, that were originally inserted between the

present folios 31 and 32 of the Metropolitan Museum's *Antiphonary P* from San Giorgio Maggiore. Above the *Saint Stephen* is the conclusion of the antiphon of the Magnificat at second vespers for Christmas Day (December 25), the text of which begins on folio 31v.

Following the present leaf and preceding folio 32 in *Antiphonary P* was a leaf with the *Stoning of Saint Stephen in an Initial L,* in the Cini Collection, Venice (2094), previously associated with the *Annunciation* frontispiece by Giordana Mariani Canova (1978a, pp. 48–49). The initial L, located on the Cini leaf's verso, illustrates the first antiphon at lauds ("Lapidaverunt Stephanum" [They stoned Stephen]) for the Feast of Saint Stephen, the text of which is continued at the top of folio 32r.

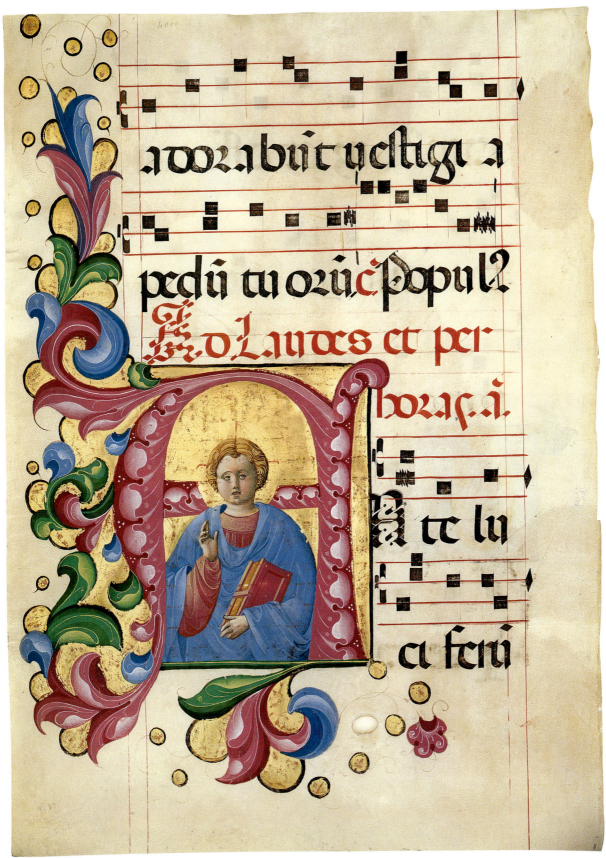

adorabut veſtigi a

pedu tuozū cõpulr

Ro Laudcs et per

horas. i.

tt lu

ca feri

58d
Young Christ Blessing in an Initial A

Circa 1467–70
Leaf from an antiphonary

Tempera and gold leaf on parchment. Leaf: 22 ⅛ × 16 in. (56.3 × 40.7 cm). Initial: 8 × 8 ½ in. (20.4 × 21.6 cm). Stave: 4.2 cm

Recto: [inqui]ram[us] eum et offeram[us]/ ei munera aurum/ thus et miram all[elui]a euouae / Venie[n]t ad te q[ue] detraheba[n]t tibi et. Verso: adorabunt vestigia/ ped[um] tuorum/[rubr.]c. Popul[us]./ [rubr.]*Ad laudes et per horas a.*/Ante luciferu[m]/

On recto, in center right margin, in black ink: 82

PROVENANCE: San Giorgio Maggiore, Venice; Olschki, Florence, 1924
LITERATURE: De Ricci 1937, p. 1708, c.33 (as page from A.4, choir book, early 15th century, written in northern Italy); Béguin 1957, p. 108, no. 156 (as circle of Belbello da Pavia); Cincinnati, 1959, p. 32 no. 332 (as Umbrian Master, 15th century); Levi D'Ancona 1970, p. 55 (as Belbello); Mariani Canova 1978a, pp. 45, 47, n. 15, fig. 82d (as Belbello, from the San Giorgio Maggiore series); Stefani 1985, p. 846, n. 105 (as Belbello, from the San Giorgio Maggiore series); Mariani Canova 1988, p. 114 (as Belbello, from the same San Giorgio Maggiore volume as Cini 2093); Melograni 1995, p. 24, n. 104 (as Belbello, from the same San Giorgio Maggiore volume as Cini 2093); De Floriani 1996, p. 40, n. 12 (as Belbello, from San Giorgio Maggiore Antiphonary M); Palladino 2002 (as Belbello, from San Giorgio Maggiore Antiphonary P)

This fragment is one of several missing leaves originally inserted between the present folios 39 and 40 of the Metropolitan Museum's Antiphonary P from San Giorgio Maggiore. The initial A, with an unusual depiction of Christ as a youth, illustrates the first antiphon at lauds ("Ante luciferum genitus" [Begotten before the Daystar]) for the Feast of the Epiphany (January 6), the text of which is continued on the top of folio 40.

On the present leaf's recto is an illuminated letter V, introducing the third nocturn antiphon ("Venient ad te" [They come to you]) for the same feast. The decorative vocabulary of this initial, distinct from Belbello's, betrays the intervention of the collaborator known as Master of Antiphonary Q in San Giorgio Maggiore, who was also responsible for the following two Lehman fragments from the series (cat. nos. 59a–b).

Master of Antiphonary Q in San Giorgio Maggiore

Veronese, active third quarter of the fifteenth century

59a
Kiss of Judas in an Initial M

Circa 1467–70
Frontispiece from an antiphonary

Tempera and gold leaf on parchment. Leaf: 22 1/16 × 15 ¼ in. (56.2 × 38.8 cm). Initial: 12 ½ × 11 ½ in. (32.4 × 29.5 cm). Stave: 4.2 cm

Recto: [rubr.] *[I]ncipit secu[n]da pars a[n]tipho/narii te[m]poris. Sabbato ante/ dominica[m] de passione ad ve/sperum R[espon]sum prolixum.* Verso: Mul/ti/pli/ca/ti sunt q[ui] tri[bulant]

PROVENANCE: San Giorgio Maggiore, Venice; Bruscoli, Florence, 1924
LITERATURE: De Ricci 1937, p. 1708, c.33 (as page from A.4, choir book, early 15th century, written in northern Italy); Levi D'Ancona 1956, p. 34 (as Veronese); Mariani Canova 1973, p. 63, n. 65 (as Master of Antiphonary Q in San Giorgio Maggiore); Mariani Canova 1978a, p. 48, n. 15, p. 50, n. 12 (as Master of Antiphonary Q); Palladino 2002 (as Master of Antiphonary Q, ca. 1467–70)

The initial M illustrates the first response at vespers ("Multiplicati sunt qui tribulant me" [How many are my adversaries]) for the Saturday before Passion Sunday. As noted by the rubric on the recto, this leaf was originally the frontispiece of a missing second volume in the San Giorgio Maggiore antiphonary series, covering Passion and Holy Weeks. During the later rebinding of the series a section of this volume was inserted into the Metropolitan Museum's Antiphonary P, between the present folios 76 and 85 (see cat. no. 58a). This insertion begins on folio 77 with the second nocturn for Passion Sunday and concludes on folio 84 with Wednesday of Holy Week. The evidence of several missing leaves between folios 76 and 77 suggests that the present frontispiece might also have been rebound into this volume.[1]

This fragment was first attributed by Giordana Mariani Canova (1973, 1978a) to the anonymous artist she named "Master of Antiphonary Q in San Giorgio Maggiore." In addition to his activity in that volume, this illuminator, who, together with Belbello, appears to have been awarded the main share of the commission,

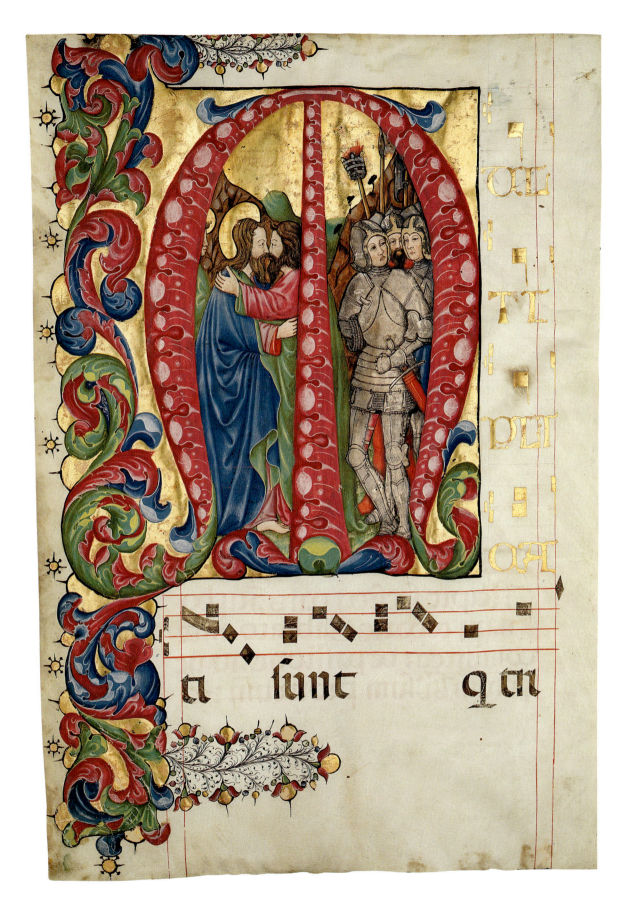

a sunt · q m

was also responsible for most of the illuminations in Antiphonary R, as well as being involved in the decoration of at least two volumes of a missing gradual, of which only a few fragments survive (Mariani Canova 1973, p. 50). His authorship of many of the painted initials throughout Antiphonary P suggests, moreover, that he may have been involved with Belbello in the execution of some of the missing historiated initials in that volume.

In contrast to Belbello's eccentric but monumental idiom, the style of the Master of Antiphonary Q is defined, above all, by a fastidious concern with decorative details, at the expense of spatial and formal clarity, and by a caricatural expressiveness that betray a fundamental allegiance to the courtly vocabulary of a previous generation of illuminators active in Lombardy and the Veneto. Based on the identification of his hand in a gradual from the Benedictine Monastery of San Zeno Maggiore, Verona (Biblioteca Civica, MS 738), Mirella

Levi D'Ancona (1956, pp. 33–34), followed by Mariani Canova and others (Castiglioni and Marinelli 1986, pp. 47–49, 185–87), first suggested a Veronese origin for the artist. To the body of works grouped around the master's name by Mariani Canova (1973) and more recent authors (Marcon 1999, pp. 190–91) should be added an antiphonary formerly on the art market in London (Christie's, June 28, 1995, lot 21), datable to the same period as the San Giorgio volumes.[2]

1. Two more folios from the same missing volume are at present inserted in Antiphonary Q in San Giorgio Maggiore (fols. 107–8).
2. The illuminations in this volume, mistakenly attributed to the Sienese artist Pellegrino di Mariano, closely reflect the style of the master in the San Giorgio antiphonaries. However, the fact that it duplicates in part the contents of Antiphonary R and that it does not correspond in stave height to any of the San Giorgio volumes would seem to preclude an association with the same series.

59b
Three Marys at the Tomb in an Initial V

Circa 1467–70
Leaf from an antiphonary

Tempera and gold leaf on parchment. Leaf: 22 3/16 × 16 in. (56.3 × 40.5 cm). Initial: 6 11/16 × 6 5/8 in. (17 × 16.8 cm). Stave: 4.2 cm

Recto: [alle]luya alleluya [rubr.]*ps.*/ Laudate dominu[m]/ om[n]es gentes lauda/te eum omnes po/puli.[rubr.] . . . *a.* Vespere. Verso: Vespere/ autem/ sabbati que luce/scit in prima sabba/ti venit maria mag[dalene]

PROVENANCE: San Giorgio Maggiore, Venice; Bruscoli, Florence, 1924
LITERATURE: De Ricci 1937, p. 1708, c.33 (as page from A.4, choir book, early 15th century, written in northern Italy); Mariani Canova 1978a, p. 48, n. 15, p. 50, n. 12 (as Master of Antiphonary Q); Palladino 2002 (as Master of Antiphonary Q, ca. 1467–70)

This leaf was originally included in the same missing antiphonary volume, covering Passion and Holy Weeks, as the preceding frontispiece by the Master of Antiphonary Q. The initial V, identical in style and execution to the frontispiece, illustrates the first antiphon at vespers ("Vespere autem sabbati" [Now

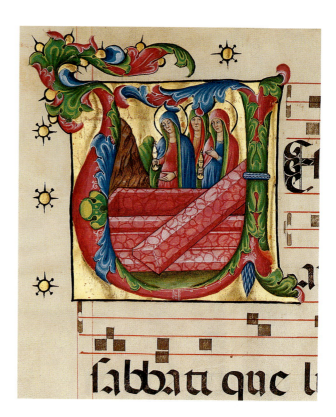

after the Sabbath]) for the Easter Vigil and may have been one of the last illuminations decorating the original volume.

Fig. 31 Second Master of Antiphonary M in San Giorgio Maggiore, *Initial L* (cat. no. 59b, recto)

The illuminated letter L (fig. 31) on the leaf's recto, introducing the psalm ("Laudate Dominum" [Praise the Lord]) at vespers for the Easter Vigil, may be attributed to the anonymous artist who collaborated with Belbello in the decoration of Antiphonary M in San Giorgio Maggiore, the so-called Second Master of Antiphonary M in San Giorgio Maggiore. This illuminator was also active in the series of choir books made for Cardinal Bessarion (Biblioteca Malatestiana, Cesena, Bessarion I; see above, cat. nos. 42–45). The master's decorative vocabulary is closely derived from the late Gothic, Lombard models of Giovannino de Grassi and Michelino da Besozzo.

Circle of Master of the Murano Gradual

Veneto, circa 1470

60
Prophet in an Initial I

Cutting from an antiphonary
New Haven, Yale University Art Gallery, 1954.7.4

Tempera and gold leaf on parchment. 9⅛ × 6³⁄₁₆ in. (23.2 × 15.7 cm)

Verso: ti me d[omi]ne de/ In di/ ulationis me

PROVENANCE: Paris, 1953;[1] gift of Robert Lehman to Yale University, 1953
LITERATURE: Seymour 1970, cat. no. 185, pp. 246–47 (as Venetian school [?], early 15th century)

The initial I, excised from an unidentified antiphonary, illustrates the first response at matins for Palm Sunday:

"In die qua invocavi te, Domine" (When I called to you, Lord). Fragments of the succeeding versicle ("In di[e trib]ulationis me[ae]" [In the day of my distress]) are preserved on the verso. The miniature was tentatively associated with the Venetian school, about 1420, by Charles Seymour (1970), who cited an unpublished opinion by Pietro Toesca.

A Venetian context for this fragment is supported by its stylistic proximity to a group of miniatures generally attributed to the so-called Master of the Murano Gradual, named after a series of cuttings divided between various collections, the provenance of which may be traced to a lost gradual from the Monastery of San Michele a Murano, Venice (Edith Kirsch, in Nordenfalk et al. 1975, pp. 70–74, with previous bibliography). Toesca (1930, pp. 93–94), who recognized the same hand in a gradual volume probably from the same series in the Kupferstichkabinett, Berlin (78 F I),[2] first identified this artist as a follower of Belbello

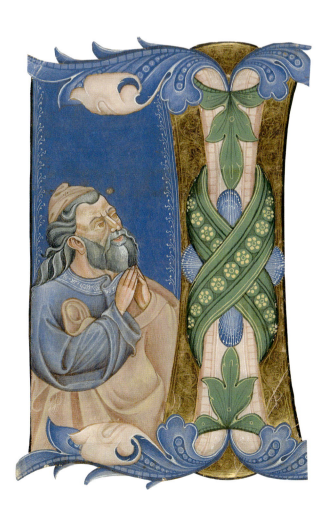

vocabulary consonant with late Lombard manuscript production, these works, as noted by Mulas *(loc. cit.)*, still reflect an allegiance to a late Gothic decorative idiom inspired by Belbello da Pavia, albeit integrated with figural and spatial concepts derived from contemporary monumental painting in Pavia and its environs.

All of the works hitherto attributed to this master appear to have been made for Benedictine monasteries that belonged to the congregation of Santa Giustina, Padua (Canova 1984, p. 490), suggesting that the artist

might have been a monk of this order. Among his later production must be counted a richly illuminated Benedictine psalter, formerly in the Jacques Rosenthal Collection, Munich, and now in the Boston Public Library (MS pf Med. 97), that was previously listed (in Hindman 1988, p. 31) as "location unknown."[2]

1. According to a note on the back of an old photograph.
2. I am indebted to Jonathan Alexander for directing me to this volume.

Frate Nebridio

Cremonese, active second half of the fifteenth century

62a

Saint Nicholas of Tolentino in an Initial E

Circa 1460–80
Cutting from an antiphonary

Tempera and gold leaf on parchment. 3¾ × 4¼ in. (9.5 × 10.7 cm). Stave: not visible

Verso: est qui. ante [Deum magna/virtu]tes operatus[est et omnis terra doctrina/ e]ius repleta est ip[se intercedat]. In a later hand, in pencil: "from the Cathedral of Como"

PROVENANCE: William Young Ottley; Lord Northwick (sale, Sotheby's London, November 16, 1925, lot 123)
LITERATURE: De Ricci 1937, p. 1715, C.20 (as Lombardy, ca. 1480)

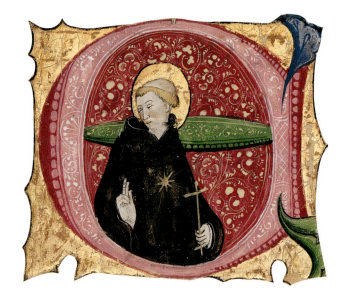

62b

Saints Maurice and Theofredus in an Initial A

Circa 1460–80
Cutting from an antiphonary

Tempera and gold leaf on parchment. 4½ × 4½ in. (11.5 × 11.5 cm). Stave: 3 cm

Verso: Text is covered by the remains of the paper onto which the miniature was previously pasted. In a later hand, in pencil: "from the Cathedral of Como"

PROVENANCE: William Young Ottley; Lord Northwick (sale, Sotheby's London, November 16, 1925, lot 123)
LITERATURE: De Ricci 1937, p. 1715, C.19 (as Lombardy, ca. 1480)

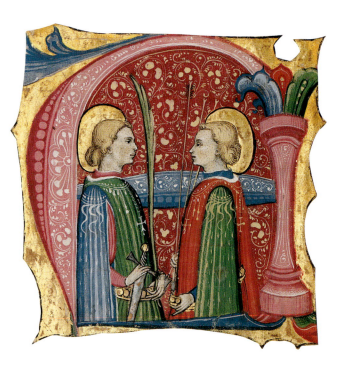

62c

Saint Holding a Casket in an Initial I

Circa 1460–80
Cutting from an antiphonary

Tempera and gold leaf on parchment. 4 × 3½ in. (10.1 × 9 cm).
Stave not visible

Verso: [Scuto]bone vol[untatis tuae/coronasti]domine.
[rubr.]*ps.*/[…]In universa t[erra gloria et honore/coro]nasti eu[m]
d[omi]ne. In a later hand, in pencil: "from the Cathedral of Como"

PROVENANCE: William Young Ottley, Lord Northwick (sale,
Sotheby's London, November 16, 1925, lot 118)
LITERATURE: De Ricci 1937, p. 1715, c.24 (as Lombardy, ca. 1480)

62d

Augustinian Nuns in a Church in an Initial I

Circa 1460–80
Cutting from an antiphonary

Tempera and gold leaf on parchment. 4½ × 4⅜ in. (11.3 × 11 cm).
Stave not visible

Verso: [orave]rit ad s[an]c[t]uarium[tuum. Exaudi. Gloria patri.
Exaudi/[rubr.] *in inoct.an.* No[n est hic aliud/nisi do]mus dei.[et]
po[r]ta [celi. Alleluia]/[rubr.]*an.* Vidit ia[cob scalam/summita]s
ei[us] celos tang[ebat et descendentes/an]gelos. [Et] dixit[:vere
locus]. In a later hand, in pencil: "from the Cathedral of Como"

PROVENANCE: William Young Ottley, Lord Northwick (sale,
Sotheby's London, November 16, 1925, lot 118)
LITERATURE: De Ricci 1937, p. 1715, c.23 (as Lombardy, late 15th
century)

These four fragments, identical in style, palette, and
foliate border, were probably excised from the same
volume of an unidentified antiphonary for Augustinian
use. The first two cuttings illustrate, respectively, the
Benediction antiphon ("Euge, serve bone" [Well
done, good servant]) for the Feast of Saint Nicholas of
Tolentino (September 10) and the first response of the
first nocturn ("Abstergat Deus" [God will wipe away])

for the feast of Saint Maurice and His Companions
(September 22).[1] The third fragment, with a martyr
saint in physician's dress, tentatively identified
as Cosmas or Damian (whose feast is celebrated
September 27), illustrates the first antiphon at vespers
("Iste sanctus" [This saint]) for the Common of One

an initial D with *Saints Philip and James,* excised from the same sanctoral volume; and an initial S with the *Resurrection,* excised from a temporal volume. The presence of Saint Nicholas of Tolentino in the Philadelphia initial and the close stylistic relationship between this group of fragments and those by Coldiradi in the Museo Civico, Cremona (D.42–44, 46–48), which include Augustinian nuns, suggest that they may have been part of a single choir book series, possibly executed for an Augustinian female institution. The same provenance may tentatively be proposed for the other surviving cuttings by Coldiradi discussed by Melograni—among them a group of six antiphonary fragments in the Bodleian Library, Oxford (MS Douce D.13)—which are also similar in style and decoration to the Cremona initials.

Like the four Lehman miniatures by Frate Nebridio that appeared in the Lord Northwick sale (cat. nos. 62a–d), the Oberlin and Philadelphia fragments are inscribed "from the Cathedral of Como." Nonetheless, a Cremonese provenance is confirmed by the presence of the motto "Usque Quo" in the Oberlin cutting; in fact, the same inscription, accompanying a coat of arms identified by Alfredo Puerari (1976, p. 93) as that of the Meli family of Cremona, appears in a series of unhistoriated initials of unknown provenance in the Museo Civico, Cremona (D.57–59). Coincidentally, these initials reflect the decorative vocabulary of Frate Nebridio, as found in the Lehman miniatures. It is therefore tempting to conclude that both groups of fragments discussed here, by Frate Nebridio and by Coldiradi, originated from the same choir book series for an Augustinian female institution in Cremona, which may be tentatively identified as the former church and monastery of Santa Monica.

Girolamo da Cremona

Veneto, documented between 1460 and 1483

64

God the Father in an Initial D (or O)

Circa 1470–74
Cutting from an antiphonary (?)
New Haven, Yale University Art Gallery, 1954.7.2

Tempera and gold leaf on parchment. 9 7⁄16 × 7 5⁄8 in. (23.9 × 19.4 cm)

Verso: donis b[ea]tis mu/ ac pat[i]na claritas/ affati ab sit libro/ a[…]is q[uem] actus noxiu/ sit ul[…] lubrica [con]pa/ po[n]is p[er] qua[m] a[…]ni i/ acrius. Ob ho…

No staves on verso

PROVENANCE: Paris, 1953;[1] gift of Robert Lehman to Yale University, 1954
LITERATURE: Seymour 1970, p. 215, no. 161 (as Girolamo da Cremona, ca. 1465–70); Christiansen 1989, pp. 287–88 (as Girolamo da Cremona, ca. 1473); De Marchi 1993, p. 235, n. 18 (as Girolamo da Cremona, Sienese period)

The present cutting was first published by Charles Seymour (1970) as a work of Girolamo da Cremona, one of the principal Italian illuminators of the second half of the fifteenth century. This identification was subsequently confirmed by Keith Christiansen (1989), who compared the fragment to the illuminations executed by Girolamo in a series of choir books for the Cathedral of Siena, datable to between 1470 and 1474.[2]

Despite the epithet "da Cremona," deriving from his father's origins in that city, Girolamo was probably born in Mantua, where his father was employed as a painter at the Gonzaga court.[3] The first record of Girolamo's activity as an illuminator is a letter dated 1461 from Barbara of Brandenburg, wife of Ludovico II Gonzaga, to her son Francesco; in it the marchioness expresses her decision to entrust the completion of the decoration of a missal begun by Belbello da Pavia in 1442 to a "young man from these parts who illuminates very well."[4] Based on the close correspondence between the illuminations in this missal, still in Mantua (Archivio Storico Diocesano, Capitolo della Cattedrale), and the artist's later documented works, scholars have unanimously identified the nameless "young man"

as Girolamo, who by this early date was already known as one of the best illuminators of his generation. Visual evidence suggests that preceding his engagement at the Gonzaga court, Girolamo was active in Ferrara, illuminating parts of the famous Bible of Borso d'Este, completed between 1455 and 1461. In addition to working in Ferrara and Mantua, Girolamo was also entrusted

with major commissions for both secular and liturgical manuscripts in Padua, Siena, Florence, and Venice, where he is last documented in 1483.[4]

As most recently emphasized by Andrea De Marchi (1993, pp. 228–37, 522) and Federica Toniolo (1997, p. 447), the single, dominant influence in the evolution of Girolamo's style was the art of Andrea Mantegna

(1431–1506), the first painter to introduce a modern, classically inspired Renaissance vocabulary in northern Italy.[5] The impact of Mantegna's art is reflected in the spatial clarity and meticulous attention to detail of the Yale fragment, as well as in the architectural rendering of the initial itself, envisioned as an elaborately carved frame with motifs loosely derived from antiquity. Also derived from Mantegna are the sculptural cherubim and seraphim inside the initial, recalling the early works produced by the painter in Ferrara, which Girolamo would have seen firsthand (Christiansen 1989, p. 288).

At the same time, however, the feeling of quiet, classical restraint that pervades Girolamo's previous production is disrupted in the Yale cutting by the broken folds and lively flutter of the voluminous draperies on the figure of God the Father. The resulting agitated atmosphere is also characteristic of Girolamo's illuminations in the choir books of Siena Cathedral and may reflect the influence on the artist of the exuberant, expressionistic vocabulary of his collaborator in this commission, Liberale da Verona.

1. As recorded by Seymour (1970).
2. The absence of staves would appear to suggest that the fragment was excised from a psalter, as stated by Christiansen (1989). However, the fragments of text on the verso do not conform to any of the psalms. Like the Frate Nebridio antiphonary cuttings in this volume (cat. no. 62a–d), clearly excised from an antiphonary for Augustinian use and without staves, the present fragment may also reflect an antiphonary text specific to a particular congregation.
3. For a complete bibliography and summary of the vast literature on the artist, with accompanying biography, see Toniolo 1994, pp. 241–47.
4. Prior to this date, the artist is named in a notarial document of 1460. The date 1451 read by Mirella Levi D'Ancona (1964, pp. 49–50) on a miniature by Girolamo in the Wildenstein Collection, Paris, though sometimes reported as the first record of the artist's activity (Christiansen 1989), was actually proven to be nonexistent by subsequent authors (see Toniolo 1994, p. 246, n. 6, with previous bibliography).
5. As pointed out by De Marchi (1993, p. 228), visual and circumstantial evidence suggests that the two artists probably met in Padua, prior to Girolamo's engagement at the Gonzaga court in Mantua. It was Mantegna, in fact, who was responsible for acting as an intermediary between Girolamo and Barbara of Brandenburg in the commission for her missal and who later accompanied Girolamo to Florence.

Lombard Artists
Active circa 1460–70

65a
Young Martyr Saint in an Initial E
Cutting from an antiphonary (?)

———

Tempera and gold leaf on parchment. 8¾ × 8⅞ in. (22.2 × 22.5 cm)

———

Blank verso

———

PROVENANCE: Lord Northwick (sale, Sotheby's, London, November 16, 1925, lot 144)
LITERATURE: De Ricci 1937, p. 1715, C.28 (as northern Italy, ca. 1480)

65b
Adoration of the Trinity in an Initial D
Cutting from an antiphonary (?)

———

Tempera and gold leaf on parchment. 6⅝ × 6⅜ in. (16.7 × 16.2 cm)

———

Verso: Not visible (cutting glued on board)

———

PROVENANCE: Hammond Smith, New York, 1922
LITERATURE: Comstock 1927, p. 57 (repr. p. 50) (as North Italian, early 15th century); De Ricci 1937, p. 1709, D.2 (as northern Italy, early 15th century

These two fragments, closely related in style, execution, and palette, may have been excised from different volumes in the same antiphonary series. The blank verso of the initial E suggests that this miniature was originally part of a frontispiece leaf, possibly to a Common of Saints.[1] The initial D, with six kneeling apostles adoring the Trinity, may illustrate the invitatory antiphon at matins for Trinity Sunday ("Deum verum unum in Trinitate et Trinitatem in Unitate venite adoremus" [The true God, One in Three and Three in One, come let us adore]). This cutting would have been included in a separate temporal volume.

Following a recent suggestion by Jonathan Alexander (verbal communication), both cuttings may be related to a group of miniatures attributed to a follower or to the school of Girolamo da Cremona now divided among the Library of the Monastery of Santa Giustina, Padua (cor. 2), the Fitzwilliam Museum, Cambridge (MS Marlay 18), and the Colchester Castle Museum (221.32).

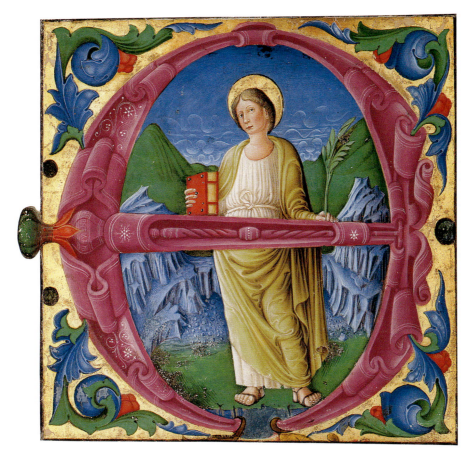

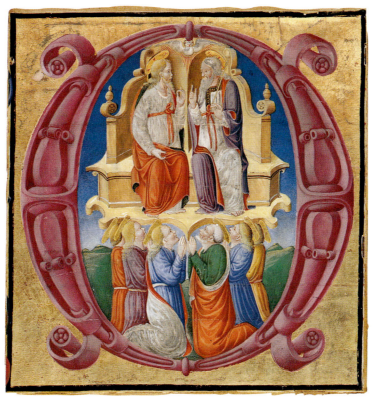

Fig. 33 Lombard artist, ca. 1460–70, *Enthroned Virgin and Child with Kneeling Saints and Benedictine Monks.* Gradual, Colchester Castle Museum, fol. 19v

The volume in the Monastery of Santa Giustina, an antiphonary from the third Sunday of Lent to the Saturday after Pentecost, is missing many of its illuminations and now contains only painted letters and two large-scale miniatures. These were first published as works of a collaborator of Girolamo da Cremona by Giordana Mariani Canova (1970, p. 43), who noted their dependence in style and decorative vocabulary upon Girolamo's two well-known cuttings in the Wildenstein Collection, Paris (Musée Marmottan, no. 64), and the Victoria and Albert Museum, London (M. 817), both of which were probably included in another volume of the same series (Toniolo 1999, pp. 257–58).[2]

The same elements that distinguish the miniatures in the Santa Giustina antiphonary also appear in five related cuttings in the Fitzwilliam Museum, identified by Mariani Canova (1984, p. 480) as missing fragments of the same volume: an initial R with *Christ in the Temple;* an initial A with the *Resurrection;* an initial V with the *Ascension;* an initial D with the *Pentecost;* and an initial S with the *Corpus Christi Procession.* These fragments were, in turn, attributed by Alexander (1985, pp. 122–24) to the same hand that executed the miniatures in Colchester, which are included in a gradual volume bearing the ownership inscription of the Benedictine monastery of San Benedetto in Polirone, near Mantua, and the date 1462.

All of the illuminations discussed above, while equally indebted to the vocabulary of Girolamo da Cremona, actually reflect in their execution the participation of several artists working together in a single

workshop. The distinction already drawn between two, possibly three, different hands in the Fitzwilliam Museum cuttings (Giles and Wormald 1982, pp. 80–81) also applies to the Colchester gradual. To a greater or lesser extent the two Lehman fragments reflect elements derived from each group. Both cuttings, for example, share the same strapwork initial style found on folios 9v and 19v of the Colchester gradual. The author of the *Enthroned Virgin and Child with Kneeling Saints and Benedictine Monks* on folio 19v in Colchester (fig. 33) may, in fact, be identified as the painter of the Lehman *Saint.* The Lehman *Adoration of the Trinity,* on the other hand, while recalling the composition of the Colchester miniature, reflects more closely the figural vocabulary of the Fitzwilliam Museum *Pentecost* (fig. 34) and *Ascension,* both probably by a different artist. As the subject of the Lehman *Trinity* corresponds to one of the missing leaves in the Santa Giustina antiphonary, it is possible that, like the Fitzwilliam Museum miniatures, it, too, might have been excised from that volume; the differences in the style and palette of the initial itself, however, make any firm conclusion impossible.

1. The saint cannot be identified by any attributes. The Common of Saints frequently begins with the Common of Apostles, in which case the initial E could introduce the response in the first nocturn ("Ecce ego mitto vos" [Behold I am sending you forth]).
2. To the Paris and London miniatures was recently added a third, previously unknown cutting by Girolamo in the Musée Condé, Paris (Toscano 2000, pp. 32–35).

Fig. 34 Lombard artist, ca. 1460–70, *Pentecost in an Initial D.* Fitzwilliam Museum, Cambridge, MS Marley 18

Domenico Morone

Veronese, circa 1442–after 1518

66

David with His Foot in a Noose in an Initial O

Circa 1500
Cutting from a gradual

New York, The Metropolitan Museum of Art, Robert Lehman Collection, 1975 (1975.1.2483)

Tempera and gold leaf on parchment. Cutting: 7⅜ × 6⅛ in. (18.6 × 15.5 cm). Initial: 6¼ × 6⅛ in. (15.9 × 15.4 cm). Stave: 4.4 cm

Verso: me et mi/[serere me]i. quoni[am]

PROVENANCE: Maggs Brothers, London
LITERATURE: Levi D'Ancona 1997, no. 26, pp. 185–88, with previous bibliography (as Martino da Modena, 1470s)

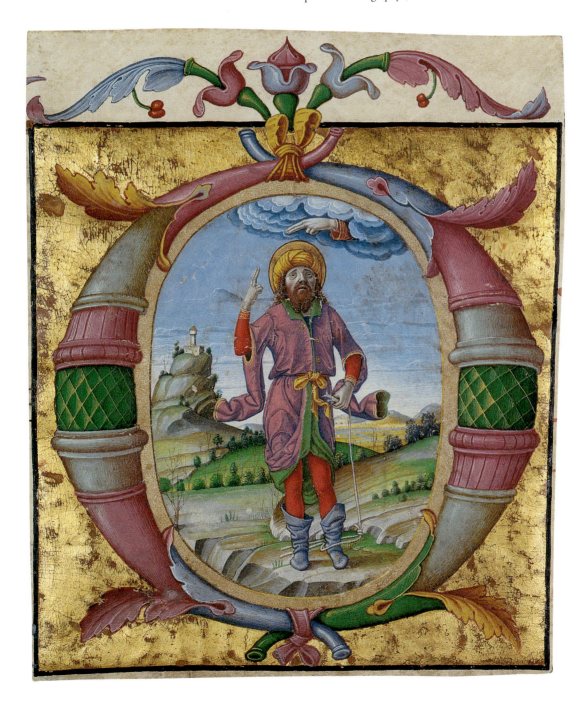

The initial O illustrates the introit to the mass for the third Sunday of Lent: "Oculi mei semper ad Dominum quia ipse ellevet de laqueo pedes meos" (My eyes are ever toward the Lord: for he shall pluck my feet out of the snare). This text, derived from Psalm 24:15, is continued on the verso of the cutting: "[respice in] me e mi[serere me]i quoni[am unicus et pauper sum ego]" (Look Thou upon me, and have mercy on me; for I am alone and poor). Inside the initial is the figure of the psalmist David holding the end of a noose around his foot and looking up to God, whose hand appears out of a cloud to bless him. The fragment was originally inserted in the temporal volume of an unidentified gradual.

This miniature, previously attributed to Benvenuto di Giovanni, Girolamo da Cremona, and Domenico Morone, was most recently catalogued by Mirella Levi D'Ancona as a work of the illuminator Martino da Modena, active in Bologna and Ferrara in the 1470s and 1480s. The similarities between Martino's production and the Lehman fragment, however, are only superficial and confined mainly to shared iconographic elements. Beyond these, the articulation of the initial itself finds no parallels in the production of Martino da Modena but reflects the fantastic, architectonic, decorative vocabulary typical of late-fifteenth- and early-sixteenth-century illumination in northern Italy (see cat. no. 70).

A more convincing attribution for the Lehman fragment was proposed by Hans-Joachim Eberhardt (1986, pp. 103–13), who included it among a small group of miniatures attributable to the late-fifteenth-century Veronese painter Domenico Morone. In addition to the Lehman initial, the group consists of a *Nativity in an Initial H* in the Kupferstichkabinett, Berlin (629); an *Ascension in an Initial D* (or O) recently on the art market in London (Maggs Brothers, *European Bulletin No. 18*, 1993, no. 14); and a *Virgin and Child with Angels in an Initial S,* formerly on the art market in Berlin (Graupe, December 12, 1927, no. 63). As pointed out by Eberhardt, these works reflect Domenico Morone's production in the last phase of his activity, from the late 1490s into the first decade of the sixteenth century.

Although a signed miniature in the Robert Lehman Collection documents his son Francesco's activity as an illuminator (cat. no. 86), the extent of Domenico Morone's own involvement in this medium remains unknown. Aside from the cuttings listed above, the artist's production consists mainly of large altarpieces and small devotional panels, as well as frescoes. Among these the most closely related to the Lehman *David* are the signed and dated 1502 fresco fragments in the Museo di Castelvecchio, Verona (2070, 2071), and the slightly later predella panels with scenes from the life of Saint Blaise in the Museo Civico Vicenza (A41, A162), where one finds similar figural types and the same plastic rendering of draperies, shown clinging to the body or caught in a voluminous flutter. The arid landscape with rocky outcrops that appears in the background of the Vicenza scenes is also comparable to that of the Lehman miniature. Similarly, the style of the decorative borders and surrounds that appear in other works by Morone from the same period, characterized by inverted candelabra and acanthus-leaf motifs, closely recalls that of the Lehman initial and its related fragments.

Girolamo Dai Libri

Veronese, 1474–1555

67
Ascension in an Initial V

Circa 1495
Cutting from an antiphonary

Tempera and gold leaf on parchment. 7⅛ × 7¼ in. (18 × 18.3 cm). Stave: 4.4 cm

Verso: veniet allelu[i]a./Cumq[ue]

PROVENANCE: A. Sambon, Paris, 1926
LITERATURE: De Ricci 1937, p. 1711, D.3 (as northern Italy, ca. 1460)

The initial V, excised from an unidentified antiphonary, illustrates the first antiphon at lauds for the Feast of the Ascension: "Viri Galilei, quid aspicitis in caelum?" (Men of Galilee, why do you stand looking up to heaven?). In the banner held by two angels above the Virgin and apostles is a variant of this text that usually introduces the introit to the mass for the same feast: "Viri galilei quid admiramini aspiecientes [in caelum?]." That the

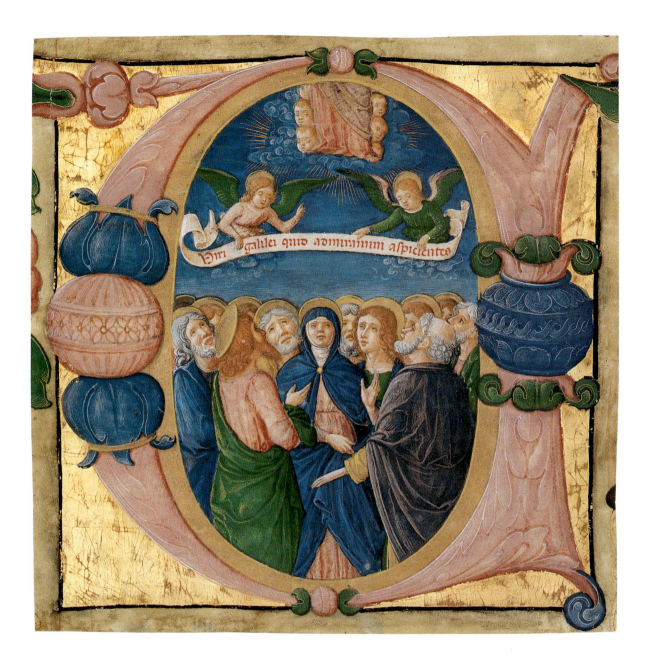

fragment is from an antiphonary and not a gradual is confirmed by the remnants of text on the back of the initial, concluding the first antiphon and beginning the second antiphon at lauds: "…veniet, alleluia. [Euouae.] Cumque [intuerentur]" (…will come, alleluia. And while they were gazing).

This fragment was probably excised from the same antiphonary volume as an initial D with the *Pentecost* in the Breslauer Collection, New York (Voelkle and Wieck 1992, no. 85, pp. 214–15). Identical to the Lehman initial in style, palette, and stave height, the Breslauer *Pentecost* was convincingly published by

Hans-Joachim Eberhardt (1986, pp. 120–21) as an early work of the Veronese painter and illuminator Girolamo Dai Libri, the dominant figure in the production of manuscripts in Verona throughout the first half of the sixteenth century.

Born into a family of illuminators, Girolamo was the son of Francesco Dai Libri (ca. 1452–1505) and grandson of Stefano Dai Libri (doc. 1433–73)—"Dai Libri" meaning "of the books."[1] According to Vasari (1880, pp. 326–33), Girolamo's father, Francesco, illuminated choir books for the principal churches and monasteries in Verona, including the important

Fig. 35 Lombard, circa 1500, *Prophet Zacharias in an Initial D.*
The British Library, London, Add. 18196, fol. 82

Fig. 36 Lombard, circa 1500, *Saint Helena Holding the Cross
in an Initial R.* Location unknown

background. On the other hand, they are distinguished
from these and other works in the same group, such
as the missing Lehman *Saint Helena,* by a harder and
more meticulous execution that might suggest a
different hand in the same workshop.

1. The possibility that the Arcimboldi Missal might be a product
 of the early career of Matteo da Milano, first suggested by
 Jonathan Alexander (1985, p. 113), is left open to question by
 Maria Paolo Lodigiani (1992, p. 98).

Master B.F. (Francesco Binasco?)

Milanese, active late fifteenth century–beginning of
the sixteenth century

70
The Prophet Isaiah in an Initial P

Early 1500s
Cutting from a gradual

———————

Tempera and gold leaf on parchment. 6½ × 6¾ in. (16.5 × 17.2 cm).
Stave: 4.5 cm

———————

Verso: Text partially covered by remnants of paper, onto which the
cutting was originally glued. The following words are visible: [con-
funden]tur. *Com./*[Dominus]dabit

PROVENANCE: Lord Northwick (sale, Sotheby's London, Novem-
ber 16, 1925, lot 151)
LITERATURE: De Ricci 1937, p. 1713, c.17 (as Lombardy, late 15th
century)

The initial P, excised from a gradual, illustrates the
introit to the mass ("Populus Sion" ["O people in
Zion"]) for the second Sunday of Advent. This text is
derived from the Book of Isaiah (30:19), the prophet
depicted inside the initial. Visible on the back of the
initial (the recto of the original leaf) are the conclusion
of the offertory and beginning of the communion
hymn for the first Sunday of Advent.

This miniature was acquired by Robert Lehman in
the Lord Northwick sale together with a second related
cutting, the present location of which is unknown
(Appendix, no. 14). Both fragments may be included
among a stylistically homogeneous group of illumina-
tions, divided between European and American collec-
tions, the provenance of which has been traced to a lost
series of choir books for the Olivetan monastery of
Santi Angeli e Niccolò in Villanova Sillaro, near Lodi
(Levi D'Ancona 1970, p. 99). The series, originally
comprising more than twenty volumes, was dispersed
after the monastery's suppression in 1799, and only
a handful of cuttings and a volume remained in
Villanova Sillaro (now in the Museo Diocesano, Lodi).
Numerous other fragments appeared in the same
Lord Northwick sale with the Lehman initial.

Based on the presence of the initials "B.F." inscribed
on several of the Villanova Sillaro miniatures, their

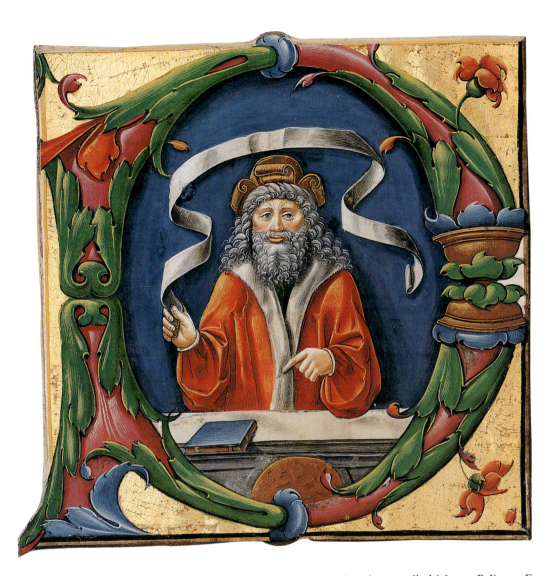

author is conventionally known as Master B.F., the name first assigned him by Paul Wescher (1931, pp. 133–35). This artist's production, which also includes works on panel, has been viewed within the context of the Leonardesque school of painting that developed in Milan in the early sixteenth century. In studying the Villanova Sillaro miniatures, scholars have pointed out the precise derivations of both compositional motifs and figural types from Leonardo, who was active in Milan from the late 1480s. Additionally, it has been noted that some of the landscape elements show direct knowledge of specific engravings by Albrecht Dürer datable to the last years of the fifteenth century, possibly confirming a date for the miniatures' execution in the early 1500s (Strehlke 2001, cat. no. 62, pp. 179–81, with previous bibliography).

In 1960 Wescher (1960, pp. 75–91) first suggested

that the so-called Master B.F. was Francesco Binasco, who is recorded as an illuminator and goldsmith at the court of Francesco II Sforza, duke of Milan from 1522 to 1535. This identification has been accepted without reservation by some scholars but rejected by others on the premise that Binasco's name does not appear in documents before 1513, whereas the earliest works attributed to the Master B.F. would seem to date to the mid-1490s, slightly before the Villanova Sillaro illuminations (Carminati 1995, pp. 111–13, with previous bibliography). Since both sides of the argument are inconclusive, most recent authors (Strehlke, *loc. cit.*) have chosen to leave open the issue of the master's identity, while not entirely dismissing the possibility that the Villanova Sillaro miniatures could represent an early phase in the career of Francesco Binasco.

The initial D, excised from an antiphonary, illustrates the first response at matins for the Feast of Saint Agatha (February 5): "Dum torqueretur beata Agatha in mamilla graviter dixit ad iudicem impie crudelis et dire tyranne" (While blessed Agatha was being cruelly tortured in her breasts, she said to the judge, "Godless, cruel, infamous tyrant"). On the back of the initial (the recto of the original leaf) are fragments of the immediately preceding antiphon at matins for this feast.

The cutting may be associated with a group of stylistically related miniatures in a series of choir books produced for the Olivetan monastery of Montemorcino, Perugia, and subsequently transferred to the Monastery of Monteoliveto Maggiore, Siena.[1] The series was first published by Alberto Serafini in 1912 (1912, pp. 41–66, 233–62; Gualdi 1958, pp. 3–26), by which time, however, many of the volumes were already in fragmentary condition and missing numerous miniatures. The Lehman *Saint Agatha* was excised from Montemorcino Antiphonary M, a sanctoral volume beginning with the Feast of Saint Andrew (November 30) and concluding with the Feast of Saint Scholastica (February 10).[2]

The decoration of the Montemorcino volumes, probably carried out in the last decade of the fifteenth century, was entrusted to a team of anonymous Umbrian illuminators whose style reflects the influence of the early works of Perugino and Pinturicchio. The artist responsible for the Lehman fragment may be identified as the author of the illuminations in Montemorcino Antiphonary Q, who may have been, according to Serafini (1912, p. 260, n. 3), a monk residing in the Monastery of Montemorcino during the late 1490s. His hand has also been identified in a group of other works for Benedictine institutions, including a miniature of *Saint Peter Enthroned* in the 1497 *catasto* (register of landed property) of the Benedictine monastery of San Pietro, Perugia (Archivio di Stato di Perugia, Catastini 2, fol. 2r), and a miniature of *King David* in a psalter in the Biblioteca Storico-Francescana of Chiesa Nuova, Assisi (MS 34, fol. 5v), datable to after 1492 (Lunghi 1987, pp. 246–47, with previous bibliography).

A second cutting by the Master of Montemorcino Antiphonary Q, showing *Job in an Initial S,* is in the Free Library, Philadelphia (M29:6; fig. 38). Closely related to the Lehman *Saint Agatha,* it clearly belonged to another antiphonary volume from Montemorcino. To these fragments may be added a number of single leaves and cuttings by the master that have appeared recently on the art market.[3] Possibly part of the same series, but by a different artist, are two initials in the Staatliche Graphische Sammlung, Munich (Bauer-Eberhardt 1984, nos. 57/1–57/2), showing, respectively, a group of Olivetan monks singing and the funeral of an Olivetan monk.

1. The transfer to Monteoliveto Maggiore took place sometime after 1831, when Pope Gregory XVI ordered the closing of all the Olivetan monasteries in the Papal States (Lugano 1903, pp. 105–6).
2. Antiphonary M was among the many volumes in the Montemorcino series that were recently stolen from Monteoliveto Maggiore. As a result, this information could not be checked and is based on Serafini's summary description of the volume's contents, included in a partial list of other antiphonaries in the series (1912, p. 233, n. 1), and on Todini's (1989, p. 117) description of the subject of the surviving miniatures.
3. Four leaves were formerly in the Pregliasco Collection, Turin (Turin 1984, nos. 18–19; 21–22); two others appeared at Maggs Brothers, London (*European Bulletin No. 19,* 1994, nos. 21–25); sixteen more at Sotheby's, London (July 6, 2000, lots 42–45; December 6, 2001, lot 41); and one at H. P. Kraus, New York (*Isaiah in an Initial P*). These have been variously listed as late-fifteenth-century North Italian, Florentine, and Umbrian.

Fig. 38 Master of Montemorcino Antiphonary Q, *Job in an Initial S.* Free Library, Philadelphia, M29:6

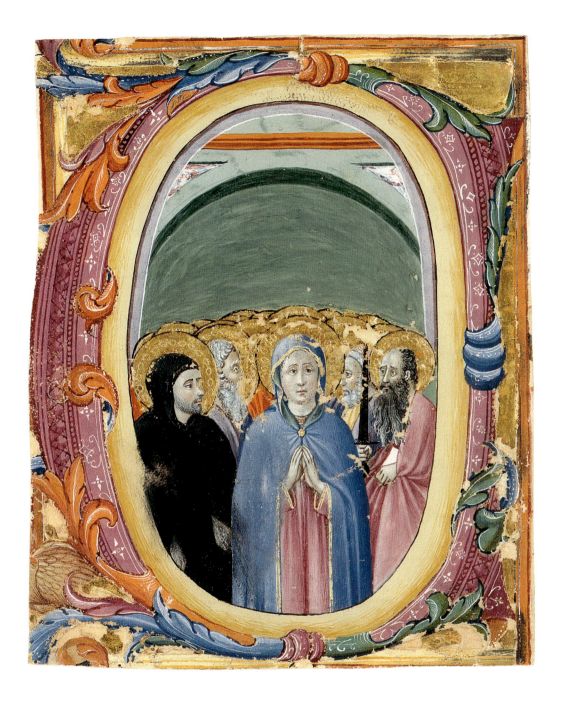

Master of the Osservanza

Sienese, active second quarter of the fifteenth century

73
All Saints in an Initial E

Circa 1430–40
Cutting from an antiphonary

New York, The Metropolitan Museum of Art, Robert Lehman
Collection, 1975 (1975.1.2484)

Tempera and gold leaf on parchment. 6¾ × 5½ in. (17 × 14 cm)

Verso: m pret[er]ita p[re]/ala pellite

PROVENANCE: Maggs Brothers, Paris, 1929
LITERATURE: Levi D'Ancona 1997, cat. no. 17, pp. 138–40, with
previous bibliography (as Master of the Osservanza, possibly 1430s)

The initial E, excised from an unidentified antiphonary, introduces the response at first vespers for the Feast of All Saints (November 1): "Exsultent justi in conspectu Dei" (Let the just exult before God). On the cutting's verso are fragments of the hymn following the first vespers response: "Christe redemptor omnium, conserva tuos famulos....Beata quoque agmina caelestium [spirituu]m pret[er]ita p[resentia, futura m]ala pellite" (Christ, Redeemer of all, preserve your servants...And may the band of celestial souls dispel future evils with their past presence).[1] Inside the initial is the Virgin in prayer, surrounded by saints and apostles; standing next to her in the foreground are Saint Augustine, on the left, and Saint Paul, on the right.

Formerly assigned to Pellegrino di Mariano, this miniature was first recognized by Keith Christiansen (1988, pp. 102–3) as a work of the fifteenth-century Sienese painter known as Master of the Osservanza. This attribution was recently reiterated by Mirella Levi D'Ancona in the 1997 catalogue of the Robert Lehman Collection.

One of the leading Sienese artists of the second quarter of the fifteenth century, the Master of the Osservanza derives his name from a triptych in the Church of the Osservanza, outside Siena, formerly assigned to his better-known contemporary Sassetta (act. by 1423–d. 1450). Based on the disparity in quality and execution among the body of works grouped around the Osservanza altarpiece, which has resulted in a long-standing debate regarding the artist's identity, Christiansen (loc. cit.) tentatively proposed that these paintings might actually be the product of a Sienese compagnia, or collaborative workshop, involving the participation of two or more painters. He defined the master's style in terms of a clear dependance on Sassetta's advanced narrative vocabulary, albeit distinguished by an emphasis on brilliant color harmonies and precious decorative effects denoting a more conservative, late Gothic sensibility.

The Lehman cutting was convincingly associated by Christiansen with two other fragments from the same workshop now in the J. Paul Getty Museum, Los Angeles (90.ms 41), and in the Fitzwilliam Museum, Cambridge (Marlay cutting it 12), showing, respectively, the *Baptism of Saint Augustine in an Initial L* and the *Burial of Saint Monica and Saint Augustine's Departure for Africa*. Based on their subjects, he advanced the hypothesis that these fragments might have been excised from a lost set of choir books for the Church of Sant'Agostino, Siena, and dated this commission to shortly after 1430, when Pope Martin V transported the relics of Saint Monica from Ostia to Rome, where they were deposited in the Church of San Trifone (now Sant'Agostino). Christiansen also pointed out the stylistic relationship of the miniatures to the series of small panels by the master showing episodes from the life of Saint Anthony Abbot, which were dated by him to the mid-1430s (loc. cit., pp. 104–23). An equally pertinent if not stronger comparison may be drawn, however, with a series of predella scenes depicting events from the Passion of Christ (Christiansen, loc. cit., pp. 126–35) that have generally been placed later in the artist's career.

1. For both texts see *Antiphonale monasticum pro diurnis horis . . . Ordinis Sancti Benedicti a Solesmensibus Monachis restitutum*, Tournai, 1934. Although Levi D'Ancona thought that the initial was more likely to be an E, she was unable to find a corresponding text, and therefore proposed that it could instead be an O, introducing the antiphon of the Magnificat for second vespers.

Sano di Pietro
Sienese, 1405–1481

74
Adoration of the Magi in an Initial E
Circa 1462–63
Leaf from a gradual

Tempera and gold leaf on parchment. Leaf: 16¾ × 13 in. (42.6 × 33.2 cm). Initial: 5⅞ × 5⅞ in. (15 × 15 cm). Stave: 3.8 cm

Recto: novissime die/ bus istis lo/cutus est no/bi[s] i[n] filio su/o.[rubr.] *In octava s[an]c[t]i step[hani]..../ In oct[av]a s[an]cti io/h[ann]is... ...*Verso: [rubr.] *In octava sanctoru[m] innocenti[um] offitiu[m] misse dicitur./ sicut in die. Excepto quod.* Gl[or]ia in excelsis deo. [rubr.] *et/* Ite misse est. [rubr.] *et* alleluia. [rubr.] d[icitur] *In vig[ilia] epyph[an]ie fit offitiu[m]/* Defuncto herode. [rubr.] *Introitus. Dum mediu[m] silentium./* [rubr.] *per ordine[m]*

In octaua sanctozū innocentū offitiū misse dicitur.
sicut in die. Excepto quod. Gloria in excelsis deo. et
ite misse est. et alleluia. d⁊. C In uig epyphie fit offitiū
misse de dn̄ica preter euangeliū quod d⁊ de uig. S.
Defuncto herode. Introitus. Dum medium silentium
per ordinē. In epiphia dn̄i. Introitus.

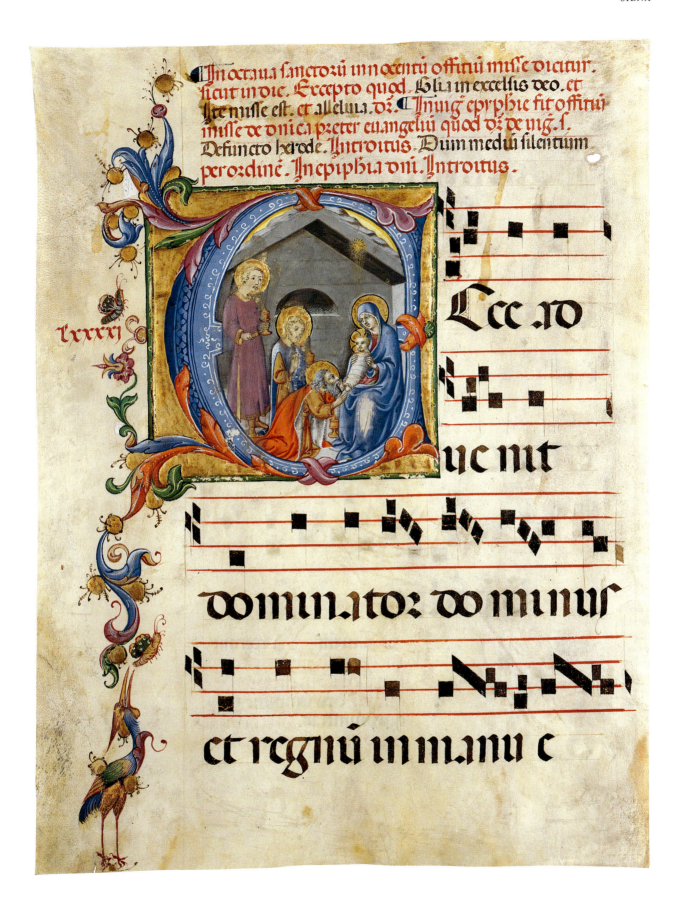

In epiph[an]ia d[omi]ni. Introitus./ Ecce ad/venit/ dominator
dominus/ et regnu[m] in manu e

On verso, in center left margin, in red ink: lxxxxi

PROVENANCE: Santa Maria della Scala, Siena; bought by Robert
Lehman in New York, 1919[1]
LITERATURE: De Ricci 1937, p. 1712, D.25 (as Sano di Pietro, ca. 1460)

The initial E, as stated by the rubric above it, begins
the introit to the mass for the Feast of the Epiphany
(January 6): "Ecce advenit dominator dominus"
(Behold, the Lord, the ruler, is come).

This leaf was correctly attributed by De Ricci to the
Sienese painter and illuminator Sano di Pietro, one of
the most influential and prolific artists in Siena from the
second through the third quarter of the fifteenth century.
First recorded in the 1428 register of the Sienese painters'
guild, Sano is thought to have been trained by Sassetta
and to have been active in the workshop of the Master of
the Osservanza (see cat. no. 73), whose production has
sometimes been confused with his own (Christiansen
1988, pp. 138–39, with previous bibliography). Sassetta's
sophisticated narrative style was translated by Sano into a
more immediately accessible, popular idiom, based on the
simplification and repetition of compositional formulas
combined with an impeccable technique of execution.
A measure of the success of his activity is the large num-
ber of commissions for panel paintings and illuminated
manuscripts that he received in Siena and its surround-
ing regions from both secular and religious patrons.

The Lehman page may be associated with an impor-
tant series of choir books decorated by Sano, along
with the Sienese painter Pellegrino di Mariano, for the
Hospital of Santa Maria della Scala, Siena, under the
rectorship of Niccolò Ricoveri (1456–76/77). The series
included a four-volume gradual, at present divided
between the Museo dell'Opera del Duomo, Siena (cod.
95.1, 96.2, 97.3) and the hospital sacristy (cod. K). The
Lehman *Nativity*, numbered lxxxxi in its left margin, is
one of five missing folios (1, 21, 56, 61, 91) in Codex
95.1, the first part of the gradual covering the liturgical
period from the first Sunday of Advent to the third
Sunday of Lent. An explicit at the end of this book
states that the writing was finished in 1462, during the
fourth year of Pope Pius II's pontificate. This suggests
that it was the first volume in the series to be illumi-
nated by Sano—probably between 1462 and 1463, in
accordance with the earliest recorded payments, from
January 13 to June 2, 1463, that the artist received from
the hospital (Cavallero 1985, p. 429, doc.360).

A date between 1462 and 1463 for the miniatures in
Codex 95.1 is also confirmed by their stylistic similarity to
other illuminations executed by Sano around the same
period, such as those in a three-volume psalter from the
Monastery of Monteoliveto Maggiore, Siena, now in
Chiusi (Museo della Cattedrale, cod. u, v, x), for which
the artist received a first payment in 1459; and those in a
series of choir books commissioned by Pope Pius II in
1462 for his newly built cathedral in Pienza (Museo della
Cattedrale, Antifonario a.1). Compared to Sano's later
production (see following entry), these works reveal a
more schematic approach to composition, defined
by compressed spaces and abbreviated architectural
structures, as well as a tighter execution of the figures.

1. A note on the back of an old photograph in the Robert Lehman
 Collection archives states: "From small Lexington Avenue frame
 shop, New York, 1919."

Sano di Pietro

75
Martyrdom of Saint Agatha in an Initial D

Circa 1470–73
Cutting from an antiphonary
New York, The Metropolitan Museum of Art, Robert Lehman
Collection, 1975 (1975.1.2488)

Tempera and gold leaf on parchment. Cutting: 10⅜ × 10⅛ in.
(26.3 × 25.7 cm). Initial: 8¾ × 9¼ in. (22.1 × 23.5 cm). Stave: 4.2 cm

Verso: Not visible (cutting glued on board)

PROVENANCE: Santa Maria della Scala, Siena; M. Drey, Munich,
1914; Luigi Grassi, Florence; Marczell de Nemes (sale, Frederick
Muller et Cie., November 13–14, 1928, lot 103); Anton W. M.
Mensing, Amsterdam (sale, November 23–25, 1937, lot 8); acquired
by Robert Lehman through Harold Beenhouwer, November 23, 1937
LITERATURE: Palladino 1997, cat. 18, pp. 142–48, with previous bib-
liography (as Sano di Pietro, ca. 1470)

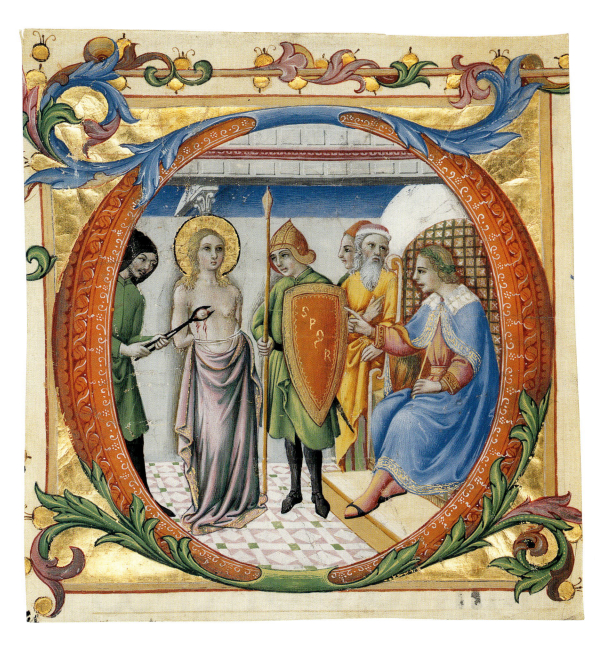

The initial D illustrates the first response at matins for the Feast of Saint Agatha (February 5): "Dum torqueretur beata Agatha" (While blessed Agatha was being tortured).

This cutting, unanimously attributed to Sano di Pietro, was first identified by Keith Christiansen (1988, pp. 158–59) as the missing folio 3 in Codex 90.L in the Museo dell'Opera del Duomo, Siena, an antiphonary covering the liturgical period from the Feast of Saint Agatha to that of the Apparition of Saint Michael (May 8). The volume originally included seventeen illuminations by Sano, twelve of which, including the Lehman *Saint Agatha,* were excised from it at an

unknown date before 1900.[1] A reconstruction of its original contents was recently made possible (Palladino 1997) by the identification of eight more missing fragments, divided between an album of miscellaneous cuttings in the Museo dell'Opera del Duomo, Siena (cod. 124–3, pp. 4, 37, 45, 47, 51, 55, 61), and the J. B. Speed Art Museum, Louisville (63.9).

Like the gradual discussed in the previous entry, Codex 90.L was included in the series of choir books decorated by Sano for the Hospital of Santa Maria della Scala. Compared to the gradual illuminations, however, Sano's miniatures in this antiphonary reflect a

later stage in his stylistic development, consonant with his protracted involvement in this commission over at least a decade, from about 1463 to his last recorded payment in 1473 (Gallavotti-Cavallero 1985, p. 433, doc. 477). As already noted (Palladino, *loc. cit.*), the clearly articulated spatial structure of the Lehman *Saint Agatha,* the elegant figures in classical poses, and the luminous palette find their closest counterparts in the miniatures executed by the artist between 1471 and 1472 in a gradual for Siena Cathedral (Libreria Piccolomini, cod. 27–11),

suggesting a nearly contemporary date for the execution of Codex 90.L. The conclusion that this may have been among the last books illuminated by Sano for the hospital, between about 1470 and 1473, is confirmed by the intervention of his collaborator, Pellegrino di Mariano, in the remaining volumes of the antiphonary series, beginning about 1471 (see following entry).

1. The illuminations are listed as already missing in a 1900 inventory of the hospital's art property (Gallavotti-Cavallero 1985, p. 231).

Pellegrino di Mariano

Sienese, active by 1449–d. 1492

76
Trinity in an Initial B

Circa 1471–76/77
Cutting from an antiphonary

Tempera and gold leaf on parchment. 6¼ × 5⅞ in. (16 × 14.9 cm).
Stave: 4.2 cm

Verso: nos de/ metuant

PROVENANCE: Paris, 1922
LITERATURE: De Ricci 1937, p. 1709, D.1 (as northern Italy, early 15th century)

The initial B, excised from an antiphonary, illustrates the third response in the first nocturn for Trinity Sunday: "Benedictus Dominus" (Blessed be the Lord). On the back of the cutting are fragments of the fourth antiphon in the first nocturn: "[Benedicat nos Deus, Deus noster, bendicat]nos de[us: Et] metuant [eum omnes fines terrae]" (May God, our God, bless us, may God bless us, And may all the ends of the earth fear him). Inside the initial is a representation of the Trinity according to the traditional iconography that became common in Italy from the twelfth century onward: God the Father, seated on a bank of clouds displaying the crucified Christ before him, and the dove of the Holy Spirit above the Cross.

This fragment, erroneously listed by De Ricci as northern Italian, is a typical work of the Sienese painter and illuminator Pellegrino di Mariano, a slightly younger

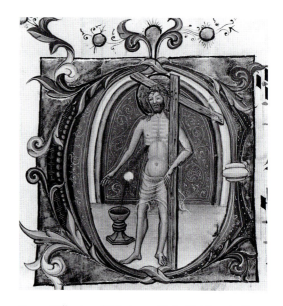

Fig. 39 Pellegrino di Mariano, *Christ Holding the Cross in an Initial C.* Museo dell'Opera del Duomo, Siena, Cod. 124–3

contemporary of Sano di Pietro. Between 1462 and 1463, the two artists worked next to each other on the choir books for Pius II's new cathedral in Pienza and subsequently collaborated on the series of choir books produced under the rectorship of Niccolò Ricoveri (1456–76/77) for the Hospital of Santa Maria della Scala, Siena. Pellegrino's most extensive contribution to this commission is found in the multivolume antiphonary set that included Codex 90.L, illuminated by Sano (see cat. no. 75). Ten other volumes of this antiphonary are preserved in the Museo dell'Opera del Duomo, Siena, albeit also deprived of their historiated letters in the early nineteenth century (Gallavotti-Cavallero 1985, pp. 228–32). Pellegrino's hand may be associated with

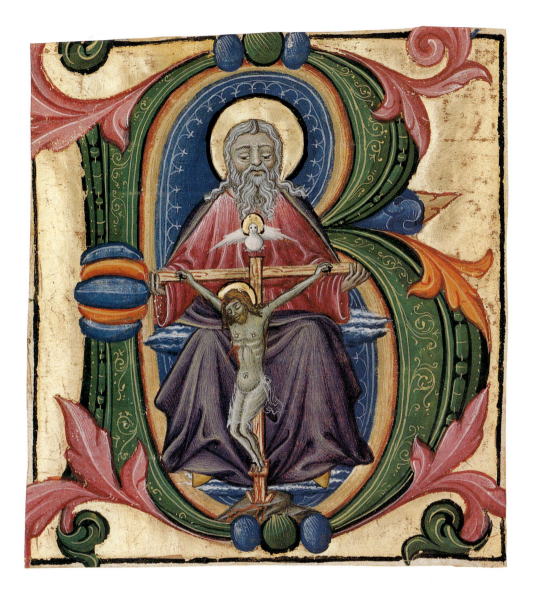

the decoration of at least five volumes, including Codex 87.G, an antiphonary covering the liturgical year from the vigil of Pentecost to Corpus Domini. The Lehman *Trinity* probably appeared on the missing folio 48 of this volume. Another fragment from the same book may be associated with an illuminated leaf by Pellegrino in the already cited album of miscellaneous cuttings in the Museo dell'Opera del Duomo, Siena (cod. 124–3, p. 59; fig. 39). It shows an initial C with Christ holding the Cross as blood pours from his wound into a chalice, illustrating the third antiphon at vespers ("Calicem salutaris" [The cup of salvation]) for the Feast of Corpus Domini.

Pellegrino probably began work on the decoration

of the hospital antiphonaries between 1471, the date recorded in another fragment from these volumes in the Breslauer Collection, New York (Voelkle and Wieck 1992, p. 211, no. 83), and 1472, the date in the explicit of Codex 81.A in the Museo dell'Opera del Duomo, Siena (Gallavotti-Cavallero 1985, p. 228). The Breslauer fragment, showing the *Calling of Saint Peter in an Initial S*, is one of three leaves by Pellegrino with the arms of the hospital and of Niccolò Ricoveri that were convincingly associated by Carl Strehlke with different volumes in the antiphonary by (1989, pp. 243–46); a second leaf is also in the Breslauer Collection (Voelkle and Wieck 1992, p. 211, no. 84); while a third is in the Fitzwilliam Museum, Cambridge (MS 197). To these

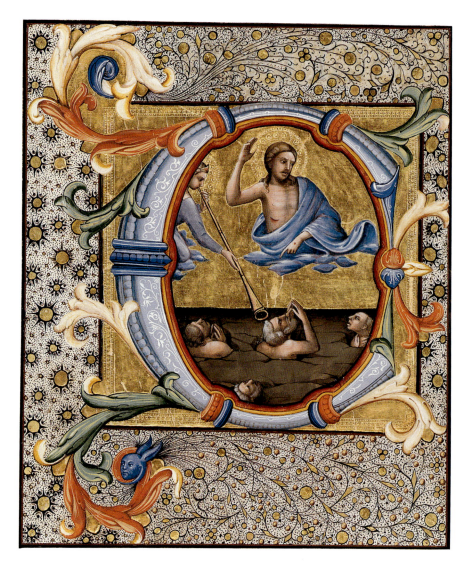

Lorenzo Monaco

Florentine, active circa 1388–d. 1423/24

78

Last Judgment in an Initial C

Circa 1406–7
Cutting from an antiphonary
New York, The Metropolitan Museum of Art, Robert Lehman
Collection, 1975 (1975.1.2485)

Tempera and gold leaf on parchment. Cutting: 12⅜ × 10⅜ in.
(31.3 × 26.4 cm). Initial: 7⅞ × 7¾ in. (19.9 × 19.8 cm). Stave: 5 cm

Cutting glued on board. Pen work added at a later date (nineteenth
century?)
Visible under ultraviolet light above the initial: heredi (the end of a
line of text that has been scraped away)

PROVENANCE: Santa Maria degli Angeli, Florence; Bernard
d'Hendecourt, Paris, 1920
LITERATURE: Saffiotti 1997, cat. no. 21, pp. 164–68, with previous
bibliography (as Lorenzo Monaco, ca. 1406–7)

This cutting was first associated by Mirella Levi
D'Ancona (1978, p. 228) with the celebrated series of
choir books of the Camaldolese monastery of Santa
Maria degli Angeli, Florence. Written and illuminated
over a period of 135 years, beginning in 1370, these
choir books have been unanimously viewed by scholars
as the crowning achievement of the art of illumination
in early Renaissance Florence. According to Vasari
(1906, II, p. 24), they were so admired by Pope Leo X
(r. 1513–21) that he wished to take them for the Basilica
of Saint Peter's, but he refrained from doing so because
they were written according to Camaldolese instead of

Roman usage. Vasari himself was amazed by the refinement and size of these volumes, which he apparently saw many times and described as the largest and most beautiful in all of Italy. It is unclear how many books were originally included in the Santa Maria degli Angeli series, although Vasari gave their number as twenty. Following the suppression of the monastery at the beginning of the nineteenth century, eighteen codices, most of them already missing illuminated leaves presumably cut out and sold to collectors, were transferred to the Biblioteca Medicea Laurenziana, Florence.

The Lehman fragment was identified by Levi D'Ancona as one of three missing initials from Corale 7 in the Biblioteca Medicea Laurenziana, part of a thirteen-volume antiphonary for Santa Maria degli Angeli. Laurence Kanter (1994, pp. 229–34, 262–66), who first proposed a partial reconstruction of this series, identified Corale 7, which is dated 1406, as a supplemental volume that was added to the original twelve-volume set written between 1385 and 1397. Its contents include the continuation of the Common of Saints found in Corale 11, votive offices of the dead and of the dedication of the church, and offices for certain feasts in April and May that were omitted from Corale 1. The Lehman initial, which originally appeared on the missing folio 124 of Corale 7, introduces the second response of the first nocturn for the Office of the Dead: "Credo quod redemptor meus vivit, et novissimo die terra resurrecturus sum, et in carne mea videbo Deum, Salvatorem meum" (I believe that my Redeemer lives, and that on the last day I shall rise from the earth, and in my flesh I shall see God, my Savior). A second fragment from the same codex, excised from the missing folio 45, was identified by Kanter with an initial D with *The Man of Sorrows between the Virgin and Saint John the Evangelist* in the Musée des Beaux-Arts, Dijon (1474).

Corale 7 is one of five volumes (cor. 1, 5, 7, 8, 13) in the Santa Maria degli Angeli antiphonary set that were decorated by Lorenzo Monaco, a monk in the same monastery and the leading painter in Florence during the first quarter of the fifteenth century.[1] The earliest document pertaining to the artist, dated 1391, records Lorenzo's profession of simple vows in Santa Maria degli Angeli, at which time he exchanged his given name, Piero di Giovanni, for his religious name, Don Lorenzo. Although he was probably apprenticed as a painter in the workshop of Agnolo Gaddi before entering Santa Maria degli Angeli, it is generally assumed that he was trained in the craft of manuscript illumination in the monastery's scriptorium, under the tutelage of its most famous illuminator, Don Silvestro dei Gherarducci (1339–1399). Following Don Silvestro's death, Lorenzo was entrusted with all the scriptorium's major commissions, beginning with the completion of the antiphonary series, which had been started during Don Silvestro's residence.

1. For a summary of the literature on the artist, with a specific focus on his activity as an illuminator, see Palladino 1997, pp. 162–63.

Bartolomeo di Fruosino

Florentine, circa 1366/69–1441

79
Virgin and Child in an Initial H

1413–24
Cutting from an antiphonary

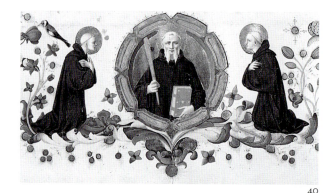

40

41

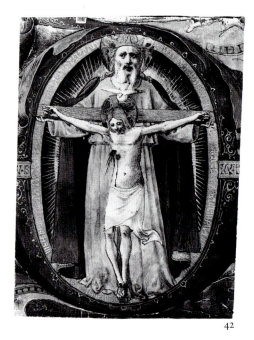

42

Fig. 40 Zanobi Strozzi, *Saint Benedict with Saints Maurus and Placidus*. Private collection

Fig. 41 Zanobi Strozzi, *Two Scenes from the Life of Saint Benedict*. Wallraf-Richartz Museum, Cologne, inv. 185

Fig. 42 Zanobi Strozzi, *Trinity in an Initial D.* Fondazione Giorgio Cini, Venice, 2131

The style of the four cuttings closely reflects Zanobi Strozzi's mature production, as represented by the series of choir books he illuminated between 1446 and 1454 for the Monastery of San Marco, Florence (Museo di San Marco, 515–18, 520–22, 524–27). The dominant component of all these works is their clear dependence in figural style and composition upon Fra Angelico's models of the same period.

1. According to an unsigned, undated note in the Robert Lehman Collection files.
2. [Dominus a dextris tui]s confregit/[in die irae suae rege]s/[iudicabit in nationi]bus imple/[bit cadavera conquass]abit ca[pita in terra multorum....]

Battista di Niccolò da Padova

Paduan, active in Tuscany 1425–52

81

Crucifixion with Penitent Saint Jerome

Circa 1448–52
Cutting from a confraternity missal (?)

Tempera and gold leaf on parchment. Composite ornamental border, comprising nine fragments, glued around miniature at a later date. Miniature: 8 7/8 × 6 3/4 in. (22.5 × 17 cm). With border: 11 3/8 × 8 1/2 in. (28.8 × 21.7 cm)

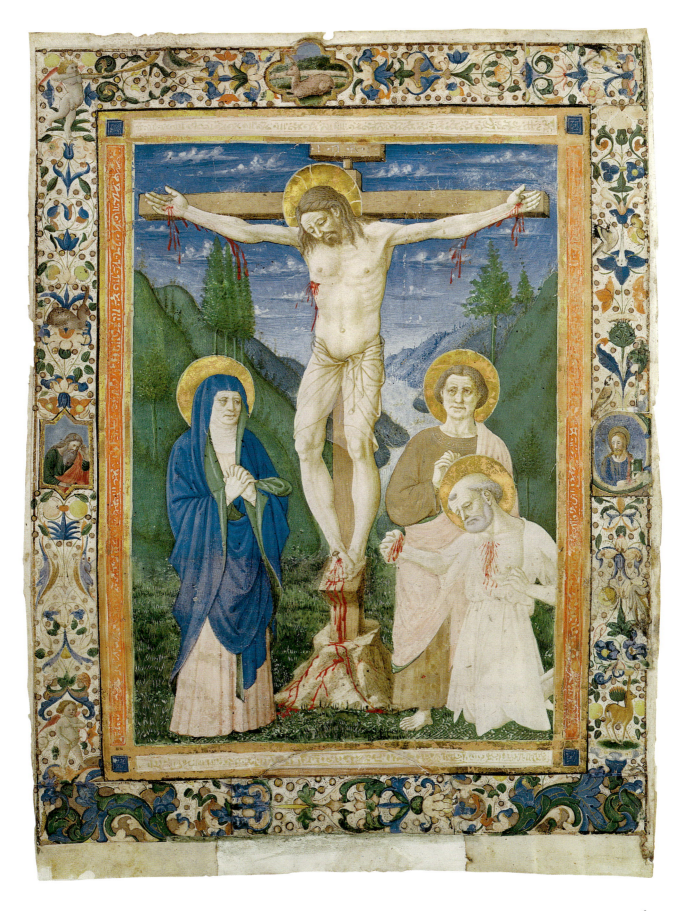

a diamond ring with three feathers and a scroll inscribed "SEMPER" (always); and a yoke interlaced with a scroll inscribed "SUAVE" (sweet), in reference to Matthew 11:30, "For my yoke is sweet and my burden light" (Wieck 1994, p. 4). Other allusions to the pope are found in the composition of the *Crucifixion,* which includes, behind the figure of Saint John the Evangelist, Saints Cosmas and Damian, patrons of the Medici. In the landscape background is a walled city by a river that can be identified as Florence. Additionally, the presence of Saint John the Baptist between the evangelists Luke and Mark in the left border of the *Crucifixion* and that of Saint Lawrence in the outer right border fragment may refer to Leo's baptismal name, Giovanni di Lorenzo.

Listed in two Sistine Chapel inventories recently published by Emilia Anna Talamo (1997, pp. 213, 216–17) are three missal volumes bearing the arms of Leo X. The Lehman miniature may be associated with one of two volumes, a "Papal missal for Saints Peter and Paul" and a "Papal missal for the Nativity" (Archivio di Stato di Roma, Camerale 1, vol. 1560, fasc. 24, A.I.3, A.I.4), which are described as including a Crucifixion with various figures at the foot of the Cross. The third volume, a "Papal missal for the Resurrection" (A.I.2), listed as containing a "Crucifixion with the Three Thieves," may instead be related to another collage of fragments, identical in style and execution to the present one, which was also included in the Celotti sale (lot 53) and is now in a private collection in England (Garzelli 1985, I, p. 225, II, p. 469, fig. 793). Possibly also connected to these missals are a series of cuttings with the arms of Leo X that appeared recently on the art market in London (Sotheby's, December 2, 1997, lot 82).

Beginning with De Ricci, all of these miniatures have been unanimously attributed to Attavante degli Attavanti, the most successful and prolific illuminator in late-fifteenth- and early-sixteenth-century Florence. Their execution was probably contemporary with that of another Sistine Chapel manuscript decorated by the artist for Leo X, which is inscribed with the date 1520 (Pierpont Morgan Library, New York, H.6; Wieck 1994, pp. 4–5). This volume, containing the psalms and prayers recited by the pope in preparation for the celebration of the mass, may have been included with the three missals in the same commission.

Attavante's luxurious pages, overflowing with ornamental details and classical motifs framing monumental compositions, mark the final evolution of manuscript illumination from the simple decoration of the initial toward painting on a small scale. His art reflects the sophisticated tastes of a discerning, literary class of patrons that included some of the most important families and royalty in Europe. The demands placed on the artist's workshop, however, and the frequent repetition of the same designs ultimately lend his production a uniform character that has often hindered the full modern appreciation of his work and made difficult the distinction between his own hand and that of his numerous assistants.

Francesco di Marco Marmitta da Parma

Emilian, 1462/66–1505

85
Adoration of the Shepherds

Circa 1492–95
New York, The Metropolitan Museum of Art, Robert Lehman Collection, 1975 (1975.1.2491)

Tempera and gold leaf on parchment. 9⅝ × 6 in. (24.4 × 15.2 cm)

Blank verso

PROVENANCE: Pope Clement VII (r. 1523–34); Pope Gregory XIV (r. 1590–91); Christine of Lorraine, grand duchess of Tuscany (1591); acquired by Robert Lehman at an unknown date[1]
LITERATURE: Levi D'Ancona 1997, cat. no. 27, pp. 190–94, with previous bibliography (as Francesco Marmitta, ca. 1500)

This exceptionally fine miniature, conceived as a small painting, was purportedly once included among the possessions of Giulio di Giuliano de Medici, Pope Clement VII (r. 1523–34). Formerly glued to the back of the illumination was a long letter dated February 7, 1591, from Pope Gregory XIV (r. 1590–91) to Christine of Lorraine, grand duchess of Tuscany, which stated that the enclosed *Adoration of the Shepherds,* "painted with wonderous skill," had been found among the household goods of the Apostolic Palace and was said

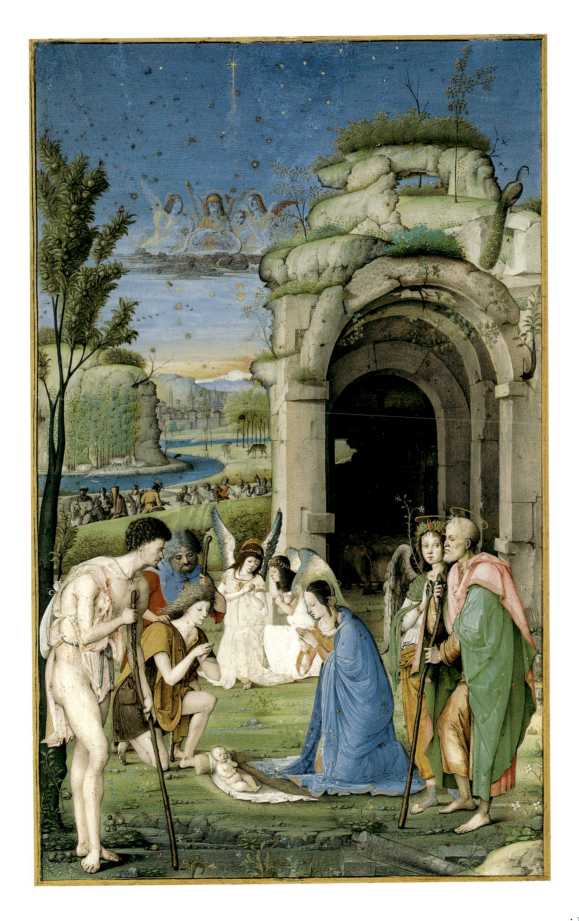

to have belonged to Clement VII. Wishing to bestow upon the grand duchess an enduring token of his benevolence, the pope wrote, he thought that this miniature, once the property of a Medici, would be an especially fitting present to her, as wife of the Medici grand duke Ferdinand I (1549–1609). Moreover, the pope concluded, the grand duchess would be granted plenary indulgences every time she offered penance before the image, praying for the triumph of the Church in the struggle against heresy.

The author of the Lehman *Adoration* was first identified by Beatrice Bentivoglio-Ravasio (1992) as Francesco Marmitta, one of the rarest and most sophisticated artists in the history of late Italian manuscript illumination. Sixteenth-century sources describe Marmitta as a painter, illuminator, goldsmith, and engraver of precious stones; however, in addition to very scanty biographical information, only a few miniatures and panel paintings by his hand have come down to us. Although he was born in Parma, sometime between 1462 and 1466,[2] stylistic evidence suggests that the artist was probably trained in Bologna, where he was influenced by the Ferrarese painters Ercole de Roberti and Lorenzo Costa, active there in the 1480s. A further stimulus was provided by the production of the Bolognese goldsmith-turned-painter Francesco Francia, whose work is recalled in the sweet sentimentality and enamel-like quality of the Lehman *Adoration* and in its Flemish-inspired landscape background with closely observed atmospheric effects and naturalistic details (Bacchi and De Marchi 1995, pp. 11–59).

Marmitta's only documented work is a copy of Petrarch's *Rhymes and Triumphs* in the Landesbibliothek, Kassel (IV MS poet. et roman. 6.), datable to after 1483 (Bentivoglio-Ravasio 1995, p. 96). On the basis of this manuscript, Pietro Toesca (1948) attributed to Marmitta a small book of hours, known as the Durazzo Hours, in the Biblioteca Civica Berio, Genoa (m.r. Cf. Arm. 1.), and a missal commissioned by Cardinal Domenico della Rovere in the Museo Civico di Arte Antica, Turin (inv. gen. 497, inv. part. 6). The Lehman *Adoration*, regarded as one of Marmitta's most refined and technically accomplished creations, has been placed in close stylistic relationship to the della Rovere missal (De Marchi 1995, pp. 316–29; Levi D'Ancona 1997). Silvana Pettenati (1995, pp. 142–43), who convincingly

dated that manuscript to between 1490 and 1492, during the artist's hypothetical sojourn in Rome, suggested that the *Adoration* might have been executed in the same city before the artist's return to Parma in 1495.

A clue to the miniature's original function may be offered by the wording of Gregory XIV's letter, referring to the image as a *"tavoletta"* (tablet). This may indicate that the *Adoration* was never part of a larger leaf in a manuscript but conceived at the outset as an independent object for private devotion—perhaps in the same category as the two "historie miniate in carta pecorina" by Apollonio Buonfratelli that are listed in a mid-sixteenth-century inventory of the Sistine Chapel.[3]

1. The miniature is not listed by De Ricci, suggesting that it was acquired sometime after 1937.

2. The birth date of 1457, published by Levi D'Ancona (1997), does not take into account the archival documents discovered by Bentivoglio-Ravasio (1992).

3. Archivio di Stato di Roma, camerale I, vol. 1557, fasc. B, folio 44v (Talamo 1997, p. 216): "Due historie miniate in carta pecorina l'una serve per principio dela 3.a Messa di Natale, l'altra per il Te igitur del la med.a Messa fatto da m. Apollonio buonfratelli..." (Two illuminated scenes on parchment, one needed for the beginning of the third mass for Christmas, the other for the Te igitur of the same mass, executed by m. Apollonio buonfratelli). Next to this entry is a later note stating that the miniatures are "now in the possession of Pope Paul IV" (r. 1555–59). From an earlier entry on folio 36r, we gather that on November 18, 1554, the two miniatures were sent to the sacristy by the previous pope, Julius III (r. 1550–55). These documents suggest that the illuminations were made as independent pictures, perhaps mounted in some sort of frame, which could be inserted and removed at will from the missal portions they illustrated.

Francesco Morone

Veronese, 1471–1529

86

Virgin and Child Enthroned between Saints Cecilia and Catherine of Alexandria

Circa 1510–15
New York, The Metropolitan Museum of Art, Robert Lehman Collection, 1975 (1975.1.2489)

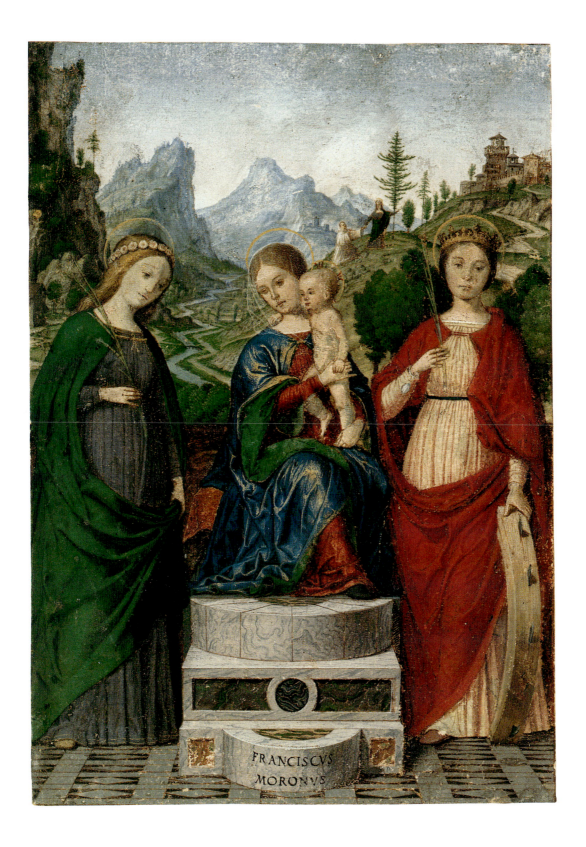

FRANCISCVS
MORONVS

Tempera on parchment. 8 × 5⅝ in. (20.2 × 15.4 cm)

Verso not visible (miniature glued on paper)

Inscribed, on the curve of the bottom step of the throne, in black ink: FRANCISCUS/ MORONUS

PROVENANCE: William Young Ottley, London (sale, Sotheby's, London, May 11–12, 1838, lot 230); Charles L. Cleveland, Chappaqua, New York; Miriam (Mrs. Charles L.) Cleveland, Chappaqua, New York. Acquired by Robert Lehman from Miriam Cleveland after 1942 or 1943

LITERATURE: Levi D'Ancona, Palladino, Saffiotti 1997, cat. no. 25, pp. 182–84, with previous bibliography (as Francesco Morone, ca. 1515)

This miniature, signed "FRANCISCUS MORONUS" on the bottom step at the base of the Virgin's throne, is the only known illumination by the artist, son of the Veronese painter Domenico Morone (see cat. no. 66). Like his father, in whose workshop he was trained, Francesco Morone is known primarily as a painter of altarpieces and frescoes. He was, however, a close friend of the leading Veronese painter and illuminator Girolamo dai Libri (see cat. no. 67), with whom he was also involved in a business relationship. Between around 1515 and 1520 they collaborated on various painting commissions, chief among which was the decoration of a set of organ shutters for the important Olivetan monastery of Santa Maria in Organo, Verona (now Chiesa Parrochiale, Marcellise). Both artists had begun their careers working for this monastery—Girolamo as an illuminator and Francesco as a painter. About 1503 Francesco signed and dated a large altarpiece still in Santa Maria in Organo, and between 1505 and 1510 he frescoed some scenes in the church's sacristy that were greatly admired and discussed at length by Vasari (1880, pp. 311–12).

Like the preceding catalogue entry (no. 85), the Lehman *Virgin and Child* is conceived as a small independent work, the composition of which emulates paintings by Francesco, such as the signed *Virgin and Child Enthroned between Saints Anthony Abbot and Onophrius*, in the Gemäldegalerie Berlin (46B). A date for the miniature's execution around 1510–15, first advanced by Erica Tietze-Conrat (1943, pp. 85, 87) is confirmed by its stylistic similarity to the Santa Maria in Organo organ shutters, a commission given to Francesco and Girolamo Dai Libri in 1515; and to other works dated by scholars to the same period, such as the Berlin painting and the *Virgin and Child* in the National Gallery, London (NG 285; Del Bravo 1962, pp. 11, 13; Penny 1996).[1]

It was recently proposed (Levi D'Ancona et al. 1997) that the Lehman *Virgin and Child* also be associated with the Monastery of Santa Maria in Organo on the basis of the inclusion, in the landscape background, of a white-clad, perhaps Olivetan monk, being led by a female saint to a walled complex in the upper right of the composition. This saint may be identified by her dress and crown of roses as Saint Cecilia, also shown standing in the position of honor to the Virgin's right. It has therefore been suggested that this scene might allude to the *schola sacerdotum* dedicated to the Virgin, Saint Agatha, and Saint Cecilia that was attached to Santa Maria in Organo and was responsible for the education of its monks. The Lehman miniature could have been commissioned by a canon or former pupil of that school.

1. Del Bravo's dating of the Lehman illumination to a decade earlier than these works, around 1498 (Del Bravo 1962, p. 7), seems too early.

Roman School
Circa 1567/68–72

87a
Christ Carrying the Cross in an Initial D
Cutting from a gradual

Tempera and gold leaf on parchment. 6¼ × 6½ in. (16 × 16.7 cm). Stave: 4.3 cm

Verso: itates no/ tribuas

PROVENANCE: Santa Croce a Bosco Marengo; Bruscoli, Rome, about 1924[1]
LITERATURE: De Ricci 1937, p. 1716, B.2 (as northern Italy, ca. 1500, from same choir book as cat. no. 87b)

87b
Last Judgment in an Initial S
Cutting from a gradual

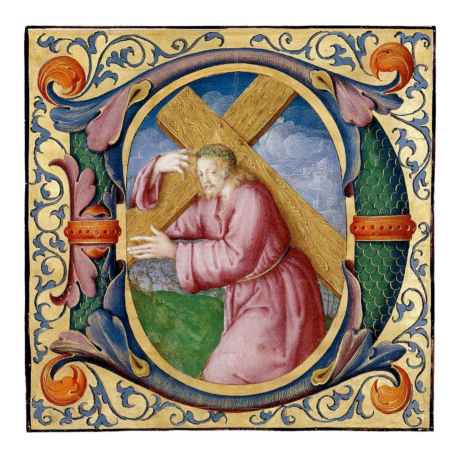

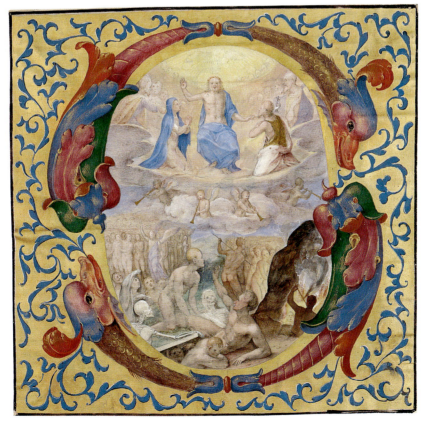

Tempera and gold leaf on parchment. 6⅛ × 6¼ in. (15.6 × 16 cm). Stave: 4.3 cm

Recto: bit tibi/ nis eius spe

PROVENANCE: Santa Croce a Bosco Marengo; John F. Murray, Florence, 1925

LITERATURE: De Ricci 1937, p. 1716, B.2 (as northern Italy, ca. 1500, from same choir book as cat. no. 87a)

These fragments were excised from a series of choir books commissioned by the Dominican pope Pius V (r. 1566–72), canonized in 1712. The books were produced for the Dominican convent of Santa Croce, which was founded by the pope in 1566 in his native town of Bosco Marengo, near Alessandria. Recently published by Silvana Pettenati (1998), the entire series originally comprised thirty-four volumes, thirty-one of which, some in fragmentary condition, are now in the Museo Civico, Alessandria, while two others are in the Convent of San Domenico, Chieri. The last volume is missing.

The Lehman cuttings were first associated with the Bosco Marengo volumes by Jonathan Alexander (verbal communication), who related them to two other fragments from the same series in the Brooklyn Museum of Art, New York: an initial I (or L) with the *Return of the Prodigal Son* and an initial F with *Christ and the Samaritan Woman*. To these may be added a leaf formerly on the art market that was published by Pettenati (1998, p. 17) and two fragments in the Cini Collection, Venice, showing *Jonah and the Whale in an Initial R* and *Expulsion of the Money Changers from the Temple in an Initial D* (Toesca 1958, p. 54, plates 67–68). Except for the art-market leaf, excised from an antiphonary, all of the miniatures were originally included in Corale II in the Museo Civico, Alessandria, a gradual volume from Bosco Marengo, covering the liturgical season from the first to the fourth Sunday of Lent, which has been deprived of all its illuminations (Pettenati 1998, p. 61). The Lehman initial D with *Christ Carrying the Cross,* probably the missing first illumination from this volume, introduces the tract of

the mass for Ash Wednesday: "Domine non secundum peccata nostra, quae fecimus nos" (The Lord does not deal with us according to our sins). This text is continued on the fragment's verso: "[neque secundum iniqu]itates no[stras re]tribuas [nobis]" (nor requite us according to our iniquities). The Lehman initial S with the *Last Judgment* begins the introit to the mass for Monday in the first week of Lent: "Sicut oculi servorum" (Behold as the eyes of servants). On the back of the initial, the original leaf's recto, are fragments of the communion hymn from the preceding mass for the first Sunday in Lent: "[Scapulis suis obumbra]bit tibi[et sub pen]nis eius spe[rabis]" (He will cover you with his pinions and under his wings you will find refuge). The Cini and Brooklyn miniatures illustrate, in turn, the introit to the masses for Tuesday and Wednesday of the first week of Lent, Saturday of the second week of Lent, and Friday of the third week of Lent in the same volume.

According to Pettenati (1998, p. 9), the choir books were written and decorated in Rome between around 1567/68 and 1572 by a team of illuminators whose style reflects the most recent developments in monumental painting and manuscript production at the papal court. The Lehman initials and their sister leaves compare most closely to the illuminations in Corale Q in the Museo Civico, Alessandria, a gradual that follows Corale II in liturgical sequence and covers the period from the fourth Sunday in Lent to Easter Sunday (Pettenati 1998, pp. 93–94). Considered among the most accomplished works in the series, the miniatures of Corale Q have been viewed by Pettenati in relationship to the work of the foremost illuminator at the papal court, Giulio Clovio, as well as to the paintings of the Flemish artist favored by Pius V, Bartolomeo Sprangher, appointed official painter to the pope in 1570.

1. According to a note on the back of a photograph in the Robert Lehman Collection archives, which contradicts De Ricci's claim that this cutting was acquired from Murray together with cat. no. 87b. The invoice from Murray for cat. no. 87b, in fact, mentions only one miniature.

Appendix

Glossary

Bibliography

Index

Miniatore di Monza (?)

Lombard, last quarter of the thirteenth century

1

Virgin and Child in an Initial G

Cutting from a gradual
New Haven, Yale University Art Gallery, 1954.7.9
Tempera and gold leaf on parchment. 4⁷⁄₁₆ × 4¹³⁄₁₆ in. (11.2 ×
10.6 cm). Stave: 3 cm

Verso: ego op[er]a mea/ Allelu

PROVENANCE: Acquired in Paris, 1953;[1] gift of Robert Lehman
to Yale University, 1954
LITERATURE: Seymour 1970, p. 23, no. 7 (as Tuscan school, late
13th century)

1. According to Seymour (1970).

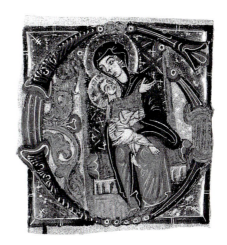

Northeastern Italy (?)

Late thirteenth century

2

Christ in Majesty in an Initial B

Cutting from an antiphonary
Tempera and gold leaf on parchment. 4½ × 3⅞ in. (11.5 × 9.8 cm).
Stave: 2.5 cm

Verso: s[an]c[t]o spir/ Benedic

PROVENANCE: Unknown
LITERATURE: De Ricci 1937, p. 1703, D.28 (as probably
Bologna, ca. 1300)

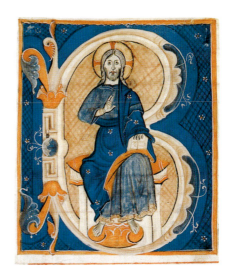

Tuscany (?)

Late thirteenth century

3

Pentecost in an Initial S

Leaf from an antiphonary
Tempera and gold leaf on parchment. Leaf: 18 × 12⅜ in. (45.6 ×
31.5 cm). Initial: 5¾ × 5⅛ in. (14.7 × 13 cm). Stave: 2.8 cm

Recto: eum alleluya/ alleluya./ [rubr.] *In die pen/tecoste[m]*
off./Spiri/tus domini/ replevit or/bem terrarum alleluya/ et hoc
quod continet. Verso: omnia scientiam habet/ vocis alleluya
allelu/ya alleluya. [rubr.] *V.* Confir/ma hoc deus quod opera/tus es
in nobis a templo/ tuo quod est in ierusalem/ Gloria. euouae.
[rubr.] *R.*

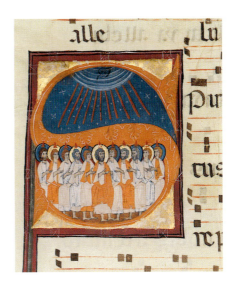

Lombard

Circa 1500

13

Saint Helena Holding the Cross in an Initial R

Cutting from an antiphonary (?)
Location unknown
Tempera and gold leaf on parchment. 3⅛ × 3⁹⁄₁₆ in. (8 × 9 cm)

PROVENANCE: Kalebdjian, Paris, 1924
LITERATURE: De Ricci 1937, p. 1713, A.6 (as Tuscany, ca. 1470);
Béguin 1957, p. 110, no. 160, pl. LXXIII (as Ferrarese Master,
ca. 1470–80); Cincinnati 1959, p. 31, no. 329 (as Ferrarese Master,
act. ca. 1470–80); Mariani Canova 1978a, p. 58 (as Master of the
Arcimboldi Missal or close follower, 1499–1511); Bauer-Eberhardt
1984, p. 59 (as Milan, beginning of the 16th century); Lodigiani
1991, pp. 297–98, n. 10 (as Lombard, last decade of the 15th
century, close to the Master of the Arcimboldi Missal)

See cat. no. 69, fig. 36

Master B. F. (Francesco Binasco?)

Milanese, active late fifteenth–early sixteenth century

14

Half-Length Saint (Prophet?) in an Initial G

Bas-de-page fragment
Cutting from a gradual
Location unknown
Tempera and gold leaf on parchment. 6¼ × 6⅛ in. (16 × 15.7 cm)

PROVENANCE: Lord Northwick (sale, Sotheby's London, November 16, 1925, lot 151)
LITERATURE: De Ricci 1937, p. 1713, C.18 (as Lombardy, late
15th century)

See cat. no. 70 [no image available]

Lombard

End of fifteenth–beginning of sixteenth century

15

Christ as Salvator Mundi and Two Angels
Location unknown
Tempera and gold leaf on parchment

PROVENANCE: Purchased in Rome (?), 1927

See cat. no. 71, fig. 37

Modern Copies

Ernesto Sprega

?–d. 1911

16

Christ's Entry into Jerusalem in an Initial D

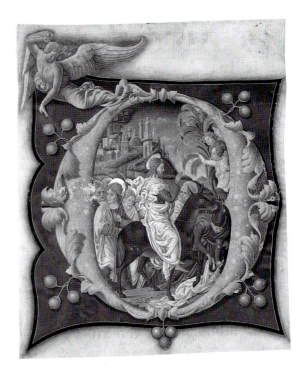

1863–64
Copy of a miniature by Liberale da Verona in the choir books for
Siena Cathedral
Tempera and gold leaf on parchment. 16⅛ × 13¾ in. (41.2 × 34.9 cm)

PROVENANCE: Edouard Kann Collection, Paris
LITERATURE: Boinet 1926, p. 30, no. XXXIV, pl. XXXIII (as North
Italian School, third quarter of the 15th century); De Ricci 1937,
p. 1712, B.20 (as probably by Girolamo da Cremona); Miner 1949,
p. 73, no. 199 (as northern Italy, 15th century); Béguin 1957,
p. 107, no. 153 (as Girolamo da Cremona); Cincinnati 1959, p. 31,
no. 328, fig. 328 (as Girolamo da Cremona)

Unknown

17

Portrait of Francesco Landini

Copy of fifteenth-century Florentine miniature in the *Squarcialupi Codex* (Florence, Biblioteca Medicea Laurenziana, Med. Palat. 87)
Tempera on parchment. 5⅞ × 4⅞ in. (14.8 × 12.4 cm)

PROVENANCE: Unknown
LITERATURE: De Ricci 1937, p. 1706, A.27 (as Italy, late 14th century)

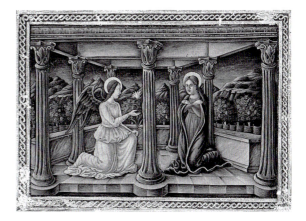

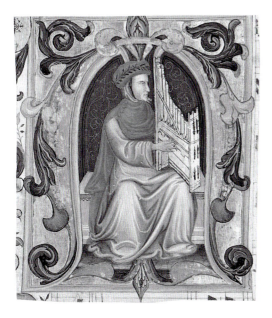

Copies of two miniatures by Girolamo da Cremona in the Bible of Borso d'Este
Tempera and gold leaf on parchment. 4⅛ × 5¾ in. (10.5 × 14.5 cm)

PROVENANCE: C. E. Rappaport, Rome, 1924
LITERATURE: De Ricci 1937, p. 1713, D.9–10 (as Ferrara, ca. 1465)

Unknown

19

Pentecost in an Initial S

Copy of a miniature by Sano di Pietro (in the choir books for Siena Cathedral?)
New Haven, Yale University, Beinecke Rare Book and Manuscript Library, MS 475
Tempera and gold leaf on parchment. 10⅞ × 7⅞ in. (27.6 × 19.9 cm)

PROVENANCE: Early provenance unknown; gift of Robert Lehman to Yale University, 1941
LITERATURE: Shailor 1987, vol. 2, p. 454 (as modern illumination)

Unknown

18

Scenes from the Lives of Saint Jerome and Saint James (recto); *Annunciation* (verso)

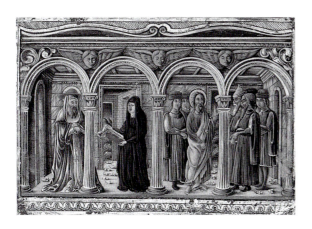

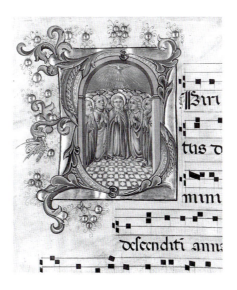

BOSKOVITS 1975
Boskovits, Miklós. *Pittura fiorentina alla vigilia del Rinascimento, 1370–1400.* Florence.

BOSKOVITS 1978
Boskovits, Miklós. "Ferrarese Painting about 1450: Some New Arguments." *The Burlington Magazine* 120, pp. 370–85.

BOSKOVITS 1983
Boskovits, Miklós. "Il gotico senese rivisitato: Proposte e commenti su una nostra." *Arte cristiana* 71, no. 698, pp. 259–76.

BOSKOVITS 1984
Boskovits, Miklós. *A Critical and Historical Corpus of Florentine Painting. The Fourteenth Century.* Sec. 3, vol. 9: *The Painters of the Miniaturist Tendency.* Florence.

BOSKOVITS 1988
Boskovits, Miklós. In Milan 1988.

BOSKOVITS 1992
Boskovits, Miklós, ed. *The Martello Collection: Further Paintings, Drawings, and Miniatures, 13th–18th Century.* Florence.

BOSKOVITS 1995
Boskovits, Miklós. "Mostre di miniatura italiana a New York-I." *Arte cristiana* 83, no. 770, pp. 379–86.

BOSTON 2002
Painting and Design in Renaissance Ferrara. Exhibition, Isabella Stewart Gardner Museum, Boston, 30 January–12 May. Catalogue by Stephen J. Campbell et al.

BOYCE AND HARRSEN 1953
Boyce, George K., and Meta Harrsen. *Italian Manuscripts in the Pierpont Morgan Library.* New York.

BREDT 1903
Bredt, E. W. *Katalog der mittelalterlichen Miniaturen des Germanischen Nationalmuseums.* Nuremberg.

BRUNORI 1998
Brunori, Lia. "Manoscritti bolognesi del XIII e XIV secolo nella Biblioteca Laurenziana." *Rivista di Storia della Miniatura* 3, pp. 69–104.

BUSSI 1997
Bussi, Angela Dillon. "La miniatura quattrocentesca per il Duomo di Firenze; prime indagini e alcune novità." In *Libri del Duomo di Firenze.* Florence, pp. 89–94.

BUSSI 1998
Bussi, Angela Dillon. "Battista di Niccolò da Padova e Giovanni Varnucci: los scambio delle parti ? (e alcune note su Ricciardo di Nanni)." *Rivista di Storia della Miniatura* 3, pp. 105–14.

BUX 1990
Bux, Nicola. *Codici liturgici latini di Terra Santa.* Brindisi.

CADEI 1984
Cadei, Antonio. *Studi di Miniatura Lombarda. Giovannino de Grassi, Belbello da Pavia.* Rome.

CALABI 1938
Calabi, A. "I corali miniati del Convento di S. Francesco a Brescia." *Critica d'Arte* 3, pp. 57–78.

CALECA 1969
Caleca, Antonino. *Miniature in Umbria.* Vol. 1, *La Biblioteca Capitolare di Perugia.* Florence.

CAMPBELL 2002
Campbell, Stephen J. In Boston 2002.

CARAPELLI 1988
Carapelli, A. *Cronologia, Cronografia e Calendario Perpetuo.* Milan.

CARLI 1998 [1943]
Carli, Enzo. "Per la pittura del Quattrocento in Abruzzo." In *Arte in Abruzzo,* by Enzo Carli. Milan, pp. 195–230. First published in *Rivista del R. Istituto d'Archeologia e Storia del l'Arte* IX, fasc. I–III, Rome 1943, pp. 164–211.

CARMINATI 1995
Carminati, Marco. *Codici miniati del Maestro B.F.* Pavia.

CASSEE 1980
Cassee, Elly. *The Missal of Cardinal Bertrand de Deux.* Florence.

CASTELFRANCO 1929
Castelfranco, Giorgio. "I corali miniati di S. Domenico di Gubbio." *Bollettino d'Arte,* pp. 529–55.

CASTIGLIONI 1986
Castiglioni, Gino. In Verona 1986.

CAVALLERO 1985
Cavallero, Daniela Gallavotti. *Lo spedale di Santa Maria della Scala in Siena: vicenda di una committenza artistica.* Pisa.

CHELAZZI DINI 1979
Chelazzi Dini, Giulietta. "Miniatori toscani e miniatori umbri: Il caso del laudario B.R. 18 della biblioteca Nazionale di Firenze." *Prospettiva* 19, pp. 14–35.

CHELAZZI DINI 1982
Chelazzi Dini, Giulietta. In *Il gotico a Siena.* Exhibition catalogue, Siena.

CHEVALIER 1892–1912
Chevalier, Cyr Ulysse Joseph. *Repertorium hymnologicum.* 6 vols. Louvain.

CHIERICI 1949
Chierici, Ugo. "Gli affreschi della Chiesa di San Silvestro all'Aquila." *Bollettino d'arte* 34, pp. 111–28.

CHRISTIANSEN 1988
Christiansen, Keith. In New York 1988.

CIARDI DUPRÉ 1976
Ciardi Dupré Dal Poggetto, Maria Grazia. Review of *L' uomo, il lavoro, l'ambiente nelle miniature laurenziane. Prospettiva* 7, pp. 72–79.

CIARDI DUPRÉ 1998
Ciardi Dupré Dal Poggetto, Maria Grazia. "A proposito della miniatura bolognese e francese e delle loro interconnessioni con la produzione libraria in Italia centrale." *Rivista di Storia della Miniatura* 3, pp. 22–23.

CINCINNATI 1959
The Lehman Collection, New York. Exhibition, Cincinnati Art Museum, 8 May–5 July. Catalogue edited by Gustave von Groschwitz.

CIPRIANI 1958
Cipriani, Renata. In *Arte Lombarda dai Visconti agli Sforza.* Exhibition catalogue, Milan.

COLLOBI RAGGHIANTI 1950
Collobi Ragghianti, Licia. "Zanobi Strozzi pittore, I." *Critica d'arte* 9, no. 1, pp. 9–27.

COMSTOCK 1927
Comstock, Helen. "The Robert Lehman Collection of Miniatures." *International Studio* 86 (April), pp. 47–57.

CONTI 1981
Conti, Alessandro. *La miniatura bolognese: Scuole e botteghe 1270–1340.* Bologna.

CORNARO 1758
Cornaro, F. *Notizie istoriche delle chiese e monasteri di Venezia e di Torcello.* Padua.

COTTINEAU 1939
Cottineau, Dom. L. H. *Répertoire Topo-Bibliographique des Abbayes et Prieurés.* Macon.

CUCCIOMINI 1989
Cucciomini, Maria Francesca. "La serie dei corali del Duomo nella minitura dell'ultimo trentennio del quattrocento." In *Corali miniati del quattrocento nella Biblioteca Malatestiana,* edited by Piero Lucchi, Milan.

DALLI REGOLI 1973
Dalli Regoli, Giggetta. In Clara Baracchini and Antonino Caleca, *Il Duomo di Lucca.* Lucca.

D'ANCONA 1904
D'Ancona, Paolo. "La miniatura alla mostra senese d'arte antica." *L'Arte* 7, pp. 377–86.

DAUNER 1998
Dauner, Gudrun. *Neri da Rimini und die Rimineser Miniaturmalerei des frühen Trecento.* Munich.

DE BENEDICTIS 1976
De Benedictis, Cristina. "I corali di San Gimignano, II." *Paragone: Arte,* no. 315, pp. 87–95.

DE BENEDICTIS 1979
De Benedictis, Cristina. *La pittura senese, 1330–1370.* Florence.

DE BENEDICTIS 1994
De Benedictis, Cristina. "Pietro Lorenzetti e la miniatura." In *Studi di storia dell'arte in onore di Mina Gregori.* Milan, pp. 21–25.

DE BENEDICTIS 1996
De Benedictis, Cristina. In Todini 1996.

DE FLORIANI 1996
De Floriani, Anna. In Todini 1996.

DE MARCHI 1992
De Marchi, Andrea. *Gentile da Fabriano.* Milan.

DE MARCHI 1993
De Marchi, Andrea. In *Francesco di Giorgio e il Rinascimento a Siena, 1450–1500.* Exhibition catalogue, Milan.

DE MARCHI 1995
De Marchi, Andrea. In Bacchi et al. 1995.

DE RICCI 1913
De Ricci, Seymour. *Catalogue d'une collection de miniatures gothiques et persanes appartenant a Léonce Rosenberg.* Paris.

DE RICCI 1937
De Ricci, Seymour, with the assistance of William J. Wilson. *Census of Medieval and Renaissance Manuscripts in the United States and Canada.* Vol. 2, New York.

DEGL'INNOCENTI GAMBUTI 1977
Degl'Innocenti Gambuti, Marcella. *I codici miniati medievali della Biblioteca Comunale e dell'Accademia Etrusca di Cortona.* Florence.

DEL BRAVO 1962
Del Bravo, Carlo. "Francesco Morone." *Paragone* 13, no. 151 (July), pp. 3–23.

DOCAMPO 1997
Docampo, Javier. "Aportaciones al estudio de la miniatura gotica italiana: tres fragmentos de la Biblioteca Nacional." *Archivio espagnol de arte* 70, pp. 315–19.

EBERHARDT 1986
Eberhardt, Hans-Joachim. "Nuovi studi su Domenico Morone, Girolamo dai Libri e Liberale." In Verona 1986, pp. 103–51.

LES ENLUMINURES 1994
Illuminations, Gouaches, Drawings from the 12th to the 19th Centuries. Sale catalogue, no. 3, Galerie Les Enluminures, Paris, 20 September–30 November.

LES ENLUMINURES 1996
Illuminations, Gouaches, Drawings from the 13th to the 18th Centuries. Sale catalogue, no. 5, Galerie Les Enluminures, Paris, 12 September–27 October.

LES ENLUMINURES 2001
Enluminures/Illuminations: Moyen Age. Renaissance. Middle Ages. Sale catalogue, no. 10, Galerie Les Enluminures, Paris, 28 September–26 October.

FERRARA 1998
La miniatura a Ferrara dal tempo di Cosmè Tura all'eredità di Ercole de' Roberti. Exhibition, Palazzo Schifanoia, Ferrara, 1 March–31 May. Catalogue by Federica Toniolo et al. Modena.

FERRETTI 1985
Ferretti, Massimo. "Ritagli di Cristoforo Cortese." *Paragone Arte* 36, nos. 419–23 (January–May), pp. 92–96.

FILIPPINI AND ZUCCHINI 1947
Filippini, Francesco, and Guido Zucchini. *Miniatori e pittori a Bologna: Documenti dei secoli XIII e XIV.* Florence.

FRANCESCHINI 1993
Franceschini, Adriano. *Artisti a Ferrara in età umanistica e rinascimentale. Testimonianze archivistiche.* 2 vols. Ferrara.

FREULER 1987
Freuler, Gaudenz. "Andrea di Bartolo, Fra Tommaso d'Antonio Caffarini and Sienese Dominicans in Venice." *Art Bulletin* 69, pp. 570–86.

FREULER 1991
"Manifestatori delle cose miracolose": Arte italiana del '300 e '400 da collezioni in Svizzera e nel Lichtenstein. Exhibition catalogue by Gaudenz Freuler. Lugano-Castagnola Villa Favorita, Fondazione Thyssen-Bornemisza, 1991.

FREULER 1992
Freuler, Gaudenz. "Presenze artistiche toscane a Venezia alla fine del Trecento: lo scriptorium dei camaldolesi e dei domenicani." In Lucco 1992, vol. 2, pp. 480–502.

FREULER 1997
Freuler, Gaudenz. *A Corpus of Florentine Painting.* Sec. 4, vol. 7, part 2: *Tendencies of the Gothic in Florence: Don Silvestro dei Gherarducci.* Florence.

FREULER 2001
Freuler, Gaudenz. In *Les Enluminures* 2001.

FROSININI 1998
Frosinini, Valeria. In *Fioritura tardogotica nella Marche.* Exhibition catalogue, Milan.

GARZELLI 1985
Garzelli, Annarosa, ed. *Miniatura fiorentina del Rinascimento, 1440–1525: Un primo censimento.* 2 vols. Florence.

GIBBS 1984
Gibbs, Robert. "Recent Developments in the Study of Bolognese and Trecento Illustration." *The Burlington Magazine* 126, pp. 638–41.

GIBBS 1991
Gibbs, Robert. "The Brussels Initials Master from Proto-Renaissance to Northern Renaissance and Back." *Apollo* 134, pp. 317–21.

GIBBS 1995
Gibbs, Robert. In Rimini 1995.

MEDICA 1987
Medica, Massimo. In *Il tramonto del medioevo a Bologna, Il cantiere di San Petronio*. Bologna.

MEDICA 1992
Medica, Massimo. "Aggiunte al Maestro del Messale Orsini e ad altri miniatori bolognesi tardogotici." *Arte a Bologna* 2, pp. 11–30.

MEDICA 1993
Medica, Massimo. "In margine all'attività bolognese di Taddeo Crivelli: il caso del 'Maestro del Libro dei notai.'" *Arte a Bologna* 3, pp. 121–28.

MEDICA 1997
Medica, Massimo. "Un problema di pittura bolognese della metà del Quattrocento." *Arte a Bologna* 4, pp. 65–73.

MEDICA 1999
Haec Sunt Statuta: Le corporazioni medievali nelle miniature bolognesi. Exhibition, Rocca medievale Boncompagni, 27 March–11 July. Catalogue edited by Massimo Medica, Modena.

MEISS 1969
Meiss, Millard. *French Painting in the Time of Jean de Berry*. London.

MELOGRANI 1990
Melograni, Anna. "Appunti di miniatura lombarda. Ricerche sul Maestro delle Vitae Imperatorum." *Storia dell'arte* 70, pp. 273–314.

MELOGRANI 1992
Melograni, Anna. "I corali quattrocenteschi della Collegiata di S. Lorenzo a Voghera." *Storia dell'arte* 75, pp. 117–64.

MELOGRANI 1994
Melograni, Anna. "Miniature inedite del Quattrocento lombardo nelle collezioni americane. Prima parte." *Storia dell'arte* 82, pp. 283–302.

MELOGRANI 1995a
Melograni, Anna. "Miniature di Frà Antonio da Monza (e altri) in Terra Santa." *Arte Cristiana* 83, pp. 135–38.

MELOGRANI 1995b
Melograni, Anna. "Miniature inedite del quattrocento lombardo nelle collezioni americane. Seconda parte." *Storia dell'arte* 83, pp. 5–27.

MILAN 1988
Arte in Lombardia tra Gotico e Rinascimento. Exhibition, Palazzo Reale di Milano.

MILAN 1991
Le Muse e Il Principe: Arte di corte nel Rinascimento padano. Exhibition, Museo Poldi Pezzoli, Milan, 20 September–1 December. Catalogue edited by Rolando Bussi. Modena.

MILAN 1997
Miniature a Brera, 1100–1422. Exhibition, Biblioteca Nazionale Braidense, 11 February–23 April. Catalogue edited by Miklós Boskovits, with Giovanni Valagussa and Milvia Bollati. Milan.

MOROZZI 1980
Morozzi, Luisa. "Contributo alla ricostruzione delle miniature appartenenti ai corali di San Pietro a Gubbio." *Paragone* 31, pp. 53–67.

MULAS 2000
Mulas, Pier Luigi. *Enluminures italiennes. Chef d'oeuvre du Musée Condé*. Chantilly.

NATALE 1982
Natale, M. In *Museo Poldi Pezzoli. Diputi*. Milan.

NEW YORK 1988
Painting in Renaissance Siena, 1420–1500. Exhibition, The Metropolitan Museum of Art, 20 December 1988–19 March 1989. Catalogue by Keith Christiansen et al.

NEW YORK 1994
Painting and Illumination in Early Renaissance Florence, 1300–1450. Exhibition, The Metropolitan Museum of Art, 17 November–26 February. Catalogue by Laurence Kanter et al. New York.

NORDENFALK ET AL. 1975
Nordenfalk, Carl, et al. *Medieval & Renaissance Miniatures from the National Gallery of Art*. Washington.

OFFNER 1922
Offner, Richard. "Pacino di Bonaguida, a Contemporary of Giotto." *Art in America* 11, pp. 3–27.

OFFNER 1930
Offner, Richard. *A Critical and Historical Corpus of Florentine Painting*. Sec. 3, vol. 2. New York.

OFFNER 1956
Offner, Richard. *A Critical and Historical Corpus of Florentine Painting*. Sec. 3, vol. 6. New York.

OFFNER 1957
Offner, Richard. *A Critical and Historical Corpus of Florentine Painting*. Sec. 3, vol. 7. New York.

OFFNER/BOSKOVITS 1987
Offner, Richard. *A Critical and Historical Corpus of Florentine Painting. The Fourteenth Century*. Sec. 3, vol. 2, edited by Miklós Boskovits, Florence.

OTTOLENGHI 1996
Ottolenghi, Maria Grazia Albertini. *I graduali miniati dell'abbazia del San Salvatore presso Pavia*. Edited by E. D. Marni. Pavia.

PÄCHT 1948
Pächt, Otto. *The Master of Mary of Burgundy*. London.

PADOVA 1999
La miniatura a Padova: dal medioevo al Settecento. Exhibition, Palazzo della ragione, Padova, 21 March–27 June. Catalogue edited by Giovanna Baldissin Molli et al. Modena.

PADOVANI 1978
Padovani, Serena. "Su Belbello da Pavia e sul 'Miniatore di San Michele a Murano.'" *Paragone* 29, no. 339, pp. 25–34.

PALLADINO 1997a
Palladino, Pia. *Art and Devotion in Siena After 1350: Luca di Tommè and Niccolò di Buonaccorso*. San Diego.

PALLADINO 1997b
Palladino, Pia. In Hindman et al. 1997.

PALLADINO 1999
Palladino, Pia. Review of *Tendencies of the Gothic in Florence: Don Silvestro dei Gherarducci. A Critical and Historical Corpus of Florentine Painting, Sec. 4, vol. 6 (Part 2)* by Gaudenz Freuler, *The Burlington Magazine* 141 (May), p. 290.

PALLADINO 2001
Palladino, Pia. In *Les Enluminures* 2001.

PALLADINO 2002
Palladino, Pia. "Ancora sui corali di San Giorgio Maggiore, con qualche oppunto su Belbello e Stefano da Verona." *Arte Veneta*.

PALLADINO FORTHCOMING
"Further Inquiries into the Choirbooks of Cardinal Bessarion."

PARENTI 1992
Parenti, Daniela. In Boskovits 1992.

PARIS 1957
Exposition de la Collection Lehman de New York. Exhibition, Musée de l'Orangerie. Catalogue by Charles Sterling et al. Paris.

PASSALACQUA 1980
Passalacqua, Roberta. *I codici liturgici miniati Dugenteschi nell'Archivio Capitolare del Duomo di Arezzo.* Florence.

PASUT 1998
Pasut, Francesca. "Qualche considerazione sul percorso di Niccolò di Giacomo miniatore bolognese." *Arte Cristiana* 86, pp. 431–44.

PASUT 2002
Pasut, Francesca. In *Benozzo Gozzoli, allievo a Roma, maestro in Umbria.* Exhibition catalogue, Milan.

PENNY 1996
Penny, Nicholas. "The Madonna and Child by Francesco Morone in the National Gallery in London and its Relative in the Museo di Castelvecchio." *Verona illustrata* 9, pp. 23–28.

PERETTI 2000
Peretti, Gianni. In *Da Paolo Veneziano a Canova. Capolavori dalle Regione del Veneto 1984–2000.* Exhibition catalogue, Venice.

PERUGIA AND OTHER CITIES 1982
Francesco d'Assisi: Documenti e archivi. Codici e biblioteche. Miniature. Exhibitions held in Perugia, Todi, and Foligno to commemorate the 800th anniversary of the birth of St. Francis of Assisi. Vol. 3, Milan.

PETTENATI 1995
Pettenati, Silvana. In Verona 1986.

PETTENATI 1998
Pettenati, Silvana. *Grandi Pittori per Piccole Immagini nella Corte Pontificia del '500. I corali miniati di San Pio V.* Alessandria.

PIETROPOLI 1986
Pietropoli, Fabrizio. In Verona 1986.

PUERARI 1976
Puerari, Alfredo. *Museo Civico Ala Ponzone, Cremona. Raccolte artistiche.* Cremona.

QUATTRINI 2000
Quattrini, Cristina. "Fra Antonio da Monza e il suo influsso in alcuni corali francescani lombardi-II parte." *Arte Cristiana* 88, pp. 201–9.

RICE 1985
Rice, Eugene F. *Saint Jerome in the Renaissance.* Baltimore, 1985.

RIMINI 1995
Neri da Rimini: Il Trecento riminese tra pittura e scrittura. Exhibition, Museo della Città, Rimini, 2 April–28 May. Catalogue by Andrea Emilani et al. Milan.

ROTILI 1972
Rotili, Mario. *I codici danteschi miniati a Napoli.* Naples.

ROTILI 1978
Rotili, Mario. *La miniatura nella Badia di Cava,* vol. 2: *Cava dei Tirreni.*

SAFFIOTTI 1997
Saffiotti, Maria Francesca. In Hindman et al. 1997.

SALMI 1952
Salmi, Mario. "La miniatura fiorentina medioevale." *Accademie e biblioteche d'Italia* 20, pp. 8–23.

SALMI 1953
Salmi, Mario. In *Mostra storica nazionale della miniatura.* Florence. Exhibition, Palazzo di Venezia, Rome.

SALMI 1954a
Salmi, Mario. *Italian Miniatures.* New York.

SALMI 1954b
Salmi, Mario. *La miniatura fiorentina gotica.* Rome.

SANTI 1984
Santi, Bruno. "'De pulcerima pictura…ad honorem beate et gloriose Virginis Marie': vicende critiche e una proposta di lettura per la 'Madonna Rucellai.'" In Santi et al. 1984, pp. 11–32.

SANTI ET AL. 1984
Santi, Bruno, et al. *Gli Uffizi: Studi e Ricerche,* no. 6. Florence.

SBARLEAE 1978 [1921]
Sbarleae, Hyacinthi Fr. Jo. *Supplementum Et Castigatio Ad Scriptores Trium Ordinum S. Francisci A Waddingo, Aliisue Descriptos,* II. Bologna. Reprint of Rome, 1921.

SERAFINI 1912
Serafini, Alberto. "Ricerche sulla miniatura umbra." *L'Arte* 15, pp. 41–66, 233–62.

SEYMOUR 1970
Seymour, Charles. *Early Italian Paintings in the Yale University Art Gallery.* New Haven.

SHAILOR 1987
Shailor, Barbara A. *Catalogue of Medieval and Renaissance Manuscripts in the Beinecke Rare Book and Manuscript Library, Yale University.* Vol. 2, Binghamton, New York.

SIENA 1904
Mostra dell'antica arte senese. Catalogo generale. Siena.

STEFANI 1985
Stefani, Letizia. "Per una storia della miniatura lombarda da Giovannino De'Grassi alla Scuola Cremonese Della II metà del Quattrocento: Appunti Bibliografici." In *La miniatura italiana tra gotico e rinascimento: Atti del II congresso di storia della miniatura italiana,* vol. 2, Florence, pp. 823–81.

STEYAERT AND STONES 1978
Steyaert, John, and Alison Stones. *Medieval Illumination, Glass, and Sculpture in Minnesota Collections.* Minneapolis.

STONES 1969
Stones, Alison. "An Italian Miniature in the Gambier-Parry Collection." *The Burlington Magazine* III, pp. 7–12.

STREHLKE 1988
Strehlke, Carl. In New York 1988.

STREHLKE 1994
Strehlke, Carl. In New York 1994.

STREHLKE 2001
Strehlke, Carl. In *Leaves of Gold: Manuscript Illumination from Philadelphia Collections.* Philadelphia.

SUBBIONI 2001
Subbioni, Marina. In *"Per buono stato de la citade": le matricole della arte di Perugia.* Exhibition, Palazzo della Penna, 20 July–15 September. Catalogue edited by Mario Roncetti.

SUTTON 1991
Sutton, Kay. "The 'Master of the Modena Hours,' Tomasino da Vimercate, and the Ambrosianae of Milan Cathedral." *The Burlington Magazine* 133, pp. 87–90.

TALAMO 1997
Talamo, Emilia Anna. *Codices cantorum. Miniature e disegni nei codici della Cappella Sistina.* Florence.

TIETZE-CONRAT 1943
Tietze-Conrat, Erica. "Francesco Morone in America." *Art in America* 31, no. 2 (April), pp. 83–87.

TODINI 1982
Todini, Filippo. In Perugia and other cities 1982.

TODINI 1989
Todini, Filippo. *La pittura umbra dal duecento al primo cinquecento.* 2 vols. Milan.

TODINI 1996
Todini, Filippo, ed. *La Spezia: Museo Civico Amedeo Lia. Miniature.* Milan.

TODINI 1999
Filippo Todini, ed., with text by Milvia Bollati. *Una collezione di miniature italiane dal duecento al cinquecento: Parte terza.* Milan.

TOESCA 1912
Toesca, Pietro. *La pittura e la miniatura nella Lombardia dai più antichi monumenti alla metà del Quattrocento.* Milan.

TOESCA 1930
Toesca, Pietro. *Monumenti e studi per la storia della miniatura italiana: La collezione di Ulrico Hoepli.* Milan.

TOESCA 1948
Toesca, Pietro. "Di un miniatore e pittore emiliano: Francesco Marmitta." *L'Arte* 17, pp. 33–39.

TOESCA 1958
Toesca, Pietro. *Miniature di una collezione Veneziana.* Venice.

TONIOLO 1994
Toniolo, Federica. In Hermann 1994 [1900].

TONIOLO 1997
Toniolo, Federica. In *La Bibbia di Borso d'Este. Commentario al codice.* 2 vols. Modena.

TONIOLO 1998
Toniolo, Federica. In Ferrara 1998.

TONIOLO 1999
Toniolo, Federica. In *La miniatura a Padova dal medioevo al settecento.* Exhibition catalogue. Modena.

TORLONTANO 1987
Torlontano, Rossana. "La pittura in Abruzzo nel Quattrocento." In *La pittura in Italia. Il quattrocento.* Venice.

TOSCANO 1998
Toscano, Gennaro. "Per Belbello in Laguna." *Arte Veneta,* pp. 7–27.

TOSCANO 2000
Toscano, Gennaro. In Mulas 2000.

TURA 2002
Tura, Cosimè. In Boston 2002.

VAN MARLE 1925
Van Marle, Raimond. *The Development of the Italian Schools of Painting.* Vol. 5, The Hague.

VANOLI 1997
Vanoli, Gisella. In Milan 1997.

VASARI 1878–85 [1568]
Vasari, Giorgio. *Le Vite de' più eccellenti pittori scultori ed architettori.* 9 vols. Edited by Gaetano Milanesi. Florence. Based on the 2d ed. of 1568.

VASARI 1880
Vasari, Giorgio. Vasari 1878–85, vol. 5.

VASARI 1906
Vasari, Giorgio. Reprint edition of Vasari 1878–85. Florence.

VERONA 1986
Miniatura veronese del Rinascimento. Exhibition, Museo di Castelvecchio, Verona. Catalogue by Gino Castiglioni, edited by Sergio Marinelli.

VIGI 1989
Vigi, Berenice Giovannucci. *Il Museo della Cattedrale di Ferrara.* Bologna, 1989.

VOELKLE AND WIECK 1992
Voelkle, William M., and Roger S. Wieck. *The Bernard Breslauer Collection of Manuscript Illuminations.* Exhibition, Pierpont Morgan Library, 9 December 1992–4 April 1993. New York.

WAGSTAFF 1965
Wagstaff, Samuel. *An exhibition of Italian Panels and Manuscripts from the Thirteenth and Fourteenth Centuries in Honor of Richard Offner.* Exhibition catalogue, Hartford.

WESCHER 1930
Wescher, Paul. "Buchminiaturen im Stil Cosimo Tura." *Berliner Museen, Berichte aus den preussischen Kunstsammlungen* 60, pp. 78–81.

WESCHER 1931
Wescher, Paul. *Beschreibendes Verzeichnis der Miniaturen, Handschriften und Einzelblätter des Kupferstichkabinetts der Staatlichen Museen Berlin.* Leipzig.

WESCHER 1960
Wescher, Paul. "Francesco Binasco Miniaturmaler der Sforza." *Jahrbuch der Berliner Museen,* vol. 2, pp. 75–91.

WIECK 1994
Wieck, Roger S. In London 1994.

ZANONI 1955
Zanoni, Felice. *I corali del Duomo di Cremona e la miniatura cremonese del quattrocento (Annali della Biblioteca Governativa e Libraria Civica di Cremona),* vol. 8.

ZERI 1963
Zeri, Federico. *The Cleveland Museum of Art Bulletin,* vol. 50, no. 61.

ZIINO AND ZAMEI 1999
Ziino, Agostino, and Francesco Zamei. "Nuovi frammenti di un disperso laudario fiorentino." In *Col dolce suon che da te piove: Studi su Francesco Landini e la musica del suo tempo, in memoria di Nino Pirrotta,* edited by Antonio Delfino and Maria Teresa Rosa-Barezzani, Florence, pp. 485–505.

Index

Photograph Credits

Unless otherwise noted, photography of works formerly in the Lehman collection are by Eileen Travell of the Photograph Studio of The Metropolitan Museum of Art or were supplied by the lending institutions. Catalogue number 35c is courtesy of the Robert Lehman Collection archives. Photographs of comparative illustrations are courtesy of the credited institutions, except as follows: figs. 2, 6, Institute of Fine Arts, New York University; fig. 7, from *La maestrà di Duccio restaurata* (Florence, 1984), p. 77; fig. 10, Robert Lehman Collection archives; fig. 11, from *Les Enluminures* (Paris and Chicago, 2001), p. 73; fig. 19, Robert Lehman Collection archives; fig. 21, Sherman Fairchild Center for Works on Paper and Photograph Conservation; fig. 23, Arte Fotografica; fig. 24, Robert Lehman Collection archives; fig. 31, Eileen Travell; fig. 33, Jonathan Alexander; fig. 35, Courtald Institute of Art; fig. 36, Robert Lehman Collection archives; fig. 37, Robert Lehman Collection archives; fig. 39, Fotografia Lensini; fig. 40, courtesy of Laurence Kanter; fig. 41, Institute of Fine Arts, New York University. Photographs of works in the Appendix are by Eileen Travell or lending institutions except as noted. Appendix nos. 8, 10, 12, Robert Lehman Collection archives.